T0161562

KILL ALL YOUR DARLINGS

ALSO BY LUCY SANTE

Low Life: Lures and Snares of Old New York
Evidence
The Factory of Facts
Folk Photography
The Other Paris
Maybe the People Would Be the Times

CO-EDITOR (WITH MELISSA HOLBROOK PIERSON)
O. K. You Mugs: Writers on Movie Actors

EDITOR AND TRANSLATOR
Novels in Three Lines by Félix Fénéon

Kill All Your Darlings

PIECES 1990–2005

Lucy Sante

YETI books are published by Verse Chorus Press in association with YETI
Verse Chorus Press, Portland, Oregon | *versechorus.com*

Cover painting: Francesco Clemente, *Palladium Door IX* (1985)
Cover design: Patrick Barber / McGuire Barber Design
Book design: Steve Connell

Country of manufacture as stated on the last page of this book

Library of Congress Cataloging-in-Publication Data

Sante, Luc.
 Kill all your darlings : pieces, 1990-2005 / Luc Sante. -- 1st ed.
 p. cm.
 ISBN 978-1-891241-53-6 (pbk. : alk. paper)
 1. Popular culture--United States. 2. Arts, American. 3. Popular music--United
States. 4. United States--Intellectual life. 5. Popular culture. 6. Arts. 7. Sante, Luc.
8. New York (N.Y.)--Description and travel. 9. New York (N.Y.)--Social life and
customs. I. Title.
E169.1.S258 2007
306.0973--dc22
 2007012128

To Barbara Epstein
1928–2006

I had intended to dedicate this book to Barbara back when I thought she would live forever. She did more than just edit five of the best things herein; she formed me as a writer. The dedication was to have been a public thank-you note. I can only hope she had a glimmer of how much she meant to me.

Acknowledgments:

I would like to thank the editors who solicited, encouraged, and abetted the pieces herein (my apologies to those few whose names I have not retained): Tom Beller, Chuck Eddy, Anne Fadiman, Sean Howe, Andrew Hultkrans, Wendy Lesser, Greil Marcus, Susan Morrison, Annie Nocenti, Ed Park, Ann Philbin, Rob Polner, Joy Press, Jason Shinder, Paul Smart, Matt Weiland, Eric Weisbard, Sean Wilentz, and Rebecca Wilson; also thanks to Robert Christgau. Special thanks to Jonathan Galassi, instrumental in both the first and the last items in the collection. Very large extra thanks to Greil Marcus and to Francesco Clemente, as well as to Raymond Foye. Thanks as ever to Joy Harris. Big huge thanks to "Yeti" Mike McGonigal and Steve Connell for taking a chance on this book. And no end of thanks and love to Melissa and Raphael, my constant inspirations.

Most of the contents of this book have previously been published, often in somewhat different form and under different titles, in the following: "My Lost City," "I Is Somebody Else," "The Invention of the Blues," "The Hunger Artist," and "The Perfect Moment" in the *New York Review of Books*; "A Riot of My Own" in *Mr. Beller's Neighborhood*; "The Bandit King" in the *New York Times* (City Section); "In a Garden State" in *The Nation*; "The Injection Mold" in *Granta*; "Why Do You Think They Call It Dope?" in *High Times*; "Auld Lang Syne" in the *New York Observer*; "Strength Through Joy" in *Ulster Magazine*; "I Can't Carry You Anymore," "Teenage History," and "Getting By and Making Do" in the *Village Voice*; "The Detective" in the *Threepenny Review*; "The Department of Memory" (first part) in *Bookforum*; "The Department of Memory" (second part) in *Modern Painters*; "A Companion of the Prophet" in *The American Scholar*; "The Ruins of New York" in *Francesco Clemente: Palladium* (Nürnberg: Verlag für moderne Kunst, 2000); "The Sea-Green Incorruptible" in *America's Mayor*, edited by Rob Polner (Soft Skull, 2005); "I Thought I Heard Buddy Bolden Say" in *The Rose and the Briar*, edited by Greil Marcus and Sean Wilentz (W. W. Norton, 2004); "The Octopus Bearing the Initials V. H." in *Shadows of a Hand: The Drawings of Victor Hugo*, edited by Florian Rodari and Ann Philbin (The Drawing Center/Merrell Holberton, 1998); "The Clear Line" in *Give Our Regards to the Atomsmashers!* edited by Sean Howe (Pantheon, 2004); and "The Total Animal Soup of Time" in *The Poem That Changed America*, edited by Jason Shinder (Farrar, Straus & Giroux, 2006).

"Kill all your darlings."

 —writerly advice attributed to William Faulkner

"Et on tuera tous les affreux."

 —Boris Vian, title of book

TABLE OF CONTENTS

Introduction by Greil Marcus . 11

I

My Lost City . 18
The Ruins of New York . 33
A Riot of My Own . 39
The Sea-Green Incorruptible . 48
The Bandit King . 54
In a Garden State . 58

II

The Injection Mold . 66
Why Do You Think They Call It Dope? 80
Our Friend the Cigarette . 85
Auld Lang Syne . 100

Strength Through Joy . 110

I Can't Carry You Anymore . 120

III

Teenage History . 132

Getting By and Making Do . 137

I Is Somebody Else . 142

I Thought I Heard Buddy Bolden Say 165

The Invention of the Blues . 177

IV

The Octopus Bearing the Initials V. H. 208

The Detective . 221

The Clear Line . 229

The Hunger Artist . 238

The Department of Memory . 252

The Perfect Moment . 261

V

The Total Animal Soup of Time 282

A Companion of the Prophet . 289

INTRODUCTION

by Greil Marcus

As I read through the pieces Luc Sante has collected here, the phrase that came to mind was "hard-boiled." As in a hard-boiled detective, poking around in a place where something happened, knowing that the clues will be less obvious in a neat, spotless room where it seems inconceivable that anyone was killed there than in a room so tossed by violence it seems inconceivable somebody wasn't. Not that this book, despite its title, has much to do with mayhem in any conventional manner—unlike Sante's *Low Life* and *Evidence*, or *New York Noir* and *The Big Con*—the last two, a collection of photos from the New York *Daily News* and a reissue of David W. Maurer's 1940 study of con artists, merely introduced by Sante, but with such immediacy you feel his voice all through their pages. It's that a feeling of suspense is just as present—or more present. With the work for which Sante is best known, he writes as a historian, and the suspense is in the past. Here—where Sante is writing about New York City, cigarettes, drugs, and his own earlier years, but most carefully

and intensely about music, painting, photography, and poetry—the suspense is active on the page, or even pushed into the future. Here, to be hard-boiled means to go in ready to get the truth out of the suspect, knowing that the crunch may come when the suspect begins to get the truth out of you.

When you truly put yourself face to face with a piece of art, it will interrogate you as surely as you might flatter yourself to think that you have interrogated it, because unlike an ordinary crime, a work of art is never finished. No matter how complete it might appear to the world at large, when a writer confronts a book or a painting or a song, nothing is settled and anything can happen. You can make the work new, or it can leave you exposed in all your stupidity on your own page.

It's all in the tone, which for Sante means a quiet, calm, forceful attempt to get inside those people, places, artifacts, and memories that attract him, with a commitment to the subject at hand that is as passionate as it is modest. There is no hyperbole, or critical hysteria: there is no panic in the face of the writer's inability to make a melody, an image, or a patch of words give up its secrets. Modesty is part of what it means to be hard-boiled: an acceptance that some secrets will never be given up. The tone comes out of empathy, on the one hand—empathy for the perpetrator, the artist or the art work, the person or the act remembered—and it produces respect, for the reader, for the person who has to be brought into the story, the writer making his own story unfamiliar to himself in order to open it up to others. "Everything seemed possible then," Sante writes of how Bob Dylan, in his book *Chronicles, Volume 1*, situates himself early in his career, but Sante doesn't rest with the cliché, which is to

say he doesn't insult either Dylan or his reader with it. He redeems the cliché, returns it to real speech, by making it speak: "Everything seemed possible then; no options had been used up and nothing had yet been sacrificed."

The tone demands incisiveness and concision, a sense of what to leave in and what to leave out, as with Sante's startling argument that the blues—"the now-familiar three-line verse, with its AAB rhyme scheme and its line length of five stressed syllables"—was invented, by a single person, on a certain day, in a certain place. There is a sociological setting that makes the notion seem ordinary—"The origin of the blues occurred close to our time, within a historical corridor that makes it possible to place it among the early manifestations of modernism—between the automobile and the airplane, and not long after the movies, radio transmission, and cylinder recordings"—a setting that only seems sociological, because it is in fact moving toward a setting where sociology cannot go. If the invention of the blues took place on the broad, visible terrain of modern technology, it also, Sante says, appeared, and in an uncanny sense remained, "in an inaccessible back street of history, so that we don't know who or when or how or why, just that it happened." And then, with an economy and a cold eye worthy of Twain, or Hemingway, or Chandler, a story: "The very success of the invention must also have mitigated against anyone knowing who was responsible. Even if a front-porch guitarist was responsible, rather than an itinerant songster, it is easy to imagine that within twenty-four hours a dozen people had taken up the style, a hundred inside of a week, a thousand in the first month. By then only ten people would have remembered who came up with it, and nine of them weren't talking."

"It is awfully easy to be hard-boiled about everything in the day-time, but at night it is another thing," as Hemingway had Jake Barnes say in *The Sun Also Rises*, putting the phrase into the air: Sante's story is unbearable, because like him you are there and you aren't. You can't be and you can't not be. The detective never has to be more hard-boiled than in the moment when he realizes, like Jake Gittes at the end of *Chinatown*, that he will never solve the case, never bring the perpetrator home. The modesty is patent; the passionate critic walks away from his own mystery. The suspense is itself mysterious. As the critic walks away, the suspense doubles, moving from the sus-pense that gathers around an event that, like a planet beyond Pluto, can be inferred but not seen, to the greater suspense that attends the realization that a true event is defined precisely by its unpre-dictability: if the invention of the blues occurred once, in a certain place, at a certain time, it might as likely have never occurred at all. And then neither you or the writer who is telling the story would be who you are. Just as the existence of the blues and the self is patent, everything goes up in smoke.

The balance of modesty and suspense that creates the hard-boiled face carries Sante through his adventures in these pages; keeping that balance, he can take you to strange places, and pull the ground from right under your feet. I saw him do it once, on a night when many writers and musicians had come together to perform American bal-lads—the musicians to play and sing them, and the writers to read what they'd written about them. Luc Sante read a shortened version of the piece that appears here as "I Thought I Heard Buddy Bolden Say."

Sante began with the night that, in New Orleans in 1902, on

a bandstand in a hot, stinking dancehall, someone heard what he thought he heard Buddy Bolden say—and then, somehow, weaving a spell of facts over the course of no more than ten minutes, Sante high-jacked everything—Bolden, his band, the building in which they were playing, the audience to whom Sante was reading, the building in which they were sitting—into the sky. There were other memorable readings that night, from Joyce Carol Oates, Sarah Vowell, John Rockwell, and Paul Berman, and shining performances, from "Omie Wise" by Bob Neuwirth and Jenni Muldaur to "Ode to Billie Joe" by Rosanne Cash to "Volver, Volver" by Perla Batalla to "Barbara Allen" by Terre Roche and Madigan. But there was no moment that was greeted by the shock, and then the earthquake of an ovation, that followed Sante's last words. He was able to hold that hard-boiled tone without its ever breaking: speaking modestly, as if nothing were happening, the suspense built invisibly, so that it was only with the last word that anyone realized that from beginning to end everything was at stake, and all of that is in these pages.

MY LOST CITY

The idea of writing a book about New York City first entered my head around 1980, when I was a writer more wishfully than in actual fact, spending my nights in clubs and bars and my days rather casually employed in the mailroom of the *New York Review of Books*. It was there that Rem Koolhaas's epochal *Delirious New York* fell into my hands. "New York is a city that will be replaced by another city," is the phrase that sticks in my mind. Koolhaas's book, published in 1978 as a paean to the unfinished project of New York the Wonder City, seemed like an archeological reverie, an evocation of the hubris and ambition of a dead city. I gazed wonderingly at its illustrations, which showed sights as dazzling and remote as Nineveh and Tyre. The irony is that many of their subjects stood within walking distance: the Chrysler Building, the McGraw-Hill Building, Rockefeller Center. But they didn't convey the feeling they had when they were new. In Koolhaas's pages New York City was manifestly the location of the utopian and dystopian fantasies of the silent-film era. It was *Metropolis*, with elevated roadways, giant searchlights probing the

heavens, flying machines navigating the skyscraper canyons. It was permanently set in the future.

The New York I lived in, on the other hand, was rapidly regressing. It was a ruin in the making, and my friends and I were camped out amid its potsherds and tumuli. This did not distress me—quite the contrary. I was enthralled by decay and eager for more: ailanthus trees growing through cracks in the asphalt, ponds and streams forming in leveled blocks and slowly making their way to the shoreline, wild animals returning from centuries of exile. Such a scenario did not seem so far-fetched then. Already in the mid-'70s, when I was a student at Columbia, my windows gave out onto the plaza of the School of International Affairs, where on winter nights troops of feral dogs would arrive to bed down on the heating grates. Since then the city had lapsed even further. On Canal Street stood a five-story building empty of human tenants that had been taken over from top to bottom by pigeons. If you walked east on Houston Street from the Bowery on a summer night, the jungle growth of vacant blocks gave a foretaste of the impending wilderness, when lianas would engird the skyscrapers and mushrooms would cover Times Square.

At that time much of Manhattan felt depopulated even in daylight. Aside from the high-intensity blocks of Midtown and the financial district, the place seemed to be inhabited principally by slouchers and loungers, loose-joints vendors and teenage hustlers, panhandlers and site-specific drunks, persons whose fleabags put them out on the street at eight and only permitted reentry at six. Many businesses seemed to remain open solely to give their owners shelter from the elements. How often did a dollar cross the counter

of the plastic-lettering concern, or the prosthetic-limb showroom, or the place that ostensibly traded in office furniture but displayed in its window a Chinese typewriter and a stuffed two-headed calf? Outside under an awning on a hot afternoon would be a card table, textured like an old suitcase with four metal corners, and around it four guys playing dominoes. Maybe they'd have a little TV set, up on a milk crate, plugged into the base of a streetlight, emitting baseball. On every corner was a storefront that advertised Optimo or Te-Amo or Romeo y Julieta, and besides cigars they sold smut and soda pop and rubbers and candy and glassine envelopes and sometimes police equipment. And there were Donuts Muffins Snack Bar and Chinas Comidas and Hand Laundry and Cold Beer Grocery and Barber College, all old friends. Those places weren't like commercial establishments, exactly, more like rooms in your house. They tended to advertise just their descriptions; their names, like those of deities, were kept hidden, could be discovered only by reading the license tacked up somewhere behind the cash register. At the bodega you could buy plantains and coffee and *malta* and lard, or a single ciga-rette—a loosie—or a sheet of paper, an envelope, and a stamp.

I drifted down from the Upper West Side to the Lower East Side in 1978. Most of my friends made the transition around the same time. You could have an apartment all to yourself for less than a hun-dred and fifty dollars a month. In addition, the place was happening. It was happening, that is, in two or at most three dingy bars that doubled as clubs, a bookstore or record store or two, and a bunch of individual apartments and individual imaginations. All of us were in that stage of youth when your star may not yet have arisen, but your moment is the only one on the clock. We had the temerity to

laugh at the hippies, shamefully backdated by half a decade. In our arrogance we were barely conscious of the much deeper past that lay all around. We didn't ask ourselves why the name carved above the door of the public library on Second Avenue was in German, or why busts of nineteenth-century composers could be seen on a second-story lintel on Fourth Street. Our neighborhood was so chockablock with ruins we didn't question the existence of vast bulks of shuttered theaters, or wonder when they had been new. Our apartments were furnished exclusively through scavenging, but we didn't find it notable that nearly all our living rooms featured sewing-machine tables with cast-iron bases.

When old people died without wills or heirs, the landlord would set the belongings of the deceased out on the sidewalk, since that was cheaper than hiring a removal van. We would go through the boxes and help ourselves, and come upon photographs and books and curiosities, evidence of lives and passions spent in the turmoil of 1910 and 1920, of the Mexican Border War and Emma Goldman's *Mother Earth* and vaudeville and labor unions and the shipping trade, and we might be briefly diverted, but we were much more interested in the boxes on the next stoop containing someone's considerably more recent record collection. One day something fell out of an old book, the business card of a beauty parlor that had stood on Avenue C near Third Street, probably in the 1920s. I marveled at it, unable to picture something as sedate as a beauty parlor anywhere near that corner, by then a heroin souk.

The neighborhood was desolate, so underpopulated that landlords would give you a month's free rent just for signing a lease, many buildings being less than half-full, but it was far from tranquil. We

might feel smug about being robbed on the street, since none of us had any money, and we looked it, and junkies—as distinct from the crackheads of a decade later—would generally not stab you for chump change. Nevertheless, if you did not have the wherewithal to install gates on your windows you would be burglarized repeatedly, and where would you be without your stereo? In the blocks east of Avenue A the situation was dramatically worse. In 1978 I got used to seeing large fires in that direction every night, usually set by arsonists hired by landlords of empty buildings who found it an easy choice to make, between paying property taxes and collecting insurance. By 1980 Avenue C was a lunar landscape of vacant blocks and hollow tenement shells. Over there, commerce—in food or clothing, say—was often conducted out of car trunks, but the most thriving industry was junk, and it alone made use of marginally viable specimens of the building stock. The charred stairwells, the gaping floorboards, the lack of lighting, the entryways consisting of holes torn in ground-floor walls—all served the psychological imperatives of the heroin trade.

Dealers knew that white middle-class junkies thrived on squalor, that it was a component of their masochism, and that their masochism, with an admixture of bourgeois guilt, was what had drawn them to the neighborhood. The dealers proved this thesis daily, at least to themselves, by requiring their customers to stand for an hour in pouring rain before allowing them inside, for example, and then shifting them up five flights with interstitial waits on the landings, and then possibly, whimsically, refusing to sell to them once they finally arrived in front of the slotted door. Of course, a junkie becomes a masochist by virtue of his habit, and any of those people

would have done much worse to obtain a fix, but the dealers were correct to a degree. Some did indeed come to the neighborhood to revel in squalor, and junkiedom was part of the package, as surfing would be if they had moved to Hawaii instead. They were down with the romance of it, had read the books and gazed upon the pop stars. Junkiehood could happen to anyone, for a complex of reasons that included availability, boredom, anxiety, depression, and self-loathing, but many were tourists of scag, and if they wiped out as a consequence it was the inevitable effect of a natural law, like gravity. They had been culled.

For those of us who had been in the city for a while, squalor was not an issue. Most of the city was squalid. If this troubled you, you left, and if you were taken by the romance of it, a long regimen of squalor in everyday life would eventually scrub your illusions gray. At this remove I'm sometimes retrospectively amazed by what I took for granted. Large fires a few blocks away every night for a couple of years would seem conducive to a perpetually troubled state of mind, but they just became weather. I spent the summer of 1975 in a top-floor apartment on 107th Street, where at night the windows were lit by the glow of fires along Amsterdam Avenue. A sanitation strike was in progress, and mounds of refuse, reeking in the heat, deco-rated the curbs of every neighborhood, not excepting those whose houses were manned by doormen. Here, though, instead of being double-bagged in plastic, they were simply set on fire every night. The spectacle achieved the transition from apocalyptic to dully nor-mal in a matter of days.

Two summers later I was living with two roommates in a tall building on Broadway at 101st Street. It had both a doorman

and an elevator operator; most of the other tenants were elderly European Jews; our rent for five large rooms was four hundred dollars a month. I note these facts because the other buildings lining Broadway in that area were mainly single-room-occupancy hotels, tenanted by the luckless, the bereft, the unemployable, dipsomaniacs, junkies, released mental patients—exactly that portion of the population that would be turned out and left to conduct its existence in shelters or doorways or drainpipes or jails in the following decade. What those people had in common was that they could not blend into mainstream society; otherwise there was no stereotyping them. For example, a rather eerie daily entertainment in the warmer months was provided by a group of middle-aged transvestites who would lean against parked cars in their minidresses and bouffantes and issue forth perfect four-part doo-wop harmonies. You had to wonder in which volume of the Relic label's "Golden Groups" series they might figure, perhaps pictured on the sleeve in younger, thinner, pencil-mustached, tuxedo-clad incarnations. For them, as for most people on the street—including, we liked to think, us—New York City was the only imaginable home, the only place that posted no outer limit on appearance or behavior.

When the blackout happened, on the evening of July 13, 1977, it briefly seemed as though the hour of reckoning had arrived, when all those outsiders would seize control. Naturally, no such thing occurred. The outsiders seized televisions and toaster ovens and three-piece suits and standing rib roasts and quarts of Old Mr. Boston and cartons of Newports and perhaps sectional sofas, but few would have known what to do with the levers of society had they been presented to them in a velvet-lined box. But then, my friends and I

wouldn't have known, either. For all the obvious differences between the SRO-dwellers and ourselves, we were alike in our disconnection from any but the most parochial idea of community. In the end the mob dissolved like a fist when you open your hand, and the benches on the Broadway traffic islands were repopulated by loungers occasionally pulling down a bottle hanging by a string from a leaf-enshrouded tree branch overhead.

The looters were exemplary Americans, whose immediate impulse in a crisis was to see to the acquisition of consumable goods. They had no interest in power. Neither did anyone I knew. We just wanted power to go away. Sometimes it seemed as though it already had. In those days the police, when not altogether invisible, were nearly benign, or at least showed no interest in the likes of us, being occupied with actual violent crime. Almost everybody had a story about walking down the street smoking a joint and suddenly realizing they had just passed a uniformed patrolman, who could not possibly have failed to detect the odor but resolutely looked the other way. Casual illegality was unremarkable and quotidian, a matter of drug use and theft of goods and services, petty things. We slid by in weasel jobs, in part because we were preoccupied with our avocations and in part because a certain lassitude had come over us, a brand of the era.

The revolution was deferred indefinitely, then, because we were too comfortable. Not, mind you, that we didn't live in dumps where the floors slanted and the walls were held together with duct tape and the window frames had last been caulked in 1912 and the heat regularly went off for a week at a time in the depths of winter. The landlords were the primary villains and the most visible manifesta-

tions of authority. Very few still went from door to door collecting rents, but most could be physically located, sitting on the telephone at a secondhand metal desk in some decrepit two-room office, and that included the ones who went home to mansions in Great Neck. Real estate was a buyer's market, and owners needed to hustle for every dollar, and were correspondingly reluctant to make expenditures that would be any greater than the anticipated legal costs of not making them. At the same time, you could let the rent go for a while and not face eviction, because the eviction process itself would cost the landlord some kale, besides which it might be hard to find anyone else to take up the lease, so that a tenant who only paid every other month was better than nothing. We were comfortable because we could live on very little, satisfying most requirements in a fiercely minimal style for which we had developed a defining and mitigating aesthetic. It was lucky if not altogether coincidental that the threadbare overcoat you could obtain for a reasonable three dollars just happened to be the height of fashion.

Suspicion in the hinterlands of New York City's moral fiber and quality of life, rampant since the early nineteenth century, reached new heights during the 1970s. Hadn't the President himself urged the city to drop dead? If you told people almost anywhere in the country then that you lived in New York, they tended to look at you as if you had boasted of dining on wormwood and gall. Images of the city on big or small screens, fictional or ostensibly journalistic, were a blur of violence, drugs, and squalor. A sort of apotheosis appeared in John Carpenter's *Escape from New York* (1981), in which the city has become a maximum-security prison by default. The last honest folk having abandoned the place, the authorities have merely

locked it up, permitting the scum within to rule themselves, with the understanding that they will before long kill one another off. The story may have been a futuristic action-adventure, but for most Americans the premise was strict naturalism, with the sole exception of the locks, which ought by rights have been in place. Aside from the matter of actual violence, drugs, and squalor, there was the fact that in the 1970s New York City was not a part of the United States at all. It was an offshore interzone with no shopping malls, few major chains, very few born-again Christians who had not been sent there on a mission, no golf courses, no subdivisions.

Downtown we were proud of this, naturally. We thought of the place as a free city, like one of those pre-war nests of intrigue and licentiousness where exiles and lamsters and refugees found shelter in a tangle of improbable juxtapositions. I had never gotten around to changing my nationality from the one assigned me at birth, but I would have declared myself a citizen of New York City had such a stateless state existed, its flag a solid black. But what happened instead is that Reagan was elected and the musk of profit once again scented the air. It took all of us a while to realize that this might affect us in intimate ways—we were fixated on nuclear war. So while we were dozing money crept in, making its presence felt slowly, in oddly assorted and apparently peripheral ways. The first sign was the new phenomenon of street vendors. Before the early 1980s you never saw people selling old books or miscellaneous refuse from flattened boxes on the sidewalk. If you truly wanted to sell things you could rent a storefront for next to nothing, assuming you weren't choosy about location. But now, very quickly, Astor Place became a vast flea market, with vendors ranging from collectors of old comic books to

optimists attempting to unload whatever they had skimmed from garbage cans the night before. Those effects of the deceased that had once been set out for the pickings of all were now the stock of who-ever happened upon them first. The daily spectacle was delirious, uncanny, the range of goods boundless and utterly random. You had the feeling you would one day find there evidence of your missing twin, your grandfather's secret diary, a photograph of the first girl whose image kept you awake at night, and all the childhood toys you had loved and lost.

What it meant, though, was that people who had previously gotten by on charm and serendipity now needed ready cash. It also meant that there now existed consumers who would pay folding money for stuff that had once been available for nothing to anyone who read the sidewalks. Part of the reason the *Luftmenschen* had to have dollars was the vast increase in heroin traffic, caused by a steep plunge in prices. All of a sudden people who had been strictly holiday users were getting themselves strung out. While this was happening the neighborhood was filling up, rapidly. Every day the streets were visibly more congested than the day before. The vacancy rate fell to near zero. Speculators were buying up even gutted shells, even tenements so unsound they would require a fortune to fix. Was the fall in the price index of junk connected to the rise in that of real estate? Street-corner theorists were certain we were all marked for death. It was obvious, no? If you OD'd or went to jail your apart-ment would become vacant, and legally subject to a substantial rent increase. A folklore emerged, with tales of people paying rent to sleep on examination tables in medical offices, of landlords murdering rent-controlled tenants or simply locking them out and disposing of

their chattel. Whether those tales were true or not, everyone spent increasing amounts of time in housing court, battling the fourth or fifth landlord in as many months, who all but treated the property as vacant. The neighborhood was subjected to lifestyle pieces in the glossies; a crowd of galleries sprang up. You could spot millionaires making the rounds in old sweaters.

The more I felt I was losing my city the more preoccupied I became with it. I gradually became interested in its past, an interest that grew into an obsession. It was triggered by what seemed like chance—by things I spotted on the flattened cardboard boxes on the sidewalk. On Astor Place I acquired for a dollar a disintegrating copy of Junius Henry Browne's *The Great Metropolis* (1868) and, a week later, Joseph Mitchell's incomparable *McSorley's Wonderful Saloon*, a 1940s paperback with a ridiculous cover that almost dissuaded me from picking it up—I had never heard of it or him. In a heap of miscellanea on Seventh Street I found a pristine copy of Chuck Connors's very rare *Bowery Life*, and took it home for fifty cents. In a parking lot on Canal Street I bought a stereoscope card of the Second Avenue El; a table outside a junkshop on Thirtieth Street yielded lithographs pulled from nineteenth-century copies of *Valentine's Manual*. These things were mysterious, slices of a complex past of which I had little sense. I was already fascinated by the strange process whereby the glamorous city of the 1920s had become the entropic slum that was my home; now I was discovering that the slum had far deeper roots.

One day, probably early in 1980, a film crew commandeered Eleventh Street between Avenues A and B and, with minimal adjustments, returned the block to the way it had looked in 1910. All

they did was pull the plywood coverings off storefront windows, paint names in gold letters on those windows, and pile goods up behind them. They spread straw in the gutters and hung washlines across the street. They fitted selected residents with period clothes and called forth a parade of horse-drawn conveyances. They were shooting a few scenes of *Ragtime* (Milos Forman, 1981). After the production packed up a week later, the Dominican evangelical church on Avenue A held a sort of exorcism ceremony in the middle of the intersection. I hadn't paid much attention to the goings-on, but I had been struck by how little effort was needed to conjure up a seemingly unimaginable past. When I walked down that street at night, with all the trappings up but the crew absent, I felt like a ghost. The tenements were aspects of the natural landscape, like caves or rock ledges, across which all of us—inhabitants, landlords, dope dealers, beat cops, tourists—flitted for a few seasons, like the pigeons and the cockroaches and the rats, barely registering as individuals in the ceaseless churning of generations.

And now everything was up for grabs. The tenements were old and unstable; the speculators were undoubtedly buying them up for the value of their lots. One day in the near future they would be razed and containment units at least superficially more upscale would be built. Maybe the whole neighborhood would be reconfigured, the way Washington Market and the far Lower East Side were swept, to the point where whole streets had disappeared. Within a decade, all of us who had lived there in the last days of the tenement era might seem as distant and insubstantial as the first people to move in when the buildings were new. I told myself it was inevitable. I remembered Baudelaire's warning that the city changes faster than the human

heart. I thought of my grandfather saying that progress was a zero-sum game in which every improvement carried with it an equivalent loss, and decided that the reverse was also true. I considered that at the very least nobody in the future would have to contend with a stiff wind sucking out an entire loose windowpane, as had once happened to me. Then I pictured the high-rises themselves falling inch by inch into ruin. I bore an old-timer's resentment toward the children of privilege who were moving into tastefully done-up flats and about to start calling themselves New Yorkers, even Lower East Siders, and might spend decades without once having spent a winter sitting in front of an open oven wearing an overcoat and hat, or having to move pots and pans and furniture by subway in the middle of the night, or having bottles thrown at them by crack dealers, or having to walk home from Brooklyn in the rain for want of carfare. But it was for more than personal reasons that I wanted to prevent amnesia from setting in.

Now, more than a decade after I finally finished my book *Low Life*, the city has changed in ways I could not have pictured. The tenements are mostly still standing, but I could not afford to live in any of my former apartments, including the ones I found desperately shabby when I was much more inured to shabbiness. Downtown, even the places that used to seem permanently beyond the pale have been colonized by prosperity. Instead of disappearing, local history has been preserved as a seasoning, most visibly in names of bars. The economy has gone bad, but money shows no signs of loosening its grip. New York is neither the Wonder City nor a half-populated ruin but a vulnerable, overcrowded, anxious, half-deluded, all-too-human town, shaken by a cataclysm nobody could have foreseen. I

don't live there anymore, and I have trouble going there and walking around because the streets are too haunted by the ghosts of my own history. I wasn't born in New York, and I may never live there again, and just thinking about it makes me melancholy, but I was changed forever by it, and my imagination is manacled to it, and I wear its mark the way you wear a scar. Whatever happens, whether I like it or not, New York City is fated always to remain my home.

2003

THE RUINS OF NEW YORK
Francesco Clemente's Palladium frescoes, 1985

Late in 1985 a previously unsuspected volcano suddenly reared up
from the floor of Upper New York Bay, about midway on a lateral
line between what were then Bedloes Island and Governors Island.
At 9 A.M. on December 19th the peak was observed just above the
water's surface; by noon it had risen to one hundred meters; by
sunset it was ten times higher. Apparently, few people took notice,
fewer still showed alarm, and hardly anyone took action. In view of
what we know about the extreme self-absorption and narcissism of
New Yorkers, this indifference is less surprising than it might at first
seem. When the volcano erupted, shortly after midnight, the city's
inhabitants were pursuing their usual course of nightlife, skuldug-
gery, and chaos. The entire island of Manhattan—all but the peaks
of its very highest buildings—as well as significant portions of the
other boroughs of New York City and most of Hudson County,
New Jersey, were buried by molten lava.

Their misfortune is our boon. Five centuries after that epochal disaster, we are in the unique position of being able to observe a single night in the life of the past, flash-frozen and preserved as if in amber. Wherever we dig we find the whole panoply of human activities in the great metropolis, encased in fine white ash but otherwise undisturbed. We see thieves holding guns to the heads of grocery-store proprietors, prostitutes leaving grimy hotel rooms bearing the wallets of drunken clients, policemen in uniform clutching envelopes filled with cash in the hallways of ghetto drug dens. We see sex slaves in leather harnesses cowering in expensively appointed dungeons, clergymen of high rank sharing drugs with naked schoolchildren in the crypts of great churches, fresh corpses rolled up in carpets in the trunks of limousines arrested in flight on the peripheral roadways. Everywhere we dig, it seems, we find exchanges of money, sex, drugs, and death.

New York in 1985 was an open city, where everything was permissible, like a gold-mining or oil-pumping boom town of the previous century. The infusion of capital in this case came primarily from real estate. After more than three decades of neglect, following the mass exodus of the white middle class to the suburbs after World War II, the children of that white middle class were rediscovering the city's possibilities. Its industries had in the meantime died off or moved, real-estate prices had plummeted, and whole neighborhoods lay nearly vacant. The potential profits were enormous, and it didn't hurt that the city's dangers added a glamorous frisson. It cannot be coincidental that the art world, which since the early 1970s had been marked by an austere, consciously anticommercial conceptualism, suddenly rediscovered flash, publicity, and marketable objects.

Photographs of the period show artists looking like bankers, wearing expensive suits and smoking large cigars. The city's remaining elite had formerly clustered in certain uptown neighborhoods, fearful of venturing into the crime-ridden districts further south. By 1982 or '83 their focus had been redirected, thanks in large part to the art world, and they began actively to colonize the area known generally as "downtown." The epicenter of nightlife at the city's twilight moment was a large building called The Palladium, appropriately situated on Fourteenth Street, traditionally the boundary line between uptown and downtown. Built a century earlier and known almost all its life as The Academy of Music, it had originally been an opera house that catered to the old families and discouraged attendance by the rising new-money class, who took their revenge by building the Metropolitan Opera, which soon eclipsed its rival. For decades afterward it had been a movie house and then, in the 1970s, a concert hall given over to the more aggressive and déclassé forms of popular music, from glam to metal to punk.

The entrepreneurs who purchased the building in the early 1980s entirely reconfigured it, removing the banks of seats and all but a memory of the proscenium stage, converting it into a multilevel dance palace. The Palladium was intended to unite all the subcultures of the city's nightside, which had each formerly been segregated in its own separate clubland. The atmosphere would blend and mingle and conjoin: black hip-hop kids from the Bronx and gay disco habitués who left clubs at noon, art punks in thrift-shop clothing and gossip-column celebrities in fifty pounds of makeup, working-class Latinos for whom dancing was an exact science and junior Mafiosi

for whom spending money was an article of machismo, fashion-forward nebbishes who liked to pretend they were robots and sullen Jamaican Rastas who danced by moving their ribcages a fraction of an inch on the off-beat. There would be trust-fund teenagers who lived in vast lofts and hitchhiking teenagers who slept on floors, club veterans who could remember nights twenty years earlier at Cheetah or Arthur and saucer-eyed hopheads who couldn't remember the night before, speculators and drag queens, graffiti writers and tourists, runway models and leather fetishists, squatters and rock stars, artists and drunks. That at least was the theory, although surviving first-person accounts suggest that many were excluded for lack of money, and merciless gatekeepers excluded many more for want of physical beauty.

The Palladium was situated on a block that was itself a microcosm, bounded on one end by a twenty-four-hour doughnut shop whose clientele seems to have consisted mostly of transvestites and at the other by a cut-price steak restaurant that served burnt gristle to the indigent. In between were located, variously: a decorous whorehouse staffed by large, motherly women from countries to the south; a gymnasium of historical significance to the art of boxing; an enormous billiard parlor favored by old men who carried knives in their socks; and the ruins—they were already then ruins—of what had been for decades one of the city's most fashionable restaurants, fallen out of favor when *Gemütlichkeit* passed into obloquy, reduced by that time to a horror of racing vermin and liquefying plaster. Over all of these the Palladium loomed, a beacon in the night.

As we dug through the layers of the Palladium we were staggered by the press of bodies, so dense it was nearly impossible to

make out the decor, even the architecture. We were thus confronted by a dilemma. Our policy as archeologists has been to leave sites untouched as much as possible, since for sound scholarly reasons we cannot consider locations without their human component. But in the Palladium we were often incapable of threading our way through the rooms. Even the toilet stalls, intended for one person, were each crowded with as many as four or five (participating in sex acts, ingesting drugs, or often both at once). We could only surmise what the sound levels must have been like—imagining the noise of the crowd in addition to the volume that would have been produced by the formidable amplification equipment. The Palladium is the only location so far in our excavations to have confronted us with this problem of massive crowding, since the disaster struck after midnight; subway ridership at that hour, for example, was relatively sparse. We divided into two factions, who immediately dubbed themselves the "purists" and the "pragmatists" and fought bitterly for weeks about whether to clear the rooms or keep them as found. Finally, good sense prevailed, and we unanimously decided to empty one area as a test case, leaving the rest of the building as it was.

We settled on an upstairs corridor, the walls of which appeared to be painted with figures. We brought in a bucket-loader and cleared the space, packing each individual cadaver in polyethylene for future examination. What we found underneath surprised and disoriented us. Naturally we'd had many occasions on the Manhattan dig to refer to our formations in classical archeology, but the uncovering of the corridor gave many of us the irrational sensation that we had accidentally stumbled upon a location far older than 1985 AD. We recovered our balance when we considered the style of the paint-

ings, the enjambment of surfaces, the chemical composition of the pigment. Even so, this hallway—a simple Palladian arch at either extremity, a few Ionic capitals, the walls daubed with frescoes predominantly in reds and yellows strikingly reminiscent of Pompeii—continues to fill us with an uncanny feeling of dislocation. We realize the qualities of the iconography that are specific to the times: the large isolated organs of sense, the occasional linear allusion to "wild style" graffiti, the parade of drunken or drugged or dead human heads around the archway, to name a few examples. And yet, given those colors, the impression that the finish looked somehow ancient even when it was new, the images' palpable mixture of abandon and aftermath, anxiety and serenity, we cannot help but ask ourselves a question that can never be answered: Did the artist have a premonition of what was about to befall the city?

2000

A RIOT OF MY OWN

On Saturday, August 6, I was possibly even more abstracted than usual, because it was well nigh midnight before I realized that I had neglected to eat dinner, and that the refrigerator contained nothing but half a jar of horseradish.[1] So I set out for a greasy spoon on Second Avenue, in the heart of the sidewalk market district (mismatched shoes, secondhand pornography). After refreshing myself

[1] This piece was submitted to the *New Yorker*, and published in the issue of August 22, 1988. It appeared in the "Talk of the Town" section and, as was then the custom, was unsigned. The anonymity was especially appropriate in this case, because the version printed differed so wildly from my original (which appears here) as to make it in effect the work of its editor. Nevertheless, the piece here is in many ways disfigured by my pathetic attempts at *New Yorker* style. You see me trying to sound like that magazine's man of the world, who just naturally employs constructions like "well nigh," who "decides to investigate" as if he were Philo Vance. Even the framing is phony. Although it was and is my custom when alone to eat dinner very late, in fact that night I saw the eight cop cars when I was out walking my dog, but I guess that didn't sound sufficiently interesting. And my stylistic contortions got worse: in the typescript I submitted I actually changed the first-person singular to first-person plural. (The published version reverted to the singular, as "A friend writes...")

with rubbery kielbasa slices embedded in an egglike mass, I was pro-
ceeding back up the avenue when I saw eight police vehicles come
screeching around the corner of St. Mark's Place, bearing down on
Tompkins Square Park.

I decided to investigate. The park had been much on my mind
lately, and I had been expecting trouble there for at least a year. A
decade ago, when I first moved into the neighborhood, the park had
been the undisputed province of junkies and muggers, and few oth-
ers, including me,[2] ventured into it after dark. More recently, how-
ever, it had regained its position as a public gathering site. On week-
end nights it emanated music and hijinks as the traffic among the
dozens of bars and restaurants nearby just naturally came to include
the park. At the same time it had become an encampment of the
homeless. On bitter January nights, as I headed up Avenue A from
my office to my apartment, I could see groups of people huddled
around trashcan bonfires or packed together sleeping under a tarp.
Late in the winter, though, policemen had been coming around and
dousing the flames, and otherwise harassing the occupants of this
latter-day Hooverville.[3] When summer came, the ongoing party and
the homeless settlement had in some fashion fused; it was a mild

[2]In twenty-eight years of living in New York City the only time I was actually
mugged was in the spring of 1983, when I was visiting a girlfriend who lived
on Tenth Street, on the north side of the park. She fell asleep, the apartment
was hot, and I decided to go smoke a joint on a park bench I could see from
her window. Within minutes I was face down on the bench with a knife blade
to the side of my neck as unseen hands went through my pockets and relieved
me of my twenty bucks. I felt like a fool, since I knew better. If you went to the
park at night you incurred a tax, and that was that.
[3]This designation drew letters from readers asking whether the encampment
shouldn't rightly have been called a "Reaganville." Point taken.

commotion, a bit boisterous but no threat to anyone. Nevertheless, in the view of the cops, it was a ticking bomb. The park's history had been marked for a century by clashes between police and area residents, from the gun detachments that were moved in after the 1887 execution of the Haymarket anarchists in Chicago for fear of local anarchist flareups (none occurred), to the violent turf wars of the late 1960s and early '70s, a three-way tangle among police, hippies, and Hispanic youths. Some of the tension of those post-Summer of Love days had returned, although now largely devoid of racial content[4] and set starkly between locals and the authorities. There had been talk, too, that city officials were unhappy with the park's design—disturbed by the darkness provided by the dense, ancient trees and the twisting, European-style paths—and were considering revising that landscape to a more open, policeable plan. It did not come as much of a surprise, then, to hear that the cops were intending to close the park at night, nor that the first such effort, in the last weekend in July, was met with vocal if confused resistance. On that occasion some taunting went on and there were a scattering of arrests, but around two in the morning the thirty or forty cops went home and jubilant locals moved back into the park, convinced that they had won.

On this night, though, things looked different before I had even reached First Avenue. Groups of people massed on the four corners of First and St. Mark's were yelling such slogans as "The Park Belongs to the People!" Halfway down the next block a cordon of cops in riot gear was blocking access in the direction of the park,

[4]A pretty hasty assertion, this, given how many of the homeless were black or Hispanic.

not even letting through residents of buildings located beyond their post, nor were they deigning to answer questions. Even if one knew that there had been some recent disputes over use of the park—and such knowledge was by no means general in the neighborhood—the obviously hostile police presence appeared inexplicable. Overhead, a police helicopter hovered, coming so low that the roar of its blades seemed to be rising from behind the houses on both sides of the street, and then coming lower still, so that the backwash of its rotors kicked up the debris from the gutters and the trash from the trashcans and drew it upward in spirals.

On Avenue A the helicopter aimed its spotlights at the tops of buildings.[5] Was it looking for snipers? The avenue was full of people, some protesting but many more pulled, dazed, from bars and apartments, some from bed; one guy was wearing a bathrobe and slippers. A group crowded around a man who said he had heard the chief of the Ninth Precinct assert that he was calling for reinforcements due to "Communist agitators" among the protestors. This drew a laugh. Police were everywhere (by the end of the night their numbers would be estimated at 450): beat cops with their caps turned around and badge numbers obscured, plainclothesmen trying with little success to look like locals, vehicles marked with designations ranging from "Hazardous Materials Squad" to "DWI Task Force," and, just below the park's main entrance opposite St. Mark's Place, an Emergency Services truck the size of a bus, with lamps like Klieg lights aimed up and down the avenue. Suddenly a detachment of mounted cops

[5]How did I get there? The cops made a great show of cordoning off St. Mark's Place, but characteristically they didn't bother with any of the other side streets leading to the park.

went tearing down St. Mark's at full gallop.

On First Avenue, where the horses were headed, all was chaos. Trash cans lay on their sides in the middle of the street, small groups of civilians were being chased this way and that by mounted cops and foot cops wielding nightsticks. The police appeared to be acting in purely random fashion, suddenly deciding to empty a particular corner or stretch of sidewalk of its occupants, or, hearing an insult launched at them from the crowd, undertaking a flanking maneuver, sticks braced, advancing to their own rhythmic chant: "Kill, kill, kill!" More vehicles—patrol cars and paddy wagons—came roaring down St. Mark's Place the wrong way at high speed. Then they parked and the cops got out and just milled about for a while, eventually beginning their own game of patternless rousting and containment actions.

Back on Avenue A, the block between Sixth and Seventh streets just below the park was now an empty zone between police lines at either end. A handful of cops were stalking the block demanding that shopkeepers and the owners of bars and restaurants shut their gates. A middle-aged cop who looked a little like the actor Brian Keith was shouting himself hoarse ordering the owners of the large mid-block Korean grocery to lock their doors. "With a key!" he screamed again and again. Earlier I had heard someone in the crowd say, "You know who's really hurting tonight? S.Y.P." I tried to decipher the acronym: Socialist Youth Party?[6] Now I realized they had

[6]Pretty unlikely that the Trots would have been out in force, but as a veteran of the early 1970s at Columbia, when I witnessed a fair amount of violence and pantomime violence between left and crypto-left factions—often involving Trot splinter groups and thugs from Lyndon LaRouche's National Caucus

been referring to this popular albeit grossly overpriced convenience store, locally known as Save Your Pennies, which under ordinary circumstances would have been doing its heaviest business at just that hour. I watched the activity for about fifteen minutes, virtually the only civilian on the block, until finally a small cop came up to me and yelled, half-pleading, "What are you doing? Go home!" as if I were an errant toddler and he a nervous young father.

Below Sixth Street the heaviest concentration of police stood cordoning off the block from a crowd of several hundred locals. Every sort of attitude was present on both sides. There were cops who wanted to talk, for example, trying to reason it out with their opponents, although they were a distinct minority among the blue ranks. The civilians comprised a wide range of ages, dispositions, and sartorial adornments. One long-haired peacock in an incongruous black duster staggered around in confusion, preening reflexively. A shirtless man paced in front of the crowd with the air of a prophet, lifting his cane in the air as he instigated chants. Most people simply looked dazed. Others kept appearing, homeward bound from work or bars and entirely unprepared for the situation; most ended up staying with the crowd. A knot of people on a corner clustered around two priests, who seemed to have been among the complainants responsible for the police presence. That is, they had asked the precinct to try to reduce the volume of noise emanating from the park, and now they were alternately embarrassed and defensive in the face of the semi-military occupation. A couple of reasonable-sounding

of Labor Committees—I was still at that late date expecting that a riot would bring the ideologues out of the woodwork. Nobody was selling *Workers' Vanguard* in Tompkins Square Park, though.

passersby had seen the beginnings of the fray, around eleven o'clock, when the cops had evacuated the park, a group of youths had turned around and rushed the fence, sticks had been wielded and bottles thrown. From there matters had escalated. The passersby, avoiding ideological argument, were making the point that bad policing had been and continued to be manifest. The priests kept insisting that a large police presence was necessary to protect their parishioners from the crack trade. They didn't seem to register the fact, even when it was pointed out to them, that such trade does not take place in the park but in derelict buildings on side streets that are raided every now and then but reopen almost immediately. Finally one of the priests lost his cool. "You think this is bad?" he asked, having by his own admission perceived that a number of his interlocutors looked Jewish. "You should go to Israel, see what the Israelis are doing on the West Bank. They're really cracking heads there!"[7]

Over the next few hours events became increasingly repetitive as cops and crowd were locked in a face-off, which would momentarily be broken when somebody (always someone invisibly in the rear of the crowd) would lob a bottle and the cops would charge and

[7] This anecdote, or whatever shard of it was preserved in the published version, raised a certain amount of controversy. The pastor of St. Brigid's, on Avenue B and Seventh Street, wrote in to protest that, far from the anti-Semitic police defender he was depicted as, he was actually out that night trying to negotiate with the cops on behalf of the protesters. In fact I knew him by sight, and acknowledged his negotiation in the following paragraph, although that part of the piece didn't survive the edit (Father Moloney, if I remember his name correctly, went to prison a few years later for his alleged involvement in a scheme to run guns to the IRA). I couldn't identify the two priests in question; there are or were at least five Catholic or Eastern Rite churches within a block or two of the park.

club heads. A young woman who had done nothing but stand in the wrong place was clubbed so badly her shirt was soaked through with blood. After she had been taken away in an ambulance, others raised her shirt on a stick like a flag. Onlookers wept, screamed in frustration, exhorted their fellows to take up sticks and do battle. The crowd had no leaders and no logic. Neither did the cops, apparently. They spent a great deal of time dispatching units to investigate rooftops from which nothing was being thrown. Periodically cops would go around dumping garbage cans and smashing the empty bottles with their clubs and feet, invariably drawing applause from the crowd. They seemed particularly vehement in going after bicycles, deliberately wrecking them with their truncheons. Every now and then a fire truck would pull up and, after a few minutes, depart. This remained inexplicable until a radio report the following day quoted police officials as saying that the crowd started fires along the avenue, but no fires were seen, at least by me. A negotiation session between locals and cops, mediated by a third priest, ground down into a circular bout of repeated arguments.

Finally, about five o'clock or so, I was getting so sleepy, having been up since seven the previous morning, that the tableau before my eyes began to look imaginary. I decided to go. Just then the huge Emergency Services truck began broadcasting news of a Community Board meeting to be held the following Wednesday.[8] Then somebody threw a bottle and the cops charged yet again. All night I had been pretty deft at staying out of their path, but this

[8]Not as incongruous as that sounds, since the Community Board, a body despised by many in the neighborhood (and the feeling was mutual), was always calling for preemptive police actions, allegedly on behalf of "the community."

time I did not move quickly enough down Sixth Street, and I was slammed against a building and then dragged along the sidewalk. I limped home, fingering the gashes in my shirt and pants, wishing I hadn't been wearing new clothes that day.[9]

1988, 2001

[9] The next day I took the Hampton Jitney to Sagaponack, where I wrote the piece. The edits were dispatched via the bus and picked up by me at the Candy Kitchen on Main Street. Yes, those kinds of strange paradoxes were a feature of the 1980s. I made probably fifteen thousand dollars a year then, paid less than two hundred dollars a month for my apartment on Twelfth Street and an equally trifling sum for my office on Sixth, but I had more successful artist friends with whom I was renting a house near the beach—the Hamptons had not yet been so grotesquely disfigured by money then either, and the rent was not astronomical. My friends had all lived in the East Village when they were poorer a few years earlier, and the major topic of discussion at that time was the infuriating death of Jean-Michel Basquiat, killed by success. I had known him in the neighborhood—I remembered sitting with him on the fire-escape stairs of the old Center Bar on St. Mark's as, flushed with excitement, he told me he had that day sold Henry Geldzahler (the doyen of the NYC art world from the '60s through the '80s) one of his color-Xerox postcards. That was the beginning of his rise, and of his fall. The death of Jean-Michel and the debacle in the park are now entwined in my mind, both representative of how, beginning in the early '80s, money moved through Manhattan, sucking up and then spitting out everything in its path.

THE SEA-GREEN INCORRUPTIBLE

You really couldn't hope to find a better illustration of Rudolph Giuliani's tenure as mayor of New York City than his policy on jaywalking. The practice of crossing the street against traffic or when the light is red or in the middle of the block is probably the single most common form of law-breaking, especially now that littering has become deeply unfashionable and spitting on the sidewalk has virtually disappeared. Laws prohibiting jaywalking are universally understood to symbolize a city's parental stance toward its infantile citizens; in cities around the world they are primarily a cheap and easy way for a beat cop to meet his daily ticket quota. New York City, however, might as well be the capital of jaywalking—it could call itself the City of Jaywalkers. It is the inverse of those German cities in which travelers are astonished to find crowds of pedestrians waiting placidly for the light to change even when there is no traffic to be seen for miles in either direction. Jaywalking is a New Yorker's birthright, a minor but indispensable sign of his or her independence and self-sufficiency. New Yorkers can cross anywhere at any

time if they need to, and if they get themselves creamed they accept that it will be their own damn fault. It is their city, after all, not one lent to them on a merit basis by cops or bureaucrats.

Therefore, the fact that, as mayor, Giuliani chose to have his policemen aggressively enforce the anti-jaywalking statutes was a flung gauntlet, a proclamation that he intended to remake the city in his own image for his own pleasure. Unlike most mayors, he would not be adapting himself the better to serve his city, but would be adapting the city the better for it to serve him. Not being one for half-measures, he then raised the ante far beyond anyone's speculations by declaring certain formerly legal street-crossings off-limits—installing fences on midtown corners to prevent any pedestrian traffic at those points, so as not to impede the flow of motor vehicles on the major arteries. Favoring cars over people flew in the face of most current urbanist thinking, went directly against the trend of cities, such as London and Amsterdam, that had been doing their best to reduce vehicular traffic in their centers—but Giuliani's actions had far less to do with traffic control than with behavior modification. He was determined to rule over an obedient citizenry. He would effect a personality change in New Yorkers by forcing them to adhere to whimsical and arbitrary mandates.

The enforcement of the statutes on jaywalking was perhaps thinly justified by the "broken windows" theory, a voguish neoliberal construct that held that the number of minor infractions observed in a district—graffiti, panhandling, subway-fare evasion—was proportional to the amount of significant crimes, of murders and rapes and felonious assaults. You might as well say that the number of dust bunnies observed under furniture was somehow predictive of the

odds that the house would burn down, but it was hardly coincidental that most such "lifestyle crimes"—jaywalking was a notable exception—were largely limited to, and taken for granted by, the poor. In previous decades there had been rashes of enforcement of particular infractions, notably graffiti, which was the focus of a virulent media campaign that just happened to coincide with its flowering as an art form, but most such torts had traditionally been engrained in city life. Begging, for one, went back to the prehistory of cities, and even conservative regimes had long been inclined to view it as an occasion for demonstrative charity if not as a reproach to materialist self-satisfaction. Unlicensed sidewalk vending of secondhand goods had flourished in the poorer neighborhoods of New York more or less forever, but under the mayoral administration of Edward Koch the police had begun to harass vendors on the pretext that their goods might have been stolen property—a ridiculous assertion on the face of it to anyone who had ever bothered to inspect their displays. Under Giuliani, the enforcement of such petty laws became draconian and unavoidable, and the number of targetable infractions swelled dramatically. Out-of-towners who desired a quick nutshell view of the city's tone in those years would be taken to the Criminal Courts Building on Monday morning, to observe the endless line of otherwise blameless citizens who had been given a bench-appearance ticket over the weekend for drinking beer—concealed by paper bags—on the sidewalk.

New York City was hardly alone in witnessing attempts in the 1990s to erase those aspects of its fabric that journalists tended to characterize with the adjective "gritty." It was the era when gentrification went into overdrive, and hardly any urban neighborhood,

no matter how ill-constructed and godforsaken, was safe from the incursion of smart boutiques and chic restaurants—businesses that could be of interest only to, and affordable only by, the young and well-to-do. New York's transformation differed in the pedantic obsessiveness with which laws were combed to find a basis for extirpating all manifestations of street life, and the harshly punitive way in which those sweeps were carried out. Those practices carried Giuliani's signature. He had first made his name as a prosecutor whose ruthless zeal for conviction suggested some throwback hybrid of Thomas E. Dewey and J. Edgar Hoover; it may have been the late Murray Kempton who applied to him Carlyle's characterization of Robespierre: "a sea-green incorruptible." He set the tone of his mayoral administration very early, with a speech given at a forum on crime in the cities sponsored by the *New York Post* in 1992, in which he asserted that "Freedom is about authority. Freedom is about the willingness of every single human being to cede to lawful authority a great deal of discretion about what you do." That speech struck many as uncomfortably reminiscent of some statements that had been made sixty-odd years earlier. For example: "State and individual are identical, and the art of government is the art of so reconciling and uniting the two terms that a maximum of liberty harmonizes with a maximum of public order.... For the maximum liberty always coincides with the maximum force of the state." Those words were written by Giovanni Gentile, the official philosopher of Fascism under Mussolini. Few made the connection in print, just as only a few publicly noted the then-mayor's philosophical debt to Girolamo Savanarola, the scold of fifteenth-century Florence, because of an unwillingness to appear in thrall to an ethnic stereotype.

Giuliani was tireless. He bullied, hectored, and sought to marginalize anyone who dared oppose him. No sooner had one battle been joined than he opened another front, so that he could ensure the dispersal of outrage. The mayoral podium seemed to be erected in five or six places per day for the benefit of the evening news, and it became exhausting trying to take in all his various but singularly pointed performances. He would be refusing to apologize for the unjustifiable murder of a black man by the police over here, then attempting to abrogate freedom of expression over there, then allowing tax exemptions for the very rich somewhere else, all the while conducting a very public character assassination of his soon-to-be-ex-wife. He long succeeded in outshouting and outrunning the opposition, and coasted in popular esteem on his having allegedly lowered the crime rate single-handed (the crime rate did go down during his term, but it did so in a majority of American cities; New York was statistically unexceptional). By 2001, however, his public image was somewhat battered, the greatest harm having come to it from his long-running divorce battle rather than from any graver matter. Just when it looked as though he might have lost the support of the city and would be forced to slink from office at the close of his term, he was delivered by a deus ex machina of the most theatrical sort: 9/11. He played the part of embattled leader rather well, the enormity at hand being sufficient to make his choleric personality seem reasonable by contrast. No one had ever suggested that Giuliani was unintelligent or ill-prepared, and he demonstrated his competence quite conspicuously, even allowing a reporter to witness him consulting a biography of Winston Churchill. In the end, however, a letter to the *Village Voice*, published later that September,

summarized matters rather tersely. Giuliani is forever being credited (I am quoting from memory) with "rising to the occasion," the writer noted, but the truth is that the horror of 9/11 had dragged the city down to his level.

Giuliani is in an excellent position at present. His consulting firm is regularly hired by cities at home and abroad that seek hints on how to make their intransigent underclasses and surviving dissident fringes disappear from sight. He is favored by the Republican Party as an aggressive speaker and militant presence who has had combat experience, as well as an operative who might have retained credibility in the traditionally liberal urban enclaves, who has gay friends and has been known to read a book—it remains to be seen whether the religious right could fully countenance him as a candidate for national office, however. Meanwhile, he has left as his legacy a New York City that has had much of its identity bled from it. It is a city of chain franchises and million-dollar hovels, of minimized public services and sweetheart tax deals, of a corporate Times Square and a whitened Harlem. There is less discourse and exchange across class lines than ever before, and whatever life and vigor and color the city retains has a great deal to do with Giuliani's inability to entirely vacate the rent-stabilization laws. The city he has left might in a generation or two be interchangeable with Phoenix or Atlanta, but for some geographic quirks. It should be noted, however, that the trains have already ceased to run on time.

2004

THE BANDIT KING

John Gotti was conceivably cited more often in hip-hop lyrics than any other human being, and not just because his name helpfully rhymes with body, karate, Bacardi, Maserati, and Illuminati. He was the bandit king. His sole concession to the sharing of wealth may have been the annual fireworks displays he put on outside the Bergin Hunt and Fish Club in Ozone Park (until they were halted by former Mayor Giuliani), but that was hardly the point. In today's free-market culture, a thug does not gain respect by doling out groceries or endowing hospitals. To command death while wearing two-thousand-dollar Brioni suits is the dream of the powerless, and Gotti happily embodied the possibility. Just as ingenue boxers of the 1900s assumed the names of their idols, so gangster rap—the soundtrack of the powerless—has spawned a long list of epigones of the Don: Gotti, Young Gotti, D-Gotti, Cell Gotti, Yo Gotti, Lil' Gotti Gambino. . . .

John Gotti was, after all, a pure product of the slums: the fifth of thirteen children, whose father was unskilled and often unem-

ployed, whose family managed only a lateral move from the South Bronx to East New York, then as now arguably the two bleakest neighborhoods in the city. He became a gang leader, slid out of school, was arrested nine times in eight years for the usual variety of juvenile offenses. Every element in this list is familiar from a million dossiers compiled by social workers in the slums of this and other cities. But Gotti did not wind up eating lead, did not spend his entire youth in prison, and did not succumb to dope—or, for that matter, find religion—because he caught the eye of an employer for whom his excesses and misdeeds and sociopathic tendencies made excellent résumé material. Unfortunately for those who would follow his example, few milieux in American society possess criminal organizations bound together by the principles of medieval vassalage. Even the one he worked for seems to have slipped; its ownership of judges, juries, and prosecutors is at an all-time low.

Gotti was a star. He may have come up through the ranks, humbly hijacking trucks and breathing down necks, but after Paul Castellano met the asphalt of East Forty-sixth Street in late 1985, Gotti stepped into the spotlight like an understudy in a musical. In doing so, he was filling a conspicuous vacancy—no mobster had displayed so much panache since Lucky Luciano was deported to Italy in 1946. With the possible brief exception of the psychotic Joey Gallo, the intervening years had been dominated by expressionless men in fedoras. Their style had tended to focus on deeds rather than appearances, even if half of them had taken lessons in body language from George Raft. Gotti, suddenly if belatedly, invented a kingpin style for the television era. His hair alone was a

minor masterpiece; his wardrobe suggested Prohibition splendor
with a 1950s Miami Beach palette; his demeanor flickered con-
stantly from amusement to bonhomie to menace. Had he mastered
the art of the soundbite as well he would have been overpowering,
but among the Mob pithiness apparently went out with Carmine
("The Snake") Persico (who, acting as his own attorney in the
1986 RICO case that sent him and many other prominent *capi*
away, described the proceedings as "a bus tour of Tinseltown").
Gotti wielded language like a two-by-four—excision of the word
"fuck" would trim his collected utterances by half—and his most
quotable quotes were picked up by concealed microphones.

"La-di da-di, free John Gotti, the king of New York," warbled
the Fun-Loving Criminals, a second-string white hip-hop crew,
a few years ago. You could buy "Free John" hats and shirts in se-
lect locations, and there were a number of web sites given over
to the cause (their guestbooks were dense with condolence mes-
sages within a few hours of his death). He was a king to many
who could not see themselves ever achieving a place in society as
it is conventionally constituted, and his downfall and improbably
lengthy term in solitary only reinforced the notion, oddly enough.
His previous ability to buy acquittals had made him an object of
admiration, but his inability to do so in 1992 inspired love. He was
revealed as human, one of us; he had enjoyed a wild ride at the ex-
pense of the power elite—compared to which his own exercise of
power could be seen as insurgent, even brave—and then had been
undone by the treachery of Sammy the Bull, an archetypal Judas.
He had risen from the dirt of poverty to the plateau of celebrity, a
place of fine dining, superb haberdashery, constant presence in the

headlines, and disposal over life and death. Of course he was going to go down. Gotti somehow managed to tap into a tradition, that of the criminal as popular hero, that dates back to peasant societies in the mists of time. By popular reckoning Dutch Schultz was a killer, Al Capone was a warlord, Carlo Gambino was a remote figure who directed fate with a mere nod of his head—but John Gotti was a bandit. His life and actions were not much different in substance from theirs, but he possessed charisma and swagger, and he conveyed the very American humbug that because he lived large, you could, too.

2002

IN A GARDEN STATE

New Jersey, a smallish state with an insistent, almost typographical shape—an ampersand—has for three centuries had the mingled good and bad luck to be the neutral conjunction between New York City and Philadelphia. If it were a country it would be a sort of Belgium, constantly run over by armies surging or retreating from one center of power to the other. Instead it became a domestic colony, employed as vegetable patch, factory lot, depot, dumping ground, and eventually spare bedroom for the great cities on either side. Its nickname, "the Garden State," is a nice way of acknowledging this servile condition. It doesn't grow much for the market anymore anyway; agribusiness probably has single-crop spreads in Texas that are bigger. The only two significant rural regions left in the state are the pie-slice of the Appalachian Range in the extreme northwest and the ineffable Pine Barrens in the south, both of them saved from subdivision by their topographical inhospitality. The rest is mostly suburb.

It does have cities, almost all of them beset, aggrieved, half-ruined,

embodying the idea of city in the sense of demographic density but not in that of power, prosperity, or even pleasures of the flesh. Most arrived at this condition as industry tumbled in the latter half of the last century; earlier they had been hard-edged, unglamorous communities of strivers. Newark, Jersey City, Elizabeth, Bayonne, Paterson, Camden, Trenton. The first has had some intermittent fleeting success in positioning itself as a subsidiary Gotham; the second has become a catchment for lower-Manhattan overflow. They also retain their share of misery, however, and misery is most of what you find in the other cities, not excepting the state capital. If the American middle class continues to expand its numbers and stomach, it will eventually find a way of refashioning and inhabiting former factory cities, but for the time being they are useless except for housing the poor—badly. They have inferior building stock, vast and unrecyclable vacated plants, empty lots of poisoned soil, populations that have never recovered from the loss of security—if, indeed, they ever knew such a thing. Seemingly everyone who can do so has bolted to the suburbs, which lie all around, just beyond the highway belt.

Oh, and there is also Atlantic City, in which a froth of imitation high life sits atop a heap of misery. The misery is real enough, but the casino fringe is less a place than a drug or a manic episode. It is a feeble knock-off of Vegas, which is itself a three-dimensional metaphor you can almost put your arm through. Atlantic City is tethered to New Jersey, but it really seems to drift five miles offshore.

The predominant look of New Jersey these days is pale if not pastel, ostensibly cheerful, ornamented with gratuitous knobs and fanlights, manufactured in such a way that clapboard is indistin-

guishable from fiberglass—the happy meeting of postmodernism and heritage-themed zoning codes. A couple of decades ago the latter asserted themselves in the state by coating diners in ersatz brickface and carriage lamps, the former by turning out dry-cleaners' establishments and ten thousand bars with plural names (Mumbles, Fumbles, Stumbles) that were apparently made of beaverboard and aluminum and featured French-mansardish roof extensions that all but scraped the ground. But that was adolescence. Now, with maturity, the suburban style of New Jersey has attained a purposeful, militant blandness, the kind you associate with plainclothes security personnel at Disney parks. The "welcome" signs, artfully disposed, make it clear that hospitality is merely an allusive flavor; they are in no wise meant to be taken literally. The past, similarly, is a reference without a referent—all you need to know is that some humans, now dead, invented the principles of quaintness. And nature is a commodity that, while valuable, is yet in a primitive state of development. It will be a better thing all around when bioengineering has refined the landscape so that people no longer need to coax proper behavior from its component parts. Someday you will be able to unscrew your trees, rotate your hedges, and shampoo your lawn.

Such suburban commonplaces exist across the nation, of course, but as potent as they may be in California, say, that state also has mountains and deserts, extremes of weather, remote settlements at the ends of roads. New Jersey, with its accommodating temperate flatness and closeness of scale, was virtually designed to be a suburb. Accommodation was the operative quality. The elements rolled out the carpet for exploitation in the first place, and then successive generations of rural aldermen and freeholders happily

submitted their townships to the shredder. They traded their placid, neighborly four-corners and pastoral outlands to the shopping-mall and condo-complex bulldozers in exchange for golfing vacations in Bermuda. But what self-preserving trustee wouldn't do the same? New Jersey has always been all about location; North Dakotans can only gnash their teeth in envy. And people have to live somewhere, don't they, there being so many more of them than there were yesterday. Among the numerous consequences of such accommodation is the eradication of historical identity. This tract-house suburb began life as a utopian agricultural commune, that one as a religious sect's earthly fortress; today the only evidence of these origins resides on the unvisited shelves of the local historical society. Of course, the way such origins have been turned into tourism fodder in places where the architectural heritage is more abundant suggests that the loss may not be so great after all.

Bereft of history, though—and, yes, New Jersey does boast a dozen George Washington sites, as well as the more apposite traces of Thomas Edison—the state's identity is pretty thin. Like a Belgium, New Jersey has long been the butt of jokes and complaints, a convenient kick-me for its more powerful neighbors. Hoboken and Ho-Ho-Kus, or at least their names, served as the mythic Nowheresville in urban smart talk for generations. The state's name was shorthand for soulless commuter dump back when Long Island was still overwhelmingly rural. And the Jersey driver remains a prominent folk devil all over the Northeast: bumptious, heedless, hostile, and barely competent. The epithets chart a subtle change in perception of the state, from dull, square outland to parking lot for middle-class transients. The New Jerseyan is generally seen as the embodiment

of upwardly-mobile rootlessness and material self-satisfaction. He or she may have grown up in Oklahoma or Idaho, or even abroad, but has shed every trace of accent and custom somewhere on the climb, and now marks time in a factory-fresh jumbo house made of two-by-fours and gypsum and Tyvek and filled with gadgetry, on a street with no sidewalks and planted with saplings, while awaiting a corporate transfer to some interchangeable burg on the other coast. Whole swaths of the state are held together only by school sports and property-tax outrage. If you parachute into one of these places without a global positioning device you will be more lost than if you landed on the steppes.

It remains true that if you navigate around the gated communities and behind the corporate campuses, you will come upon remnants of a former New Jersey. There are still tomato fields and cranberry bogs here and there, and old Italians babying their backyard fig trees in urban neighborhoods that have so far managed to avoid detection by the hip dollar and its agents. There are still rogue bars, many of them along highways demoted by the interstate system, and now and then you'll see a local diner that is still primarily made of sheet metal and caters to a clientele constitutionally similar to the one it served forty years ago. There are still factories in the state, with attendant industrial housing precincts, even if every year more of them are admitted to the ranks of the dead. The Pine Barrens continue their mysterious ways, and down there you can still go shoot skeet behind somebody's barn and canoe down swampish rivers far from any road. Immigrant communities, some of them new, maintain their churches and groceries in obscure byways on the fringes of cities. It is also true that the curvilinear streets of neo-suburbs can shelter the

most unlikely assemblages of citizens behind the apparent uniformity of their extruded facades. Some places, after all, readily admit that they are but containing vessels; as long as the inhabitants keep their doors shut and their lawns manicured they are free to worship shrubs and paint themselves blue if that's what floats their boat.

New Jersey, a conveniently flat and temperate piece of real estate situated between two great cities, one of them possessing capital-of-the-world pretensions, has long served as a laboratory for testing upgrades and streamlinings of middle-class life. The success of these innovations has assured their application around the country and in the more prosperous countries in the rest of the world. It is thus possible to see the spirit of New Jersey in a great many places as you travel. When you come upon a grouping of large tract houses, or of low-rise apartments masquerading as large tract houses, that is heralded by a signboard bearing a title ("Lark's Crest Estates"; "The Village at Hunter's Ridge"), you are seeing New Jersey, even if you happen to be in Colorado. When you enter a venerable rustic inn that has lately come under new management, and notice that the reproduction antiques in the foyer are labeled with instructions for purchasing duplicates, and that the desk personnel sport matching blazers, hands-free telephone headsets, and friendly smiles under impenetrably dead eyes, you have come into New Jersey, even if the hostelry is situated in Europe. When you opt for the latest technological innovation, the biggest car, the smallest portable device, the most all-encompassing home entertainment system, not from any specific need but simply because you want the best, you yourself have become a New Jerseyan, even if you have never set foot in that state. It is not so much that any of these modes of living or conducting

business was necessarily pioneered in New Jersey itself—California does have a lot to answer for—but that no state is as exemplified and ruled by them. New Jersey, an old state with many fascinating historical byways and a considerable fund of lore and legend, is the image of the future, assuming that the future is assigned a value of perhaps fifteen minutes.

2003

THE INJECTION MOLD

I was fated to work in a factory. I was born in a Belgian textile-factory town, and my ancestors had worked in the mills for at least two or three centuries before I came along. Almost all of them were employed by Simonis, once the most prominent of many local makers of worsted cloth, now the world's leading manufacturer of billiard-table baize. It is very nearly the last survivor of a once-crowded industrial hub. My father managed to avoid working in the textile plants, but he couldn't help being employed by ancillary businesses; there wasn't anything else. When I was born, he had been working for about five years in an iron foundry that made equipment for the plants. When the industry collapsed a few years later the foundry, like so many other local businesses, fell with it. We emigrated to the United States, where the initial promise of new and fulfilling employment soon gave way to uncertainty, then near-despair. Eventually my father was hired by yet another factory, which manufactured pipes and rods from a hard, resilient, slippery synthetic that for household applications is trademarked Teflon. He worked

there until his retirement at age sixty-five. Immediately thereafter he began displaying symptoms of Parkinson's disease, unprovably but almost certainly the result of twenty-seven years' daily exposure to ambient powdered fluorocarbons. Dementia followed a decade later. His death at eighty came as a consequence of his refusing food and drink for a week, a mode of death known in nursing-home jargon as "Alzheimer's suicide."

My father did not want me to follow in his footsteps. He never pushed me in any particular direction, but he let me know from an early age that mental labor was far preferable to the physical sort, and he often regretted his lack of formal education—he had quit school at fourteen, as was then the norm, to contribute to the family purse. I didn't disagree; I had vague artistic leanings, and I knew from a few visits to his factory that I would never want to work in such a place. When at sixteen I got an after-school job, it was at a five-and-dime, a Woolworth's clone, where I worked as a stock-boy. My duties consisted of unloading boxes, stocking shelves, vacuuming and buffing floors, and, every night, transferring the trash from the loading-dock area to the large wheeled bin outside.

Reporting for duty one afternoon, after I had worked there for about a year, I was met at the door by the manager and the assistant manager. I had clashed with them many times before. Junior-college graduates probably not over thirty, they were a skilled Mutt-and-Jeff torture team. Jenkins, the manager, was tidy, distant, thin-lipped, and narrow-shouldered; his assistant, called Mr. Z, might have passed for a good-natured slob to anyone but his underlings. "Come with us," said Jenkins, briskly turning on his heel, while Mr. Z favored me with one of his shit-eating grins. They brought me outside to

the bin, from which Mr. Z retrieved two large cardboard boxes. He scooped out some crumpled newspaper from each, triumphantly revealing a layer of small boxes labeled "Timex." "We won't call the police as long as you leave now," said Jenkins. I was too flabbergasted to reply. What was going on? I knew it couldn't have been an accident, since there were two such boxes, and yet I doubted my colleagues would have known any more than I did how to fence a gross of cheap watches. Were Jenkins and Mr. Z covering up some plot of their own? Was that why they refrained from calling the cops? I remain baffled to this day.

Fortunately my parents were away, so I was spared having to explain, having my father arrange a meeting with Jenkins and Mr. Z, possibly even having him believe them rather than me. But I needed a job, and fast. I was in my last year of high school, and even though I had been awarded a scholarship to college, the costs of room and board stretched my parents' finances to the limit. Spending money would be entirely my responsibility, as it was already. Friends told me about a plastics factory in a nearby town where anybody could get a job. "Just tell them you're eighteen"—that was the legal age limit for factory work. I needed no further urging. The reason anyone at all could get a job there was because the turnover was constant, and the reasons for the constant turnover were themselves an inducement to me. The place was strictly for hard cases, and I very much wanted to qualify as a hard case. The pay was low, the conditions were brutal, the work was relentless, and the workforce was possibly dangerous—a few months earlier a friend of a friend had been stabbed in the leg during an argument with the foreman, a recently released convict.

It was doubly fortunate that my parents were away, since my father would have insisted on visiting the place beforehand—if indeed he'd even consider allowing me to work there—and none of the stories were exaggerated. It was a small factory, with just four machines, three of them deafeningly packed into a space the size of a two-car garage and the one behemoth allotted its own separate shed. Nobody worked there if they could get a better job elsewhere. The employees—twelve machine operators over three shifts, plus one foreman per shift—were ex-cons, former mental patients, drunks, acid casualties, illegal immigrants, and the illegally underage. The company was run by a father-and-son team: ancient, silent, diminutive father and huge, loud, hairy son. I filled out some perfunctory paperwork in which I claimed to be eighteen; they promised to pay me two dollars per hour and sent me off to my machine.

I was on the number three machine, by the north wall. Had I been able to see through the tiny, smeared window over my head and to the left I could have gazed upon the Passaic River. Number three was medium-sized and middle-aged, a good beginner's machine. Tiny number one, in the middle, looked like a nineteenth-century relic. It was operated by Esmeralda, from Honduras, who was relieved at midnight by her daughter. Number two, on the south wall, was larger and newer, but unpredictable. Working her that day was a man in a watch cap who quit a week later. In the shed on number four was Frank, a man of around sixty who came every day with red jug wine decanted into a juice bottle that fooled no one. He was so clearly a person of substance that rumors of a former life on Wall Street did not seem implausible, although he was known to wander off or fall asleep next to his machine. It was said that one night, when

only Frank had shown up for the night shift, he had ambled down the road and nodded off in an abandoned car. His machine, running highly volatile silicon, exploded, sending the hopper magnets clear through the roof.

The routine at first looked impossible. On the average job the cycles ran four times a minute. Each cycle required me to open the machine door, remove the extruded item, strip it of its excess (its *tree*), put the tree into the grinder, and pack the item in a box, all in the space of fifteen seconds. There were many variations: cycles ran faster or slower; the tree was easier or harder to remove. The items ranged in size from four-foot-square Parsons tables down to toothpicks, which came a hundred to the tree and were sliced off with a razor into a forty-gallon drum (at the end of a week, three daily shifts had barely managed to fill a quarter of the drum). Some kinds of plastics were forgiving, but most required that the door be opened as soon as the light went on and closed the instant the product was removed. Otherwise the plastic would "freeze"—it would clog the mold, requiring you and the foreman to lengthily chip away at the gunk with screwdrivers and ice picks, and if the freeze lasted too long your pay would be docked.

Anxiety attended every part of the manufacturing process, nearly all of it focused on the foreman. The foreman had to supply plastic granules to the machines' hoppers, empty the container of the grinder, haul away the boxes of product, supply boxes to be filled, and relieve workers when they needed to go to the toilet and during their legally mandated but unpaid half-hour lunch breaks. If the foreman failed to fulfill any of these requirements with regard to you, you had no recourse. If you had no boxes, for example, you could not leave

your machine to procure some from the store-room, but would have to find creative ways of stacking finished pieces on your tray-sized table or somewhere in your available few bits of space without clogging the aisle or blocking access to the machine door.

Foremen came in two flavors: choleric and slack. The former, frequently ex-convicts, tended to act as if they owned the factory, and would harass workers for such things as not maintaining the quota. How anyone could work faster than anyone else was a mystery to me, since the tempo was entirely dictated by the machine and its protocols, as determined by the type of plastic and the size of the mold. Slack foremen were the norm, however. They were slack because they were stoned, and they would disappear for long intervals during which they presumably either read comic books or threw stones into the river, there being few other distractions available on the desolate stretch of road that was home to the factory as well as an auto-body shop and a pair of shuttered cinderblock edifices. As annoying as the choleric foremen could be, the slack foremen were a menace, requiring one to attempt improbable feats, such as climbing up the side of the machine to dump the contents of the overflowing grinder box into the hopper while simultaneously opening the mold door with one foot.

The products manufactured by the plant were the sort of junk that isn't much made in America anymore. It is left to China, Mexico, and a few Third World countries to supply the globe with playing-card boxes, audiocassette boxes, toy boats, toy sand shovels, ice-cube trays, novelty picture frames, dildos (rumored but unseen by me), and hundreds of unidentifiable widget components. The owners could not have grossed more than a fraction of a cent per unit of

any of these. Accordingly they had to run the place with the lowest overhead the law would permit—if indeed the law played much of a role in their calculations. The two dollars an hour they lavished upon me was the minimum wage of the time; the result was something like seventy-two dollars after taxes for a full week's labor. I seldom reached even that amount, since I was always being docked, either for freeze episodes that were seldom my fault or for coming in late, since the factory was in a town seven miles from mine and I had to hitchhike to work immediately after school. The punch-clock at the door was set to record only fifteen-minute intervals, so that a minute's delay would result in a loss of fifty cents. I never asked how much the illegal aliens were paid.

After a day or two I had absorbed the machine's rhythm. As I fell asleep every night in my bed I could feel each muscle group involved in the cycle going through its paces in sequence, again and again.

My job, once I had achieved a rhythmic trance in which I could do my work without thinking about it, was excruciatingly boring. The place was too loud for a radio and the machines were too far apart for even shouted conversation. For a while I entertained myself by singing—I could bellow and no one would hear—and by reciting poetry, although I quickly exhausted my repertoire. I wanted to read, but reading was circumscribed by the rhythm of the cycle. So I arranged my space for maximum efficiency, moving the boxes to the other side of the grinder so that I could pack product with one hand while discarding excess with the other. Having pared my movements down to the strict minimum I had enough time between one cycle and the next to read about half a sentence. I tried crime novels, for example, but kept losing my place. Finally I had a stroke of inspira-

tion. Only one author would do: Céline. His works, from *Death on the Installment Plan* onward, were all spat out in brief, angry bursts separated by ellipses. The solution was perfect. Not only did I have exactly the time required to read one such particule between every two cycles of the machine, but their emotional content might have been designed for the circumstances.

The job was both real and not. The relentless monotony of repeating a chain of actions four times a minute over seven and a half hours—eighteen hundred times a day—was certainly real enough, as were the broiling heat, the poisonous and unmoving air, the bad light, the punishing din, the ridiculous pay, the unpredictably varied annoyance of the commute. On the other hand, I had an end date and a ticket out. In September I would be going to college. I would not be facing an unchanging diet of that sort of despair for years, perhaps for the rest of my life, the way many of my colleagues did, and the way various of my relatives had. It was something I merely had to withstand for about six months. One night, around that same time, I was arrested, along with half a dozen of my friends. We were driving home from a party in an overcrowded car when we were stopped. A dirty hash pipe was found under a seat. We were drunk, and thought the fingerprinting and the mugshot session were hilarious. "You laugh now, but just wait until you try to get a good job or apply to college," the cop said. I laughed even harder—I had been accepted the week before. (The case was eventually dismissed on the grounds of illegal search and seizure.) The job had that same sort of unreality.

I was about to be sprung from my class status. My father worked in a factory; my parents owned a tiny house and a secondhand car;

they were socially awkward and didn't speak very good English. I didn't really know what a rise in status might entail. I had no desire to work in finance or to join any clubs. All I knew was that I would be avoiding the sort of life to which my parents had been sentenced. Nevertheless, I referred to myself as working-class, and was even more insistent about it in college, when I met kids from fancy backgrounds. This was partly in emulation of my proudly Socialist father, partly because I was an outsider in so many ways that I had no choice but to be defiant about it, and partly because it was 1972. Revolution, the great panacea of a few years earlier, had definitively been scratched, but hopes had not yet crumbled.

Neither had a certain romantic notion of the working class. The United States was famously supposed to be classless, of course, but then almost everybody knew better. In 1972 the working class (along with a few other more or less murky categories, such as "street people" and "our brothers and sisters in prison") was still being floated among middle-class would-be revolutionaries as an edifying model for imitation and as a permanent source of guilt. It was a bit complicated, because "hardhats," unassailably working-class, had beaten up antiwar protesters in the streets of New York City and been hailed as pillars of the Silent Majority by Richard Nixon and Spiro Agnew. But there remained the lingering aura of the Wobblies, of the miners' strikes and auto workers' strikes of the 1930s, as well as a cascade of images from the Paris Commune and the October Revolution and the Long March. We imagined basking in the radiance of that aura when we wore our blue chambray shirts and listened to the MC5, not suspecting that within a decade or two most of American industry would be exported or terminated. Then

the remnants of the working class would either be handed neckties and told they were middle-class, or forced into fast-food uniforms and told they didn't exist.

In 1972, then, I was a member by blood of the working class who was pretending to be a member of the working class, a bit like an African-American in blackface. My job was maddening, and I was constantly exhausted from the combination of a full day of high school with an eight-hour evening of work and frequently a few hours' partying afterward, and I stoked my rage by reading Céline—but I was impressed with myself. I needed the money and didn't have other prospects, let alone entrée to glamorous sinecures the way some of my friends did, but the job was in part a role I was playing. I was being a badass and a hard case, converting into defiance the fact that my parents were poorer than almost anyone else's parents in our comfortable New Jersey suburb. Working at the factory the night of the senior prom, I enjoyed a strange feeling of triumph, as if I were deliberately boycotting such bourgeois shenanigans rather than conceding that I was so sure of not getting a date—in part because I didn't have a car—that I didn't even try.

I took pride in my ability to endure. Indeed, in those six months at least four or five of my school friends signed on, but only two of them lasted out the first week, and neither of those managed more than a couple of months. In enduring the job I was imitating my father, who always boasted that he had spent only one week of his life on the dole, no mean feat in 1950s Belgium. I never entirely plumbed the reasons for his preferring labor, no matter how stultifying or demeaning or ill-paid, to collecting benefits, but it seemed to involve a combination of worker solidarity—not accepting handouts when

others were toiling—with a version of the drive that causes people to run marathons even as they know they have no chance of placing. Every night as I made my way to beer or bed I was under the impression that I had accomplished something, although all that I had accomplished, besides earning something less than fifteen dollars, was to have withstood eight hours of being converted into a machine part. And that, for reasons both familial and cultural, was something I thought of as ennobling and rather macho. After all, while most of my friends and classmates came from more prosperous families, I had no real idea what it was their fathers did in their offices, wearing their suits. Labor was all that I had been exposed to, and I equated it with adult masculinity.

Nevertheless, I was bored out of my mind. Reading was crucial. When occasionally I was assigned a task with a cycle so tight that I was unable to carve out an interval for reading, I suffered terribly. Reading allowed me to mentally leave the premises while letting my empty body do the work. Otherwise the circumstances were like solitary confinement in eight-hour installments, something I understood when my friend Garry came to work having just ingested five hundred mikes of Orange Sunshine. He felt nothing, he reported afterward, "Everything was gray." The inhuman pace and atmosphere could apparently overwhelm even LSD. As it happened, the two longest-serving employees, Frank and a fearsome character called One-Legged John, were both drunks who tippled on the job. When I left in August, hardly anyone else was still there from when I began in March. The job might best have been borne by someone who had survived solitary—someone with the ability to, say, mentally reenact long journeys or make chess moves on an imaginary board.

Otherwise the only recourse for the imagination, and a feeble one at that, was the making of "homers." This was a word I would not learn until years later, when I read Miklós Haraszti's *A Worker in a Worker's State* (1977); it refers to items for strictly personal use that are turned out at work using the equipment provided. Haraszti and his colleagues in 1960s Hungary, operating lathes and milling machines, made for their own purposes:

> key-holders, bases for flower-pots, ashtrays, pencil boxes, rulers and set squares . . . counters in stainless steel to teach simple arithmetic to children . . . pendants made from broken milling teeth, wheels for roulette-type games, dice, magnetized soap-holders, television aerials . . . locks and bolts, coat-holders . . . knives, daggers, knuckle-dusters . . .

The Hungarian machinists were on piece-rate, meaning that they voluntarily lost money in order to work on their crafts. At the plastics factory, where we were paid a set wage but were not in control of our time, we had rather more limited resources. All that we could make were useless items from scrap. For example, using as a base an unidentified transparent cylinder that might have been part of a pill box, you could pile up widening rings of bullet-shaped tree elements, also in clear plastic, sticking them on when they were still hot from the mold, ending up with a conical whatsit you could pretend recalled a crystal chandelier. It occupied the mind, gave you something to take home and perhaps present to a slightly embarrassed loved one, and offered a tiny score against the bosses, whom you were depriving of a few pennies' worth of raw material.

My high school was the low-slung 1950s suburban type rather than the inner-city red-brick fortress model; still, like all American high schools, it resembled a factory. Immediately to the right as you came in was the office of the guidance counselors, which prominently featured a rack of yellow-covered booklets issued by the state of New Jersey, offering instruction to prospective air-conditioning mechanics, beauticians, cashiers, and correction officers in how to achieve their career goals. On the single occasion I can recall visiting that office, I noticed to my astonishment that one of these was entitled *Injection Molding Machine Operator or Tender.* I was immediately impressed by the realism of the cover photograph, which clearly showed a catchment device under the door of the machine that had been fashioned from a ragged piece of cardboard, exactly in the style prevalent at my factory. After offering a brief history of plastic, the booklet went on, for ten pages, to worry the distinction between an "operator" and a "tender," cite the physical requirements for the work ("Operators must have the use of both hands and arms. . . . They should have the temperament to perform repetitive work. . . ."), discuss employment opportunities ("positions will become available as some workers retire, advance through promotions, or leave for personal reasons"), and speculate on the future of the industry ("the future of plastics manufacturing is very bright"). I tried to imagine a student, shopping around for a way to live after being released from school, picking the booklet out of all the ones on offer and deciding that this was the job for him. Nothing in the booklet was false, even in its implications, and yet it made as little sense as if an equivalent booklet had been entitled *Prison Inmate.*

And yet, someone had to make toy sand shovels for the world.

What, in a just society, could ever induce someone to do that sort of work? Should all youths be conscripted to work in factories for a year? Should plastics-factory labor be reserved for the punishment of white-collar criminals? Finally I decided that salaries should be determined by a factor that averaged the arduousness, tediousness, futility, and imbecility of a job. The richest people in the world then would be coal miners. Injection-molding machine operators or tenders would fly to work in their own planes, and competition for such work would be stiff. Having had the experience, I would be quite content to be poor.

2004

WHY DO YOU THINK
THEY CALL IT DOPE?

You have to keep your eye on the past. Not only is it not dead yet, but it can sometimes jump up and bite you in the ankle. Not long ago, while reading the memoirs (1921) of James L. Ford, a New York theater critic and man-about-town, I ran across the following: "Many years ago, when prairie schooners were the means of transit across the continent, there hung from the axle-tree a bucket of black wagon grease containing what was called a daub stick with which the lubricant was applied. The earliest American frequenters of the Chinese joints in San Francisco were men who had crossed from the east in these prairie schooners and as the word 'daub' had become corrupted into 'dope' the opium paste which looked exactly like the axle-grease, acquired its name by a quite natural process." I promptly looked up "dope" in an etymological dictionary, which told me that the word derives from the Dutch *doop*, meaning "sauce" (Ford was wrong about "daub").

Instantly I saw before me a panorama, like a post-office mural

painted by the WPA: Dutch burghers in New Amsterdam, wearing high-crowned hats and knee-breeches, spooning gravy over the Sunday roast, were merging into pioneers, in homespun and gingham, on a dusty track in an endless field of waving rye, swabbing the wheel assembly of a Conestoga wagon with some kind of black gunk. These blended into a shadowy crowd, some wearing queues and skullcaps, others in derbies or picture hats, bent over long bamboo pipes of burbling *yen pock* from which plumes of smoke curled up into a cloud that as it drifted through time collected spiraling fumes from the reefers of Harlem rent-party revelers, the joints of Human Be-In votaries, and the blunts of an assortment of O.G.'s on a stoop. There was your cavalcade of American history, all bound together by one simple monosyllabic word!

The word may have gone out of business in Dutch (*doop* now means, of all things, "christening"), but in America its career has been even more dizzyingly various than my tableau would suggest. Not so long ago it referred to molasses, to ice-cream toppings, to soda pop—was it the gooey syrup or the onetime cocaine content that caused Coca-Cola to be called "dope" in the South for most of the twentieth century? It has meant any kind of lubricant, glue, poison, insecticide, incinerant, medicine, liquor, coffee, or unidentified gumbo. It has signified information, news, esoteric lore—even spread out amorphously to take in just about any sort of thing, stuff, or business. As a verb, meanwhile, it could mean "to poison," "to lubricate," "to medicate," "to adulterate," "to predict," "to figure out," or "to dawdle." At least for the first half of the twentieth century it was the all-purpose tool, the Swiss Army knife of the American language, and no substitute—not even "shit"—has been able to cover

all of its many functions. Yes, the word also means "idiot," but that
sense is from the British Isles and has a completely different ety-
mology, deriving either from "dupe" or from *daup*, an English dialect
word meaning "carrion crow."

But all of the other denotations and connotations derive from
the transubstantiation of axle grease into opium. The meanings re-
lated to cognition, for example—"data," "inside knowledge," "to suss
out," "to prognosticate"—ultimately descend from the unfortunate
practice of hopping up racehorses, information pertaining to which
could make anyone a mahatma at the track. Every other applica-
tion of the word refers to substances—dark, viscous, sticky, and of
complex, multifaceted, uncertain, dubious, speculative, or hazard-
ous composition or employment. You could say that "dope," a purely
and utterly American word, stands for the familiar unknown. It is
the stuff in the cabinet, under the stairs, out in the toolshed, in an
unlabeled jar, pooled at the bottom of an old tin can, stuff you use
without really knowing much about it, stuff that works but that you
don't care to inquire too deeply about. This describes an enormous
category in American life.

In our society, a great deal of business is concealed under ten-
dollar words, trademarks, cop-talk, and quasi-scientific jargon that
to the lay ear simply registers as "dope." The ingredients list on a box
of cookies might as well read, approximately: flour, butter, sugar,
dope. Much breathless packaging says, in effect, "Now With Added
Dope!" Spokespersons for energy companies, being lobbed softballs
by congressional subcommittees on C-SPAN, reply with verbiage
that can nearly always be translated as: "We plan to invest in more
dope." If pharmaceutical advertising were stripped of its misleading

charts and perspiration-free images, the industry would be stuck with saying pretty much the same thing in every instance: "Our dope is really great!" Of course it's nice that we can establish the presence of, e.g., potassium sorbate, D&C Red No. 40, chlorinated isocyanurate, and dextromethorphan hydrobromide, and have the ability to look them up and maybe figure out what they might do to us, but unless you're a chemist or a consumer advocate, how often have you bothered? It's all dope.

Think again of that miracle, when axle grease was transformed into opium. The throng in attendance included people who had abandoned everything they had known growing up in order to make a better life for themselves, had hocked most of their assets to pay for the journey, had crossed the plains, the high desert, and the Sierra Nevada in rattling wagons subject to the elements—or had crossed the Pacific in the sweltering, overcrowded holds of sailing ships with few rations and zero comforts. Now, at the end of the journey, having ascertained that El Dorado was nowhere in sight, they decided they might as well go kick the gong around. The Chinese, who supplied the stuff, had had it foisted upon them long before by the British East India Company, but the Americans would probably only know of it as a tincture, dissolved in alcohol, available in drugstores. Now they took a look at the black gunk and it reminded them of the substance that greased their wheels. After a few puffs they decided that the similarity extended to function: this shit would grease their wheels as well, in a different sort of way. And so it has. Dope, meaning everything from nicotine to selective serotonin reuptake inhibitors and from silicon implants to petroleum additives, has been doing the job for well over a century.

You just can't call it "dope" anymore. It wouldn't do to suggest it had anything to do with pleasure.

2004

OUR FRIEND THE CIGARETTE

Not very long ago, the whole world smoked, no room was truly furnished unless it contained an ashtray, and all of waking life was measured out in cigarettes. Doctors smoked in their consultation rooms. Chefs smoked in restaurant kitchens. Mothers smoked while dandling their babies. Mechanics smoked in oil-flecked garages. Athletes smoked on the sidelines. Teachers smoked in classrooms. Patients smoked in hospital solariums. Television presenters smoked on camera. Shoppers smoked in the produce aisle at the supermarket. We smoked in the rear halves of airliners, in the balcony at movie theaters, between courses at formal dinners, on crowded dance floors while gyrating, on elevators despite the signs, on the subway if the hour was late enough. We smoked in the office and at the beach, in the waiting room and at the hair salon, in the art gallery and at the stadium. We smoked in bed: just after waking and just before sleep, after making love and sometimes during it. We often smoked without being aware we were smoking.

Here, have a light. Yes, if you're going to be a connoisseur about

it you should hold the flame a couple of centimeters under the end
without touching, so that you avoid the rush of carbon—although
actually I don't know anyone who has ever observed that rule besides
cigar bores. So after inhaling you wait one beat and then release
the smoke through your nostrils, do you? That's one way to do it,
although it tends to communicate impatience. They make you look
like a dragon, those twin jets rushing forth downward from your
nose. It's the sort of exhale you might employ while negotiating with
someone over whom you have an advantage, or when arguing with a
lover. In a calmer or more tender moment you are better off letting
the smoke out through your mouth, in little puffs, like clouds for
cherubim to ride upon. Yes, *little* puffs—a long stream of smoke is
another matter altogether. It can often indicate hostility, especially
if you aim it at someone's eyes. By contrast, moments of poetic idle-
ness are best conveyed with smoke rings. You curl your tongue like
this. Yes, I know it's not easy. Learning that skill cost me many hours
that might otherwise have been spent studying ancient languages or
higher mathematics. But who impresses friends with their erudition
anymore? The smoke ring, on the other hand, is always a surefire
crowd-pleaser. It establishes you as a sport, a *flâneur*, someone with a
large share of that most precious of commodities—time. And finally
there is the fabled "French" exhale, in which you expel the smoke
from your mouth only to immediately take it in again through your
nose. Yes, it's difficult, too—although you will probably find your-
self doing it accidentally from time to time. Is it worth the hours
of application? It is if you spend a great deal of your time mingling
with minor hoodlums. It will have an impact on the sort of people
who value the ability to crack one's knuckles or whistle through one's

teeth. They will note you as someone not to trifle with. No one else will care.

I notice you're holding the cigarette in what used to be called the "American" manner, pinched between the forked index and medius of your right hand. That has become as universal as Marlboros, but there was a time when in most of the world cigarettes were poised between thumb and index. Your style was initially associated with American movie actors, who naturally gave it tremendous cachet, since everyone in Split or Macao or Port-Bou wanted to be just like Tom Mix or whomever. The thumb-index version, which Americans in turn considered effete, is really, when you think about it, the most obvious and intuitive approach. When you pick up a pencil or a coin, isn't that how you do it? Interestingly, people who employ the index-medius grip to hold their tobacco cigarettes usually persist in using the thumb-index method for their marijuana sticks. The American fashion, for all its he-man mystique, is really the more affected of the two.

So how did the Americans arrive at their manner? Perhaps by its resemblance to a forked stick, used to pick up a burning coal to light a brazier. Or maybe it was simply a desire for differentiation. You would not, after all, deploy a cigarette holder in that way, so maybe the fork was therefore intended as a symbol of common-man solidarity. The cigarette holder, very dramatic when properly flourished, came to be associated with lounge lizards and *poules de luxe*—people who needed an extension to keep cigarettes from fuming up the stones on their many rings. And so, if you were a rugged individual who had started out with nothing and now controlled the world's supply of sorghum, you would naturally want to dispel any

suspicions that you might be some mere remittance man: you would wear your ten-gallon Stetson at the Court of St. James and hold your cigarette like a farmhand. Conversely, since the thumb-index grip allows one to smoke the cigarette all the way down to the end—to the last, red-hot quarter-inch—the fork grip is a sign that one is above such miserly practices. The fork method makes it necessary to jettison the butt at barely less than an inch. Since cigarettes cost almost nothing in America for the better part of the twentieth century, even the most bootless Yankee tramp could afford to squander tobacco, a luxury not available to Chinese tailors or Senegalese traffic cops.

The thumb-index method is also handy for concealing the glowing end or even the entire cigarette if need be, so that the main exception to the fork rule among Americans was soldiers in wartime, who would want to keep the enemy from detecting their position by even the merest hint of red in the night. But then all across the land—all across the world—you could observe gas-station attendants, iron-lung mechanics, zeppelin inflators, sawdust packers, boarding-school students, church sacristans, whatever, all apparently biting their thumbnails as they cupped their cigarettes in their palms, happily oblivious to the odor detectable to everyone else.

Another matter to consider is pacing, which varies according to the individual and also according to the mood, the circumstances, the time of day, the weather, and so forth. We're all familiar—that is, we were once all familiar—with the sort of smoker who takes two puffs, possibly three, and then hastily or angrily stubs the thing out. Frequently these were older women, whose butts could be identified not only by their length but also by the generous smear of lipstick on each. Eventually this practice died out, because it cost a fortune (it

could effortlessly consume five packs a day)—or was it because the practitioners' impatience finished them off? The other extreme, that of sucking the thing down to its burning end, or its filter, was inevitably associated with deprivation, and scorned in polite company as a symptom of the blurred line between hunger and greed. Then there was the distinction between the sort of smoker whose butts spent most of their brief existences burning down in the ashtray runnel and those who never seemed to take the things out of their mouths. You remember what Raymond Chandler said about "the boys who eat and talk and spit without ever disturbing the cigarettes that live in their faces." That was a very mid-century thing in America, the petty-hoodlum custom of parking the cigarette in a corner of the mouth and employing the other corner for all other business; by the 1960s you hardly ever saw it except at the racetrack. In Europe and especially in France, however, you had the art of gluing the cigarette paper to the lower lip with saliva and allowing the butt to perform a merry little dance every time its owner got to talking. Everyone thinks of Jean-Paul Belmondo in *Breathless*, but look at this picture of Blaise Cendrars and note the squint, caused by smoke incessantly blowing into the smoker's eye, also the lopsided grin, probably also the skin as gnarled and crinkled as an ancient shoe. You saw faces like that all over Europe; I had an uncle who might have been his twin. The mystery there is the fact that these smokers' *mégots* were never more than an inch long. Did they buy them secondhand?

Between the negligent smokers who ignored their butts and the indulgent ones who kept theirs as pets was a larger group composed of those who liked to have something in their hands at all times. In between inhalations they enjoyed employing their cigarettes

as props. They could gesture and wag and stab the air and draw curlicues with their smoking sticks. They could hold the cigarette between two fingers of an upraised hand flipped back, achieving different effects whether they did this while sitting—the gesture looked imperial, as if a benediction was being considered—or in motion, when the gesture became a component of a sashay, like the flying foxtail of an Edwardian wrap. The former effect was patented by Diana Vreeland, although she did not invent it; the latter reached apotheosis among the young women of the early 1960s, who accessorized with headscarves, white men's shirts knotted at the midriff, and toreador pants, also sometimes a small transistor radio held to the ear with the other hand. In most hands the cigarette was a magical implement; in even the most graceless it could be a ceremonial dagger, not necessarily intended to stab but meant as a caution, as an ornamental emblem of power and a symbolic protection. The cigarette could be a conductor's baton, a colonial officer's swagger stick, a conjurer's wand. It functioned as an extension of the body, an exoskeletal limb with potential menace at its glowing tip. To give someone a cigarette was to confer power.

In Europe—actually in most parts of the world other than the United States—everyone was perpetually offering everyone else a smoke. Sit down at a table with three people and instantly out come four packs, an expertly gradated trio of ends poking out of a corner of each, and of course you have to take one, even if it's a brand you abhor, just as they must take yours. To refuse would be an act of aggressively bad manners, like spurning the proffered tea in an Arab country or the bread and salt in Russia. In America, by contrast, prison-yard customs prevailed: the pack was kept in a shirt or jacket

pocket and one pill was drawn out at a time and inserted into the owner's mouth. This was not viewed as a breach of etiquette since, it was reasoned, everyone you encountered would already have his or her own pack. Keeping your pack to yourself was a sterling example of the American ethos, like fencing your land and shooting trespassers and believing that basic societal benefits belong to those who can afford them. The extreme of this behavior was exemplified by a mannerism briefly in vogue in my long-ago youth: opening the pack from the bottom. We saw older hipsters doing it and had to follow suit. It actually did derive from the mores of the prison yard, where no one would think of prevailing upon a fellow inmate to break open a fresh pack. An unbroken seal would preserve a pack to the end, although the owner's shirt pocket would fill up with tobacco crumbs. Yes, in those palmy, distant days, the very summit of impeccable, unmatchable, glacial suavity was represented by a pack of filterless Kools, opened from the bottom, accompanied by Ohio Blue Tip matches, the original kind you could strike on the wall, on your shoe, or on your stubble.

I picture a tableau from some secondary Last Judgment, when all the cigarettes I have smoked shall be made whole again, all of them piled up like cordwood in a space the size of a hangar. Let's see, thirty years approximately, an average of two packs a day, that would be four hundred thirty-eight thousand, give or take a few thousand. Nearly half a million, filtered and unfiltered, more than half of them hand-rolled, all but a handful white-papered. All of them passed through my mouth, my throat, my lungs. Smoked in every possible circumstance and setting. All of them utterly eradicated by fire. But now they have returned, in their original form, with their biogra-

phies appended: This Marlboro consumed outside the head shop in 1967 and immediately followed by a breath mint—I was barely adolescent. This Gauloise with filter of tightly-rolled paper smoked while waiting to buy a ticket to *2001: A Space Odyssey*, on its original release. This Newport bummed from a friend, sucked down in despair after the collapse of a crush that then seemed mountainous. This hand-rolled Samson, wobbly and uncylindrical, representing an effort to learn to roll made in response to Scandinavian cigarette prices—so bumped up by taxes even thirty years ago that they cost four times what they did in America. This nameless evil-smelling thing made by rolling up the contents of butts harvested from ashtrays the day after a wild party. This Merit offered by a well-meaning friend but almost immediately stubbed out in horrified disgust—it tasted like burning fiberglass insulation. This American Spirit, the last bit of recidivism after quitting.

The lives of cigarettes are seldom very interesting, besides perhaps that of the one placed between the lips of the blindfolded man facing the firing squad. Cigarettes, like factory-farmed chickens, are born to die. They are anonymous, regarded collectively, appreciated fleetingly and impersonally, forgotten immediately. The exceptions, if any, are like those of the hero of Italo Svevo's *Confessions of Zeno*, who, when he resolved to quit, wrote on the front page of a dictionary: "2 February 1886. Today I finish my law studies and take up chemistry. Last cigarette!" Soon, however, he has entered such dates in the fly-leaves of all his books and has covered the wallpaper in his room with more. A cigarette can attain selfhood only when it is the last, but membership in a throng erases the individual. Nevertheless, cigarettes, like zoological parasites, are the secret sharers of countless

lives, of moments of impenetrable intimacy. They have witnessed romance, rage, epiphany, confusion, elation, despair, serenity, chaos. Significantly, cigarettes were not just present in those moments, but according to their consumers they played an active role, either in enhancing the sensation or in attempting to assuage it. And yet, for all their heroism, like front-line infantry their fate is to be expended, to be knocked off immediately and replaced by an identical copy.

Those who spend their time waiting have the deepest connection with cigarettes: prison inmates, nightwatchmen, loading-dock foremen, movie actors, undertakers' assistants, understudies, writers, anyone who works in a booth—ticket vendors, token vendors, concierges. A cigarette is a friend that helps pass the time, sharpens memory and concentration, channels inchoate emotion, sands down rough edges, blurs things when need be. Cigarettes occupy the hands, occupy the mouth, segment passages of time like ritual observations, fill the room with a screen of smoke on which anything can be projected. If a cigarette is a stalwart companion in solitude, in company it is an ally. As if you could supply your own soundtrack or interlinear commentary, cigarettes color or intensify or counterpoint the message conveyed by your words, face, and body. Simmering anger is immeasurably more effective when accompanied by wreaths of smoke that seem to emerge from the smoker's ears, hair, eyes. The transit of hand to mouth and out again, repeated metronomically, can under the right circumstances ratchet up the tension in a room to a point of explosion. The cigarette that is held no more than an inch from the face even when it is removed from the mouth can act as a mask, a veil, or a fan. Dangling a cigarette head down in nerveless fingers at the end of a dropped arm conveys world-weary languor

better than any composition ever written for violin. The already eloquent Mediterranean vocabulary of gestures becomes italicized when it is supplemented with contrails of smoke from between two fricative digits.

Obviously, the cigarette is a powerful erotic metonym. Almost as soon as cigarettes were invented there were collectors willing to pay money for photographs of women smoking; les fumeuses became a standard trope, illustrated for example by Jacques-Henri Lartigue's series from the 1930s, for which he recruited women from Parisian brothels to pose, one by one, in head-shots, smoking. Although you might at first think that cigarette smoking connotes fellatio, the range of sexual suggestion is far broader (cigars, on the other hand, have a much more limited symbology and can connote little other than fellatio). Consider the cigarette held between bared teeth, like a rose by a flamenco dancer or a cutlass by a buccaneer, which telegraphs passion and menace and glee and danger and dash all at once. Think of how a cigarette disposed in a hand suspended right next to a mouth conveys an ambiguous invitation: You are welcome into my cave, but first you must negotiate with my dragon. Note the effect of a thin downward exhale in combination with heavy-lidded eyes—Marlene Dietrich comes to mind—which sings hello while throwing down a gauntlet. Picture the defiant swagger of a cigarette pointed upward by lips curled in a snarl, and ponder the mechanics of how a gesture of nominal exclusion and self-sufficiency can turn into the friendliest of challenges.

And bear in mind the fact that the erotics of the cigarette were for many years so clearly understood that the mere presence of a white cylinder somewhere in a portrait was enough to charge the

subject—the whole composition—with a nonspecific potential for arousal. The unlit cigarette was a tease, the cigarette held near a flame was a provocation, the cigarette tucked behind an ear was a promissory note, the cigarette held aloft was a sheathed knife, the cigarette held laterally was a broken arrow, the cigarette stubbed out was an ultimatum. It was like the language of flowers, or of postage stamps, in which every nuance is pregnant with significance, and there is no possible communication that does not entrain a string of secondary and tertiary meanings. It all resided in the beholder—and the beheld, of course. Your grocer's cigarette meant nothing however it was held or employed, but your object of desire equipped with a cigarette was incapable of innocence. A cigarette added to the image of your crush, your lover, or your favorite film star, squared or cubed its intensity. Just below in the unconscious lay an impossible image: you and your love object connected by a single cigarette, smoking each other.

There were other things you could smoke, too, of course. Cigars were once the common coin and the exclusive province of men. Plutocrats in evening dress smoked panatelas five feet long, and ordinary flatfooted joes smoked horrible cheroots that smelled like burning rope. Cigars were made for guys to retire to the billiard room with after dinner while the women ate cake and gossiped. They were made for the dog track, the police precinct, the bus garage, the rooming-house parlor, the pari-mutuel office, the boxing-ring rubdown room, the burlesque theater, the barbershop, the *pulqueria* with the urinal gutter running right underneath the bar. Cigarillos, those slim brown objects, have a certain panache to them, like cigarettes on holiday; they are a part of café culture, and

look good at the old-line beach resorts—they are keen, knifelike. Cigars, on the other hand, are blunt instruments. They look best in the mouths of young women, although they generally spend their lives consorting with ward heelers, dog wardens, skip tracers, rack jobbers, claim jumpers, lawn jockeys, bounty hunters, bailbondsmen, exterminators, repo auctioneers, and persons who aspire to like status. In butt form, with the assistance of a toothpick, they belong to bindlestiffs. They can command high prices, and require an army of props and supplies, but the untutored nose will have no luck trying to distinguish between a fifty-dollar Monte Cristo and a drugstore White Owl with plastic tip.

The pipe has virtually disappeared. At one time it was taken up by men the minute gray started appearing at their temples. Your grandfather smoked one, and so did Inspector Maigret, and Sherlock Holmes, and four out of five fly fishermen, and artists who sported plaid shirts and Van Dyke beards, and Bing Crosby, and anybody nicknamed "Pop," but all of those gentlemen are now dead. College freshmen once took up the pipe in an effort to look more mature, but nobody today would make the connection; if you employ the word "pipe" in conversation people will assume you are referring to an instrument for smoking crack. In a way this is too bad, since the pipe lent gravity and an air of wisdom to numerous men whose intellectual and emotional progress had stalled barely into adolescence.

Anyway, you can't smoke anymore. You can't smoke anything—not low tar, not Sher Bidis, not all-natural additive-free tobacco in unbleached paper. It's not yet illegal to possess the materials and implements for smoking nor to consume them in the privacy of your own home, but it is increasingly difficult to smoke in public places, even

outdoors, even in Europe. It's true that a certain dark anti-glamour lingers outside the restaurant doorway, as you and people you will never meet again enjoy the rough comradeship of exile, puffing away in your thin jackets in February as if you were doing something heroic. It's true that in a few Western settings—student life, for example, or among fashion models—smoking remains almost normative. It's true that if you produce a pack of cigarettes in the right place and at the right time entire roomfuls of confirmed quitters will line up to bum one. And of course everyone knows at least one defiant and unapologetic smoker, frequently someone with sufficient force of personality that allowances are made and ashtrays exhumed in even some of the most fastidious households. In general, though, and especially in prosperous suburbs, you can expect passers-by to glare at you with undisguised contempt however discreetly you light up, whether in a far corner of a parking lot or outside the exit ramp of the bus depot.

Smoking went from universal to proscribed with incredible speed. It first became necessary to step out onto the balcony at certain private homes in the 1980s. The majority of Americans who smoked in 1990 seemingly had quit by 1995. California was the first place in the world to ban smoking in bars, in 1998. You would think that bars would be the last redoubt, short of prison—but many prisons now ban smoking as well, which does seem like a case of unnecessarily cruel punishment. A few decades ago, the traveler who fetched up in Salt Lake City, ignorant of the state's prevalent mores, and found herself unable to find a place short of the street where she could enjoy a cigarette and a cup of coffee simultaneously, could hardly have realized that this state of affairs would soon prevail in cities of

very different character. Nor could the right-thinking but blemished soul who made the mistake of trying to light up in one of Berkeley, California's more politically sensitive coffeehouses at the beginning of the 1980s have imagined that of all the causes on display in such a setting the one that would carry the day would be the crusade against tobacco. Mormons and the ultraleft make strange bedfellows, but then cigarettes are curiously bipartisan. Puritans of all persuasions were the first to take up arms against them.

Nowadays no one will really defend smoking, even the most unregenerate addicts being inclined now and then to sermonize against their filthy habit. Hardly anyone wishes to dignify the appalling cynicism of the tobacco cartels and their decades of suppressing facts and falsifying statistics. When you see a tract issued by a smokers' rights group, you can be sure that it originated either in the public-relations department of a cigarette manufacturer or else somewhere on the coldly literal-minded fringe of the libertarian movement. There is no argument: Cigarettes are bad for you, and smoking will kill you, sooner or later, and there is a strong probability that the offloaded fumes from your smoking will eventually kill non-smoking bystanders as well. Smoking shortens your breath, makes you cough and wheeze and eventually produce that weird whistling in the back of your throat, carbonizes your lungs and ravages your larynx and esophagus, visits indignities upon various other internal organs, discolors your teeth, makes you smell bad (although, oddly, one wasn't conscious of a bad smell back when everybody smoked). But then nicotine remains the most elusive and protean of drugs: it sharpens memory, aids concentration, keeps weight down, levels out emotional swings, perhaps helps prevent Parkinson's disease . . .

Maybe there are ex-smokers out there who feel uncomplicated relief at having quit. I doubt there are very many, though. Your cigarette was a friend—the sort of friend parents and teachers warned you against, who would lead you down dark alleys and leave you holding the bag when things went wrong—but a friend nevertheless. It's terribly sad that you can't enjoy a smoke now and again without tumbling into the whirlpool of perdition, the way you can take a glass of spirits on the weekend with no danger that by Monday you will end up filtering the shoe polish after exhausting the cooking sherry. But just as an alcoholic remains an alcoholic even after decades of abstinence, so a smoker is a sinner forever after. You have breathed fire. You have experienced one of the deepest satisfactions of life: the first cigarette of the day in tandem with the first cup of coffee. You have felt that knee-trembling rush upon taking the first drag after suffering an enforced separation from cigarettes—after a trip to the moon, for example. Your friend has come running to your side in the worst moments, and has been there to cheer you on in the best. You have tasted of the fruit of good and evil. Now that you have chosen the path of righteousness, can it be that the decision is fixed and irrevocable? Is it possible that smoking will be legislated or taxed out of existence? Is it possible that the earth will be wiped so clean of tobacco that, like opium, it will be difficult to find without undertaking hazardous journeys in troubled regions? Is it possible that you will never again be able to enjoy the comfort of knowing that you have traded five minutes of life for five minutes of serenity? We may all have stopped smoking, but we continue to burn.

2004

AULD LANG SYNE

If Christmas is designed to bring out the child in everyone, then New Year's brings out the fool. Sobriety is temporarily fashionable nowadays, so fewer people than usual will wake up this January 1 partly clad, in a strange hotel room, with a blinding pain above their eyes and an elusive song on their lips, but that does not mean that more people will wake up without regrets. All over the world, suckers from all walks of life will send 1993 into Chapter 11 while under the impression that they are forever free of its debts, and they will demonstrate their insouciance by, at the very least, spending way too much money on dubious entertainment.

In New York City, a mecca for fools of the overreaching sort, it is only natural that follies be expressed in figures: half a million in Times Square at midnight, chaperoned by some five thousand cops at a minimum cost of three hundred thousand dollars in police overtime, leaving behind at least one hundred thousand pounds of litter, along with several dozen arrests and at least as many injuries. Farther uptown, swells will drop three or four centuries per head

for seven courses and a piano player, while farther downtown the younger contingent will shell out a quarter as much for the perennial lesson in social Darwinism at a dance club crammed to bursting with aggressive exhibitionists.

Elsewhere, people will be hit by stray bullets and will hit each other with intentional bullets, all vying for a place in the January 2 tabloid wrap-ups as the last homicide of the old year or the first of the new. The first baby will arrive at an area hospital and probably use up its lifetime allotment of fame then and there. Taxi drivers will gouge passengers and suburbanites will smear each other all over the roads. There may or may not be a subway fare increase, a transit strike, a sanitation strike, a gravediggers' strike. Celebrities will resolve to practice tolerance and promote world peace, and representatives of the media will treat these utterances as news. The following day, the aged members of the Polar Bear Club will take to the icy waters of Coney Island.

All this diverse behavior might as well be encoded in our DNA, so programmatically does it fall into atavistic patterns. The New Year's celebration is as old as time, and its constituent features are remarkably consistent from continent to continent and century to century. The only really major difference is that few cultures have historically celebrated their turn of the year at quite this time, many opting for the more logical vernal equinox, or at least the winter solstice itself; it is to the Romans that we owe the curious present position a week and a half after the solstice. But anthropologists beginning with James Frazer, in *The Golden Bough* (1890), have sorted the New Year's rituals of most cultures into four distinct parts that have, cosmetic changes aside, held into our own day. These segments

are, in order, Mortification, Purgation, Invigoration, and Jubilation.

The first of these may appear the most remote. It is the period when, in preindustrial societies, all business was suspended. In some cases those days fell entirely outside the calendar, and were not spoken of the rest of the year. Nor, during those days, were marriages or litigation conducted, and fasting was practiced—the obvious survivals are Lent and Ramadan. Among certain societies the Feast of Misrule was celebrated then, at the tail end of the old year. The Babylonians stripped their king, made him kneel, and had the high priest humiliate him in the public square. Other societies deposed their ruler, sometimes killed him, and sometimes elevated servants or other members of inferior castes to temporary positions of power. Decorum was turned on its head, laws were contradicted, chaos reigned. Does any of this sound familiar? At least the fact that this interval lasted twelve days has left its mark on the modern holiday, both in song and in the vacation corridor between holidays claimed by anyone who can get away with it. The most recent recorded celebration of the Feast of Misrule, though, occurred in 1975, in Pontiac, Michigan, when Elvis Presley split his pants on stage just before singing "Auld Lang Syne."

The next period, that of purgation, involves the exorcism of demons and the cleansing of humans and animals and their dwellings. Much symbolic activity transpired. The Sorbs of Upper Silesia, for example, burned dummies made of straw and rags, while the Thuringians threw puppets into pools. In parts of Spain and Italy, an effigy of the oldest woman in the village was paraded around and then sawn in two. In Syria, images of the fertility god Adonis were buried and then exhumed. The Wotyaks of eastern Russia

took sticks and beat up their houses and yards, while young women among the Inuits went around stabbing everything with long knives while their elders barred the entrances to prevent the lacerated demons from returning. Many cultures took the opportunity to drive scapegoats—strangers, the unpopular, the dying, or randomly selected domestic animals—out of the settlement.

If it appears that our civilization has become too restrained or repressed to practice this sort of dispatch in any form other than spring cleaning or January white sales, then consider the three-hour riot in Reno, Nevada, in 1979, when thousands of revelers ran rampant, looting shops and injuring seven policemen. Significantly, many of the rioters carried placards denouncing the seizure of American hostages by Iran, whose minions they were presumably punishing through the proxy of Reno appliance stores. Then again, this had nothing on the Fort Lauderdale riot of 1972, when four thousand caused damages resulting in forty-four arrests and twenty-seven wounded cops, but the records are imprecise as to motive. An exorcism of the Christmas spirit itself may have inspired the Quebec City firebug who in 1979 set a Yule tree alight, ultimately resulting in forty-two deaths, but it was apparently an obscure animus against the Norwegian legal system that prompted a Londoner to attack the Trafalgar Square tree—a gift from the Norwegian government—with a chainsaw on New Year's Eve, 1990. A year earlier, drunken guests of the Atlanta Marriott Marquis may have been protesting generic contemporary architecture when they threw potted plants and fire extinguishers from upper balconies of the forty-seven-story, atrium-centered structure, resulting in fifteen injuries and fifty arrests.

Invigoration, the following item on the traditional New Year's program, has two major features: the mock combat and the period of sexual license. Both are expressions of sympathetic magic, intended to promote fertility and crop growth. In the former, such oppositions as Life versus Death, Rain versus Drought, Summer versus Winter were enacted by teams of citizens, or pairs of people on hobbyhorses. The struggle between Alexander the Great and his rival Darius was still being played out early in this century, notably in Scotland. On the border between England and Scotland, the combat was not always all that mock, but it was eventually sublimated into the form of a football game—the spread of this folkloric detail is obvious. In England, villages might stage dancing matches with each other, while the populace yelled, "Hey for our town!" Elsewhere, fruit trees were beaten with sticks—by the French, the Germans, the Jews, the Belgians, the New Caledonians—to persuade them to bear heavily in due season.

And then there's noise, which has always been a big part of ceremonies around the globe. The Tyroleans rang bells and cracked whips, the Japanese agitated bamboo rattles, the Chinese set off firecrackers, the Jews blew the shofar, the Siamese fired guns. This traditional element has remained vigorous into our own time. Consult newspapers for almost any year you choose, in this century or the last, and you will find accounts of hapless bystanders slain by bullets sent up into the air by folks who did not consider that they might eventually have to come down. The two or three annual victims of this practice, invariably asleep in their own beds when death came through the window, make for a routine item on page 37B of your average tabloid's January 2 issue, but it is the Filipinos who truly excel at this

sort of carnage. Every year, greater Manila sees the maiming or kill-
ing of hundreds from stray bullets as well as from fireworks. Then
there was the case of the two partygoers in Glenwood Landing, Long
Island, who at the close of 1985 fired into the air on the grounds of
the Swan Club and brought down a pair of Canada geese. They were
charged with hunting without a license. Further refinements include
those of the man in Bossier City, Louisiana, who saw out 1986 by
firing fifty-five rounds with an automatic rifle into a packed cocktail
lounge; the enthusiast in Cleveland who bade farewell to 1984 by
shooting up a stop sign, his bullets continuing on to penetrate the
wooden wall of a church and slay an eighty-four-year-old minister at
his pulpit; the person in 1977 whose response to being asked for a
two-dollar cover charge at a Bronx social club was to shoot the place
up. And so on. The longstanding popularity of this sort of holiday
merrymaking provoked the *Daily News* to run a message from a
retired head of Scotland Yard urging the United States to enact a
total ban on firearms, citing them as the major cause of violent crime.
That item ran on January 1, 1923.

In an earlier age, murderers might have been given pause by the
idea that the dead were said to return to earth on New Year's Day, at
least among the Finns, the Hopi, the Zuñi, the Lithuanians, and the
Mandaeans of Iraq. Everywhere, the turn of the year and the year's
first day hold ominous significance for the 364 days to follow. Such
Romans as engaged in agriculture went through an elaborate charade
of pretending to farm on the holiday, so that they might set in mo-
tion a year's worth of such activity, and in Brandenburg, Germany,
much closer to our time, people similarly went through the motions
of all sorts of work, to the extent of keeping corn in their pockets

so that they might grind it with their fingers while sitting in church. The Japanese forgave all debts; most people in all countries made it a point to return anything borrowed. In many countries the future can be read on January 1 by examining the ashes in the fireplace, or through the practice of bibliomancy, which consists of interpreting the first line of a randomly chosen page of the Bible or of Virgil. An early American work, *The Shepherd's Kalendar* of 1709, indicates that if the year's first day opens with dusky red clouds, it denotes "strifes and debates among great ones, and many robberies to happen that year." The first person one encounters on New Year's Day is considered extremely significant—in Silesia, for some reason, it was considered unlucky to meet a beggar or a gravedigger. The first foot to cross your threshold was important, too, as to whether it was a right or a left one, and to whom it belonged.

The sexual license allowed by this period of the New Year's program is an item about which traditional sources do not seem to have a great deal to say, other than that, for example, the Druids exchanged mistletoe with one another, but, on the other hand, much importance is accorded the infant. He's the one with the top hat and the sash, immediately to the right of the white-bearded character with the scythe. In Winsor McCay's 1914 cartoon for the old New York *American*, he was the one in the flivver who ran the old man's jalopy into the ditch. For many years, all newspapers other than possibly the *Times* represented him literally, in a front-page photo. In a few years the practice will probably be revived.

The fourth component of the annual ritual is jubilation, otherwise known as feasting and wassail. In Northumberland, the practice of dropping in on neighbors to eat cake and drink wine was called "fadg-

ing," which sounds appropriate. There were recommended foods—
honey for the Romans, bread baked in rings for the Swabians, fish
for the inhabitants of Mecklenburg—and proscribed foods: rice in
China, dumplings in Germany, nuts among the Jews. The consump-
tion of alcoholic beverages was, of course, significantly widespread,
and New York City for most of its history was no exception to this
rule. A coroner's verdict from 1786, for instance, accounted for a
New Year's fatality as "occasioned by the freezing of a large quantity
of water in his body, that had been mixed with the rum he drank."
Washington Irving, writing of the Dutch governors in *Salmagundi*,
noted that one of them saw out the old year by "plying his guests
with bumpers, until not one of them was capable of seeing." By 1914
or so, the rich who hosted parties of five or six at hotels like the
Vanderbilt or the Ritz were capable of spending five hundred to eight
hundred dollars for the evening, a staggering sum for the time—the
same newspaper item noted that at Second Avenue locales such as
"Greeny Mike" Bassetti's or the International Café, the same party
could imbibe an identical quantity for a ten-spot.

Then Prohibition came down, in July 1919, and although the
Volstead Act that gave it its teeth was not to take effect until the fol-
lowing March, the New Year's Eve that fell between those dates was a
grim one for most of New York. The *American* complacently set the
scene: "The rough slam-bang crowd with ticklers of past years was
missing. In its place there were thousands of well-dressed men and
women all bent on seeing the old year out." Translated, this means
that the prosperous could repair to the big hotels, which were clean-
ing out their stocks of liquor, while the masses were simply out of
luck, since their saloons had depleted theirs and, unable to reorder,

had mostly shut down. But cheer was not long in returning to the metropolis, in excessive quantities, in fact, since people who drank modestly before Prohibition tended to become two-fisted boozers during it. New Year's Eve 1922, for example, was a rip-roaring affair during which agents raided the Swiss Chalet, the Knickerbocker Grill, the Plantation, the Palais Royal ("where Vanda Hoff was starring in classical and other dances"), the Palais de Danse, the Hotel Pennsylvania Grill, the Turf Club, the Club Royale, the Jolly Friars, the Little Club, the Ambassador, the Strand Roof, Shanley's, and Gipsyland. The following year, people were paying average cover charges of from $7 to $15 to get into most of these same places, and anywhere from $2.50 for a bottle of dubious gin to $25 for decent champagne, this at a time when the latter sum represented the monthly rent on a respectable apartment. "1924 was born with a corkscrew in his mouth and a pint flask on his hip," somebody said. Two years after that, 1926, Gus Knudson and Karl Ottoson fell out of a second-story window on Fulton Street in Brooklyn while arguing over whether it was 1924 or 1925. That same night, Mrs. Catherine Kelly, also of Brooklyn, broke her leg above the ankle dancing that version of the Charleston called the Buffalo. The following day, a candy store at Broadway and Forty-ninth Street was giving out free Bromo-Seltzer with every purchase.

And so it went, until very recently. In 1965 an adult elephant, dyed pink, was brought into the ballroom of the Sheraton East. Hangover jokes were plentiful in newspapers until the late 1970s. The slack was taken up thereafter by violence stories, misery stories (that of the penniless Florida couple and their nine kids, who spent a freezing New Year's night in 1977 in their disabled station wagon

on Route 3 in Rutherford, New Jersey, was a harbinger), wretched-excess stories (the two-thousand-dollar ticket to attend a concert by Julio Iglesias and Regis Philbin at the Essex House in 1985 was a longstanding record-holder). Eventually, everyone will stay home doing calisthenics and practicing mortification, until something, like knowledge of their imminent and unavoidable doom, drives them out into the streets to carouse again and send themselves to the devil.

1993

STRENGTH THROUGH JOY

Myths die hard, especially in the country that over the course of this century has led the world in the manufacture of durable myths. All kinds of thoroughly debunked specimens—the noble cowboy, the contented housewife, the edenic small-town past—continue to stagger along in the collective imagination because of their proven effectiveness as topical analgesics for reality-based headaches. The trick is that you can't deliberately fabricate a myth; all you can do is spot one lurking among preexisting elements and then pump it full of air. The three-day festival of peace and music is among the more recent myths. The actual event was virtually preselected for mythic status, which usually is a prescription for disaster or at least evanescence, but somewhere along the line the thing developed a life of its own. After its brief incarnation on the earthly plane it enjoyed a retrospective period of fish-story growth followed by a couple of decades in mothballs. Recently the myth of Woodstock reemerged as a parable of youth, a "rite of passage," as the organizers of the latest enactment put it in their press materials. The original model

allegedly demonstrated that youth was capable of imagining un-
precedented forms of peaceful coexistence. Such ambition had now
apparently been shucked in favor of simple endurance, but the scale
remained large. Would Woodstock achieve permanence among the
psychic monuments of America? Or would it join Chautauqua in
that section of the dustbin of history reserved for eponyms of New
York State villages?

I missed Woodstock '69; I was fifteen and my parents put their
combined foot down. It sounded enticing as all heck, though: a va-
riety show, a coed sleepover, and a nature frolic all in one package!
The first reports from the site only added to the romance: the gates
coming down, the rain, the mud, the births, and even the bad acid,
even the deaths. It was no longer just a party; it had become a nar-
rative, of the best kind, involving collective struggle against various
adversaries and a reasonably happy ending. It didn't take long for
the rhetoric to sprout, however, and its self-congratulatory tone had
a certain tinniness from the beginning. The claims of a "Woodstock
Nation" dodged the fact that the masses in attendance had been pas-
sive spectators, however arduous their fight for sightlines and visits
to the toilet. To hinge a political or spiritual claim on the fact that
half a million people had sat in a field for three days without cutting
one another's throats required a generational narcissism that I was a
bit too young to share.

Ten years later, Woodstock was dormant, a word stowed in the
memory attic against a future usefulness while primarily doing ser-
vice as an item of journalistic shorthand, applied to any outdoor
gathering of like-minded hobbyists—owners of Airstream trailers,
say. Ten years after that, it was still cobwebbed with a certain irony,

at the end of a decade that saw the 1960s reduced to a sight gag in a few movies of strictly passing significance (does anyone recall the plot of *1969?*), its ideals thoroughly rubbished by its graduates who had achieved positions of power. The festival's twenty-fifth anniversary was celebrated in 1994 with an attempted reenactment. Hegel remarks somewhere that all events of great importance in world history occur, as it were, twice. He forgot to add: the first time as dinner, the second as reflux. The second attempt featured rain, mud, fallen gates, diverse alumni onstage and off, along with a new generation of paying customers. The event was an outsized shrug. Afterwards its organizers threw around the word "legendary," which in showbiz parlance means that an investment has broken even, or will eventually be recouped through subsidiary returns.

Woodstock '99 was to be different. For one thing, it was not meant to trade on nostalgia, but to cater exclusively to the tastes of a younger generation, the children of the original focus group. Nostalgia for freewheeling anarchic improvisation was likewise to be sidelined. The organizers this time were taking no chances. The sort of eleventh-hour scrambling that left the original festival with a name as apposite as that of the Holy Roman Empire (which famously was neither holy, nor Roman, nor an empire) was not to be tolerated, and nobody was to get in without forking over one hundred and fifty dollars exclusive of handling fees. The organizers got down with the mayor of Rome, New York, one of those "rock & roll Republicans" you've read so much about, and set the do in a former Air Force base lately converted into an industrial campus. Much was made of the B-52 bomber on a pedestal at the entrance, and how through some swords-into-plowshares wizardry that engine of

death would preside over a celebration of peace, diversity, and mutual understanding. Assisting in the celebration would be six miles of newly-built fencing, including several layers of six- to eight-inch razor-wire topping, since peace, diversity, and mutual understanding are not things you just throw around for free.

The site took full advantage of the earth's curvature; giant stages were planted at either end, some two-thirds of a mile apart, so that two sets of deafening noise could go on simultaneously without overlapping. This wouldn't have worked were the site not as vast and flat as the Empty Quarter; it had, after all, previously been a runway complex for giant military aircraft. A couple of hangars were pressed into service, as third stage and twenty-four-hour movie pavilion, respectively, and the former soundproof research building was festooned with a huge inflatable of the bird-on-guitar-neck motif, this year's version looking rather like a stupefied hen.

Otherwise, the decorating scheme was basic county fair, or maybe county fair on steroids. Imagine your classic sausage-and-peppers stand, hastily rigged up from two-by-fours and plastic sheeting; now imagine several three-hundred-yard-long versions of such a stand. There were a few independent operators, but most of the food services were run by an entity operated as a sideline by one of the organizers, whose employees wore uniforms. The menu ran primarily to grease, although vegetarian grease was also available. Everything cost only about a third more than it would in a commercial airport. I believe I saw a picnic table near one of the stands. If so, it was the only actual seating open to civilians in the entire complex.

During the daytime it was possible to enjoy the festivities drug-free, because the heat was so intense it provided a constant hallucina-

tory shimmer. In the interest of toughening their young charges, the organizers had decided not to provide shade. The weaker elements of the audience fought one another for space under tractor-trailers or within the two-inch strips of shadow provided by such things as the freestanding "art walls." Up above, the air was dense with advertising: blimps, enormous blimp-shaped balloons (one bore the apt legend "Fried Dough"), and small planes pulling banners. One of the latter announced: "Woodstock '99—CD and video available September." This told me that we are still at a primitive level of development; if a Woodstock IV occurs, the equivalent there will surely say "available Tuesday."

Down below, the ground consisted of concrete ribbons alternating with stretches of dead yellow grass that for some reason were invisibly furrowed, making a stroll across them a surprising challenge. The challenge was very soon no longer a surprise, as the debris piled up. Whole tracts were covered with a crust of fossilized mozzarella from the weekend's tonnage of pizzas. Kitchen middens of chicken bones dotted the landscape. Sometimes you'd see a styrofoam oyster shell containing an entire dinner, apparently untouched and left to propitiate the gods. Crunching loudest underfoot, however, were untold numbers of plastic bottles, at least two or three for each of the estimated two hundred and fifty thousand attendees. Curiously, these seemed to pile up in greatest profusion around oddly empty oil-drum garbage cans, suggesting that the crowd was made up exclusively of people with poor hand-eye coordination.

The crowd drifted in uncertain clots, stood on endless and immobile lines for the ATMs and the telephones, slept like cordwood in the rare pools of shade, and coagulated around the stage. They wore

golf hats, gym shorts, T-shirts whose messages ran the gamut from "Fuck You" to "Drunk as a Skunk," bikini tops, bedsheets draped like burnooses, garish airbrush body paintings (available at a busy midway tent, manned by sleek young women and overweight fifty-ish bearded guys, that also dispensed tattoos and piercings), doo-rags, wrap-around sunglasses, beer-brand logos, something with a maple leaf on it if they were Canadian (an inordinate number of Canadians walked around with regulation-size flags on eight-foot poles), nipple rings, loincloths. Eccentric individualism was scarce overall; the tone was much closer to spring break at Sixpack U. than to any other youth-culture manifestation of the past thirty years.

The tone was most clearly voiced by a group of guys who had clambered atop a row of tractor-trailers parked near the bottleneck entrance to the east stage area. I walked by when the troops first appeared to have noticed the trucks, and were rating one another on their climbing mettle as they worked their way up the unaccommodating sides and backs. When I next walked by there were a hundred or more aloft and they had all gravitated to the truck nearest the surging crowds. "Show us your tits!" they shouted every couple of minutes. Now and then a woman below would lift her shirt. "Raaah," they answered, like football fans.

My wife, who is a motorcyclist, had told me about the prevalence of this exchange at the larger bike rallies. It made her unhappy. But don't the women who display their breasts do so of their own free will? I asked her. You should look in their eyes, she replied. I wanted to believe that today's youth had achieved a level of unashamed comfort with their own sexuality, so that displays of body parts could be frank, proud, and burden-free, but then such a climate would

preclude the request, wouldn't it? I did see a young woman who had scrawled "Show Us Your Dick" on her T-shirt, although there wasn't much of that kind of spirit. Another young woman wore a cardboard sign around her neck that said "Tits for Hits," but its implications weren't especially reassuring, either.

While the gallery demanded tit, Kid Rock was playing on the east stage nearby. The Kid is from the white part of Detroit, and he combined the freeze-dried essence of every '70s bar band ("This is a tribute to the late, great Ronnie Van Zant") with rapping. His dual nature was eloquently expressed by his wardrobe, as he made a sweeping entrance in a gigantic pimp coat of some substance I couldn't identify from a distance (it could have been sheepskin, ermine, polyester pile, or cotton candy) and then stripped down to the basic garage-band uniform—he kept the cowboy hat on, though. At one point he delivered a short speech that you could imagine being uttered by an endless parade of entertainers all around the globe, each of their sets of eyes rapidly scanning from left to right as they spoke: "People say I'm sexist because I call wimmen hos and bitches, but I wanna say right now to all you wimmen that I luv ya. . . ."

It wasn't easy getting a glimpse of Kid Rock or anybody else on the main stages, unless you were content to view the giant video image screened within a cut-out on the side panel of the pro forma set design by Peter Max (or by www.petermax.com, anyway). Not only did the crowd carpet the entire area with a density that beggared anything I had previously seen at a show, but blocking a central view from anything beyond the first twenty-odd rows ("rows" is, of course, notional; there were no rows) was a camera emplacement roughly the size of my house. As a result I never managed to see the mosh pit, and

not for want of trying. We've since learned that at least one rape took place in the mosh pit. Assuming that the pit was at least as jammed as the area off the wings of the stage, and very probably twice as densely packed, it is plausible that any number of rapes, as well as garrotings and disembowelments galore, could have taken place without anyone three feet away being any the wiser. That sort of packing is scary under any circumstances—you feel as if you will be squeezed to death, as by a boa constrictor, your internal organs haphazardly rearranged. Somehow, you note in wonder, those people over there are able to move their arms! And so they somehow were, and were tossing around various oversized beach balls—many of them promotional items helpfully supplied by corporations, along with logo-bearing cups, fans, and assorted other impedimenta that helped swell the trash piles—and at least one life-sized inflatable sex doll.

Little wonder, then, that the most frequent medical complaint was heat exhaustion. Such occurrences presumably went unnoticed near the stage, as bodies drooped, sagged, and revived all without moving an inch, but elsewhere the cheerful bustle of the little all-terrain paramedic vehicles was constant. With practiced efficiency the sawbones would rush in, roll the body into a green plastic tray, pack it in ice, cantilever the thing on board, and tootle off again. For ambulatory victims, relief was obtainable at the various troughs and spigots dispensing tasty Roman tap water at no charge, which before long created their own miniature Woodstock mud vats.

There were also the beer gardens. These conveniences, which observed the delicacy of not opening before noon, failed to feature dirndl-clad waitresses hefting clutches of tankards. Instead, they were stretches of tarmac encircled by two sets of fences far enough

apart that you couldn't toss beers out to thirsty underage friends. The beer gardens too were unshaded, and positively throbbed with glaring heat. They were, in fact, uncomfortably reminiscent of the prison camps you see in movies set in the Pacific Theater during World War II. I half-expected to see ragged, wild-eyed inmates attempting to scale the fences and being clubbed down by attendants.

I spent a little more than four hours at Woodstock '99. Feeling slightly derelict in my duty, I booked long before nightfall. I was overheated, parched, and my eyes were exhausted from the unrelieved yellow dust, lobster skin-tones, and rippling mirages. It wasn't until a few days later that I learned I had missed all the fun. In the interim I had begun to write a piece that was largely concerned with the sheeplike passivity of the assembled consumers. I had been struck by the absence of self-determination on the part of the crowd—the only thing remotely resembling spontaneous free expression I had witnessed had been the small zone in the center of the field in which a shifting cast of characters was using anything that came to hand to drum on commandeered garbage cans. Occasionally the drumming approached a rhythm; most of the time it was strictly regressive din.

When I read about the fires and the looting I was surprised only momentarily, though. The crowd was effectively imprisoned for three days in wildly uncomfortable circumstances with nothing to do but watch, drift, burn up, and spend money. Much has been written about the role of the music, and how so many of the main acts drew on inchoate and puerile male anger, with a distinctly threatening beer-night mob-scene undertone, and this was true. There weren't a lot of women onstage, and for that matter there weren't

many acts of any sort that did anything but pound. The setting and the acoustics did not favor subtlety or reflection. The alternation of bovine stupor with unfocused rage that was manifest is of course not exclusive to the current climate; accounts of rapes and beatings and even murders run through the chronicles of festivals in the period following the first Woodstock. But unfocused rage has moved from the periphery to the center, in large part because of a lack of perceived common cause. Kids are always angry, when they become aware, first of all, of their parents' shortcomings, and then, however briefly, of society's shortcomings. But society over the past thirty years has become ever more effective and efficient at telling them to shut up. They are expected to shut up and spend, shut up and watch, shut up and join the workforce.

The generation of the first Woodstock was motivated to political action by a personal threat, in the form of the draft, and they were fortunate enough to grow up in a time that demanded less cash generally, and was much less conclusive about separating them into two piles: the elite and the serfs. Most of the kids at Woodstock '99, given that they could afford a hundred and fifty dollars, will presumably go on to apply their rage to corporate practice, and the rest will shine their shoes. There are few alternatives between those poles. If there is another Woodstock, it will not be soon, but then it may well be designed by some of this year's veterans. They will be motivated by their experience to provide an armed security force. It will be much more efficient than its predecessors. This year's organizers were correct: they did indeed create a rite of passage.

1999

I CAN'T CARRY YOU ANYMORE

1.

My adolescence wrapped itself around the end of the 1960s and the beginning of the 1970s. I was bookish and wanted terribly to be hip, so I spent a lot of time looking for hipness in printed sources. As a result, I encountered Terry Southern's name in almost everything I picked up. If I'd been going to the equivalent parties, his bearish frame would have been physically omnipresent. But he wasn't just a literary ligger; his influence was decisive. If any book changed my life it was *Writers in Revolt*, the anthology he coedited in 1962 with Alexander Trocchi and Richard Seaver—Burroughs, Ginsberg, Artaud, Céline, Genet, Sade, Beckett, Gaddis, Selby, Malaparte— which I found, when I was in seventh grade, on the blameless shelves of my local public library. Rereading Southern today, I'm struck by how much my friends and I imitated his style—and we weren't the only ones. Pick up almost any piece of prose written in that period by a young white male with aspirations to hipness and you'll find

Southern's voice. Rock writing, drug writing, the less pious factions of the underground press, the *National Lampoon*, Ron Rosenbaum's early reporting, Jim Carroll's *Basketball Diaries*—all share that swagger, echo that breezy compound of street jive and Madison Avenue knowingness woven around an arch pedantic formality that stands like the ruins of the straight world.

He wrote five novels (*Candy* and *The Magic Christian* are the best known) and two collections' worth of short pieces, and at one time you could hardly open a literary anthology without coming across "Red Dirt Marijuana" or "The Blood of a Wig" or "Twirling at Ole Miss" yet again. He earned writing credits on numerous movies, including such zeitgeist-defining pictures as *Dr. Strangelove*, *Easy Rider*, and *Barbarella*. His name was permanently parked on the masthead of the *Paris Review*; he was a frequent contributor to and occasional editor for *Esquire* in its heroic era in the early 1960s; he was a writer for *Saturday Night Live* in its second (Eddie Murphy) phase. He was a running buddy of an astonishing number of major pop-culture and underground personalities, and his visage is duly enshrined in at least one Mount Rushmore of hipness: at upper left in the collage on the front of *Sgt. Pepper's*. He was as close to responsible as any single human being could be for that giant cultural whatsit we call the Sixties.

Despite knowing all that, I could never quite get a bead on the guy. He certainly didn't lack for personality—reading him for any extended period filled you with the sense that he was seated on an adjacent stool as you and he chased vodka and tonics with lines of C. And you could not accuse him of being unproductive or inconsistent; the slightest jape in *The Realist* was manifestly from the same hand

that gave the world Candy Christian, the Candide of the sexual revolution. Nevertheless there was something sketchy, partial, inconclusive about the portrait of the author that emerged from the writing. The work added up to a tremendous act, one that carried over from skull session to party to hangover without significant change other than the addition of a headache. Even his most personal writing, such as "Red Dirt Marijuana," a semi-autobiographical story about a little white kid in Texas and his friendship with a black farmhand, fit seamlessly into the act. I never got the sense I saw Southern with his shades off.

A *Grand Guy*, Lee Hill's biography of Southern, might provide clues toward an answer, but you have to dig for them yourself. It is a laboratory specimen of third-rate biography, apparently written at high speed without much effort wasted on thought or depth or nuance, incorporating gelatinous lumps of potted history straight from the tin, long lists of undifferentiated names, much tone-deaf slinging of readymade phrases, and numerous small errors of fact and grammar. Not that the book fails to acknowledge the monumentality of Southern's act. It makes clear that from 1948, when he first made the Left Bank scene as a sometime Sorbonne student on the GI Bill, until his death in 1995 (of complications resulting from a lifetime of hard partying), Southern concealed what we are assured was a shy, sensitive interior beneath an expanse of verbal bravado. The concealment, however, was total, and the shy, sensitive inner being never gets more than a perfunctory name check, either in Southern's work or in his biography.

What might be Southern's epitaph appears instead as an epigraph on the dust jacket of *A Grand Guy*: "When they're no longer

surprised or astonished or engaged by what you say, the ball game is over. If they find it repulsive, or outlandish, or disgusting, that's all right, or if they love it, that's all right, but if they shrug it off, it's time to retire." Southern staked everything on effect. Thus he required a social context; he needed both an audience of cronies who would get it and an audience of squares who not only wouldn't, but would turn purple and thrash ineffectually in offended protest. His was the strategem of someone with a lot to prove, and perhaps a lot to conceal. Other writers of his time similarly polarized the readership, but never quite in the same way. His old friend William Burroughs, for example, put all his contradictions on the line. He might have enjoyed provoking the enemy, but he hardly appeared dependent on the finger-popping approval of his frat brothers. Anyway, his provocation had a point—there was a world of repression that had caused him misery and that he wanted to destroy. Southern never made it clear he was in it for more than high fives and free drinks.

The posthumous collection *Now Dig This: The Unspeakable Writings of Terry Southern* is a feeble collection of asterisks and throwaways, but it will do as a diagnostic model of his work. You get the Southern style: "It seems that her husband, a British stockbroker, suspected his wife of having an affair, in fact, he was abso-*tootly* (if you get my drift) *certain* that his darling star's fabulous cooze was being deeply penetrated *and* voraciously gobbled by two, three, perhaps more, persons unknown. . ." You get Southern the prankster (a proposed sketch for *Saturday Night Live*, for example, that would have merged three tabloid stories—"Human Head Transplanted Onto Pig's Body," "Giant 13-Foot Worm Strangles Baby," and "Albino Fries 3 Times"—with exacting literalness). You get the Swiftian Southern

("Heavy Put-Away," a mock as-told-to tale of a crushing and point-less con game that is sufficiently deadpan to be the most effective thing in the book). And then you get a rare glimpse of Southern being quietly appreciative and unconcerned with pitching anything to the gallery in a 1963 review-essay on Lotte Lenya that is both un-exceptionable and stone dead on the page ("What we have here, in Brecht, Weill, and Lenya, is *life* in its bedrock essence, and art at its very peak"). There was more to Southern than the parade of trivia the book presents, but how much? Like their author, who declined precipitously from the early '70s on (the last hundred pages of the biography consist mostly of a numbing list of screenwriting projects that went nowhere), many of his riffs have failed to survive their context, and there wasn't a whole lot in his work that transcended the category of riff. What we have here is a caution to the young, which might be summed up by one of Southern's most famous lines: "You're too hip, baby. I can't carry you anymore."

2.

John Leland may not have written the first history of hipness—I can't, in an admittedly casual search, find another—but it's hard to shake the thought that such a book might as well be its subject's obituary. It's like broadcasting the rituals of the lodge, or maybe spell-ing out all the names of the godhead. There are dozens of histories of bohemia, but that's not the same thing, although the two concepts have a large field of intersection. Bohemia started in Europe and spread around the world, but hip (Leland employs the word as both

adjective and noun) is indigenously American. The word derives from the Wolof *hepi* ("to see") and *hipi* ("to open one's eyes"). The idea of hip emerged from seeds sown in Senegambia that budded in America. It has everything to do with race mixing, and it works both ways, comprising not just white people's love and theft of black style but also African-American appropriations of European baggage: the pianoforte, the three-button suit, existentialism, Yiddish expressions, horn-rim glasses, the novel. And hip is occult, arcana without a heaven.

Cultural miscegenation is fundamental not just to hipness but to the United States in all its finest aspects. The fact that racial intercourse until recently had to be carried out more or less in secret accounts for the glamorous air of danger that attached to hipness, even while the product that emerged from hip might sooner or later find its way into the canon. The effects of cultural race mixing are felt every day by every single inhabitant of the United States, although, perversely, an official line persists in admitting only the Nordic Protestant sliver of the nation's identity—see for example the recent excreta of Samuel P. Huntington. That alone might ensure the continued survival of hip, even without assistance from the marketing department and its banks of iron lungs—but I'm getting ahead of myself.

"*Hip* is a term of *enlightenment*," writes Leland in *Hip: The History*. It incorporates cool, a concept that itself dates "back to a fifteenth-century king in the Nigerian empire of Benin who was awarded the name Ewuare, meaning 'it is cool,' after bringing peace to a region torn by internecine warfare." To be hip is to be awake and aware, to be pluperfect and invisibly graced, to possess secret knowledge,

knowledge that makes the owner an initiate of a nameless sect whose members recognize one another by the use of certain words, the wearing of certain garments, the tilt of a hat, the roll of a cuff. The minute those words and styles pass into the public grasp, it's time for hipsters to switch to other words, other styles. These days, with more squares than ever clamoring at the gates, assuming styles before hipsters have had a chance to try them on, it's very hard indeed to remain untouchably self-selected. That's why Pabst Blue Ribbon became the hip beer: it was unclaimed, a blue-collar vestige without a living constituency. The choice of hip shibboleths has become a process of elimination.

Leland has a multi-strand story to tell, with a great deal of heavy lifting, and he proceeds manfully, clocking a chapter at each of the major stops. The nineteenth century is represented on the one hand by the extraordinary foundation work of Thoreau, Melville, Whitman, and especially Emerson—a redoubtable tea-leaf reader who seemingly forecast every American cultural trend of the future—and on the other by the rise of minstrelsy, which laid into the edifice an oddly shaped keystone labeled "irony." The twentieth century is frenetic. You can connect the dots between New Orleans jazz and Greenwich Village bohemia, and the Harlem Renaissance and the Paris exiles of the 1920s, and then hear the riff repeated in a new key after the Second World War by bebop and the Beats. But running sideways across the story are criminals, cartoons (was there ever a more perfect hipster than Bugs Bunny, at least before he became a shill?), film noir, the put-on, drugs. Jews represent a special case, understanding both sides of the racial dichotomy and playing both at once, while being correspondingly excluded by both.

Women also represent a special case, hipper than hip unless they are relegated to reproduction and emptying bedpans. Further on in the chronological narrative we have hippies (briefly) and punk and hip-hop and hackers and so on and did I mention drugs? There are so many intersecting story lines that the subject begs for a flow chart.

Leland is a fluid writer, capable of unfurling a nice phrase, able to walk a very thin line in writing dispassionately about hip without coming off as an embalmer. Somewhere around chapter three ("Jazz, the Lost Generation, and the Harlem Renaissance"), though, I began to hear his spectral muttered curses as he came to the realization that his narrative would entail an endless assembly line of potted histories. He does manage to come up with some unexpected nuggets and apposite quotes, but if you have any previous acquaintance with his material you will wince as you are subjected yet again to anecdotes grown shiny with use. Starting about a third of the way in, your eyes will glaze over as the personnel of previous chapters is repeatedly brought back for curtain calls, so that the connections between hip model 1927 and hip model 1956 are not lost on the sluggards in the back row. Of course, since the target audience for this project has a median age of eighteen, Leland is providing a public service in rehearsing the story of, say, the Lost Generation, since it needs to be differentiated from generations Beat, blank, and X. Teenaged hipsters may once have been better versed in the works and days of their predecessors, since they were so isolated, and information on current matters was so hard to come by, that in their desperation they were forced to resort to the library.

The other major hurdle faced by the author of such a book is that it is necessarily the product of any given present moment. Unless

you declare an arbitrary stopping point and cast the whole business in the past tense, which will make you come off as an embalmer, you are faced with some tricky rhetorical footwork if you are to escape instant obsolescence. Leland looks around him at the spectrum of hipness at the time of writing and finds ... trucker caps. He knows full well that trucker caps will have hit the boneyard long before publication day. How is he to suggest that hipness has a viable future? Leland looks back at a century and a half of hip for a sign, a previously overlooked curve that will connect the misty past with the confused present, a stone that the builders rejected that will prove to be the rock on which future hipness will thrive, and sees ... advertising.

Thus, in his Mount Rushmore of anticipatory hip, alongside the faces of Emerson, Thoreau, Melville, and Whitman, he carves the countenance of Volney Palmer, who "opened the first American ad agency in Philadelphia in 1841." Now, it's true that publicity has always been of fundamental importance to artists struggling for recognition, and it has loomed even larger for hipsters, whose art is inseparably entwined with the packaging of their selves (oddly, Leland doesn't make much of Whitman's or Norman Mailer's self-advertisements). Publicity was also a major component of modernism; in the twentieth century all sorts of artists, even Communists, enjoyed trying to harness and replicate the iconic impact of ads. It's also true that advertising has constantly leeched off vanguard art (advertising needs hip a lot more than hip needs advertising), and that selling the sizzle and letting the steak take care of itself—a precept dating back at least to the work of Edward Bernays, Freud's nephew, for the tobacco industry in the 1920s—is a recipe for merchandising

hipness. But Leland has let his ear be bent by many "creatives" who are probably sincere in their belief that what they do is *just like* art, that it's *abstract*. Dig it, they're not selling *cars*—they're selling CDs by the hipsters whose tunes are used in the commercials! They're subverting the system from within! And the check is in the mail and I won't come in your mouth. The fact remains that if you shill for enterprises that exist primarily to further enrich people who are already many times richer than you, you are a servant. And you can hold my coat.

2001, 2004

TEENAGE HISTORY

The history of pop music goes marching by in eighteen-month segments, generations that last two years, epochs that barely fill half a decade—teenage time, in other words. So it is that *Nuggets: Original Artyfacts from the First Psychedelic Era* manages a double refraction of the past: the era of its contents and the era of its conception. The latter survives in its packaging. When Lenny Kaye put together the first version of the garage-band anthology *Nuggets*, in 1972, its most recent tracks were only four years old. After Woodstock, Altamont, *Tommy*, and other ephemeral disasters, though, 1968 might as well have been the days of crinolines and mustache wax. In 1972, mediocrity ruled. That accounts for the plug-ugly jacket art—unforgivably quadruplicated here—leaden 1970s psychedelia in the *Yellow Submarine* greeting-card vein. Then there's the subtitle. Anybody under thirty-five can be forgiven for wondering just when the second psychedelic era might have occurred.

Psychedelia, anyway, is only one detail among many in this typically overstuffed box set. Imagine it all on buff stock with Garamond

type and footnotes and cross-references and you'll get the idea. It's an ethnographic collection, assembling basic documents for the study of creative expression among white adolescent and post-adolescent males in the American suburbs during the key years 1963–1968. That time and place saw one of those boomlets, like doo-wop, of mass simultaneous illumination, mushrooming cottage-industry production, and anybody-can-be-a-star inconsequentiality. Great records, records that will never die, were made by people who went right back to being busboys, and the era itself sank back into the sea like Atlantis.

The phenomenon escaped notice while it was happening because at the time many of these bands could pass for parasites feeding on the larger British ruminants. The stuff was marginal chart litter without a manifest, a few lucky hits and a lot of also-rans. But while it's true the set contains its share of quasi-Beatles and pseudo-Stones, as well as dozens of debtors to the Yardbirds, the whole package gives off an unexpectedly coherent sense of purpose, with an originality that is more collective than individual. Lotus eaters like the Thirteenth Floor Elevators and frat boys like the Swingin' Medallions, who might then have spat at each other, turn out to have more in common than not.

Where did it all come from? Possibly the Pacific Northwest in the early '60s, home of the Kingsmen and the Ventures. The former (whose "Louie Louie" is semiredundantly included) galvanized ten thousand bands who assumed they could play as well as that; the latter (not included) moved another ten thousand who aspired to their chops. By the time the Beatles ate the world, their biggest contribution to the scene was a redistribution of envy. In the mid-'60s, combos and singing groups (as they were then called) decorated

the premises at pool parties, store openings, local political rallies, Founder's Day festivities, drive-in theaters, farmers' markets, tree plantings, statue unveilings. Five guys with turtleneck dickies, bangs combed down so they took a turn at the eyebrows, garrison belts, elastic-sided boots, Vox amps, Mosrite guitars, Farfisa organs, tambourines, well-rehearsed sneers. It was folk music, really. You can assume that every single band in America at the time covered "Hey, Joe" and "C.C. Rider" and "Gloria" and "Twist and Shout" and "House of the Rising Sun." And then they wrote variations on those themes, and then covered each other's variations.

Before the advent of the Sex Pistols you could always find the genre at record fairs filed under "Punk Rock," and that was accurate in several senses. Every time I hear the voice of Sky Saxon, of the Seeds, for example, I feel like I'm eleven and about to get beat up, so closely do his adenoids resemble those of Johnny K. and Jimmy H. from down the block. Then, too, the original *Nuggets* (included here as the first of the four CDs) is the one indisputable founding document of the first punk era. Probably every band that played CBGB and Max's between 1975 and 1978 covered at least one cut, and they all improvised on different tangents of the phenomenon. The Standells and the Chocolate Watch Band and the Leaves were the self-taught workingmen, and the Ramones and the Voidoids and the Heartbreakers their decadent wastrel offspring.

At 118 tracks, the set is like ten pounds of Tootsie Rolls: to be consumed at a measured pace (although it probably won't be, and stomach upset will result). You won't like every number; nobody could. On the psychedelia front alone, there's zit-cream metaphysics (the Electric Prunes), brain-pan alley (the Elevators; as Tom Verlaine

once remarked when announcing a cover of "Fire Engine": "The guy was from Texas, so he thought 'the empty place' was 'DMT place'"), Napoleon XIV babble (Kim Fowley), Stan Freberg parody (the Magic Mushrooms), slick studio contrivance (the Strawberry Alarm Clock), slick contrivance with outsized guitar heroics (the Amboy Dukes), insufferable la-la twaddle (Fenwyck), and bobbing for meatballs (the Bees).

While the folkies in the college towns read newspapers and argued policy, these garage laborers were exercised about more basic subjects, such as hypocrisy, untruth, unfairness, unhipness. "I'm up to here in lies," complains the Music Machine's Sean Bonniwell. "I guess I'm down to size." His social life's a dud, his name is really mud, and all around him is nothing but talk talk—but he doesn't whine about it, he snarls, and it wouldn't really matter anyway if it weren't for a great stop-and-go arrangement centering on the bass. So the lyrics are pretty much all inchoate flailing—big deal. It's telling that "Shape of Things to Come" by Max Frost and the Troopers, which was concocted for the teen-uprising epic *Wild in the Streets*, sounds no more artificial than anything else here. The words are not the content.

There's also plenty of juvenile-delinquent posturing, effectively recalling the days when the chief approbatory adjectives were "tough," "swift," and "hoody." You can hear the snarl on roughly one out of three cuts. The you're-gonna-die laugh on the Syndicate of Sound's "Little Girl," for example, is more sociopathic than anything Jagger ever managed (numerous are the hapless females apostrophized as "Girl" in these songs). Those bangs prevented you from seeing their eyes; the members of the Music Machine each wore one black glove. Even so, it's hard to escape the thought that few of these

boys were quite as bad as they made out. There's an undertone that
suggests even the Blues Magoos had dogs named Spot and cats named
Fluffy and accepted care packages from their moms. Today, of course,
they all have second mortgages of their own, except for the few who
genuinely had too much to dream and washed up on a beach in Baja.
Only a handful had careers that extended beyond the period, and
that includes two geniuses: Arthur Lee (one of two black musicians
here; the other, John Echols, was also in Love) and Captain Beefheart
(heard here on "Diddy Wah Diddy," his first record, and already he
does a creditable turn as Howlin' Wolf at the Cabaret Voltaire).

But the geniuses seem slightly out of place. This is genuine corn-
fed Americana, a parade of winking obscurities, like studio portraits
found at the flea market. What happened to the Castaways, whose
falsetto- and Farfisa-driven "Liar, Liar" is the eeriest number in the
box, and whose photograph reveals them to have been classic chess-
club geeks? What happened to the Hombres, whose "Let It All Hang
Out" is some kind of redneck rap, "Subterranean Homesick Blues"
crossed with the Statler Brothers' "Counting Flowers on the Wall"?
Or the Nightcrawlers, whose "Little Black Egg" is to psychedelia
roughly what Paul Klee was to Surrealism? Or the Daily Flash, or
the Mystery Trend, or the Zachary Thaks? Today they might have
their pimples magnified 500X on a billboard on the Sunset Strip
for a week, or else they might not be able to get a record contract at
all. Anyway, kiddies, these are your ancestors, who suffered through
innumerable sock hops at American Legion halls so that you can be
the little Antichrists you are today.

1998

GETTING BY AND MAKING DO

Twenty years ago or so, everybody I knew was in a band, everybody ineligible for Social Security who lived in my neighborhood (and corresponding neighborhoods around the world) was in a band, and even yours truly, with all the talent of a fencepost, was fleetingly in a band or three. But then talent is a social construct, isn't it, and it's a fact that people who couldn't have played "Chopsticks" on a bet did sometimes manage to contrive remarkable things, little epiphanies of pure will or nerve or soul or fucked-upness. Eventually the dogs barked, the caravan passed, and almost everybody gave up. The Mekons never gave up. They first drew collective breath in 1977, in Leeds. You can see the poster for their initial single in the booklet included with the second of their *Hen's Teeth* CDs, and it's the whole period contained in a teaspoon (skanky photocopy, lettering incised by somebody's fist, glum group portrait like a mutual blame session at the squat). When I first heard of the Mekons they were a byword, even at the time, for kitchen-sink, can't-play-their-instruments punk Zhdanovism. For a while they were primarily noted for the bril-

liance of the cover concept of their first album (a chimpanzee at a typewriter: *The Quality of Mercy Is Not Strnen*).

Then, in 1985, *Fear and Whiskey* came out and caught everyone off-guard. The Mekons had remade themselves, thoroughly. The music was country, or actually a sort of cargo-cult exquisite-corpse reinvention of country. Some of the musicians were still feeling their way around, while others (such as occasional member Dick Taylor, an early Rolling Stone and once and future Pretty Thing) were quite adept, and the mix of elements had a loose-limbed exuberance that was at once rent-party and avant-garde. Susie Honeyman's fiddle, in particular, was true and rough and poignant and somehow ancient. The lyrics were jagged, mostly unrhymed—prosy and allusive bits of autobiography (in part a naive assumption, as it turns out, since "Flitcraft" is lifted from *The Maltese Falcon* and "Country" from Michael Herr's *Dispatches*; the Mekons are deft literary magpies who leave no fingerprints). They covered Hank Williams in a way that made him sound alive and living in Sheffield—no, actually, they built an imaginary America out of pocket lint, the way Bertolt Brecht or Sergio Leone did. Jon Langford's and Tom Greenhalgh's voices alternated like the night out and the morning after.

Time passed. They became ever more at ease on their various instruments (without, however, coming to sound "professional"). They added Sally Timms, who constructed a fierce and endearing hard-boiled chanteuse persona. They played around with diverse genres and forms. They were furiously prolific, putting out albums annually (*Honky Tonkin'* is still unfolding after twelve years; *So Good It Hurts* contains two or three of their best songs). They toured with a lineup that expanded and contracted like the bellows of Rico Bell's

(occasional) accordion, and they toured relentlessly, like Nazareth or something. There seemed no stopping them. In 1989 they finally signed with a major label and released their arena-filling juggernaut, *The Mekons Rock 'n' Roll*. Soon teenage headbangers everywhere, gleefully ignoring the song's impeccably dialectical meta-critique, were body-slamming to "Memphis, Egypt": "Destroy your safe and happy lives, before it is too late . . . Up in the rafters a rope is dangling, spots before the eyes of rock and roll . . ." It entered heavy rotation on all broadcast media. The band got rich and fat and loathsome. It was hard to remember them as young rebel poets from Leeds considering the gaseous VIP-lounge hairballs they had become.

Well, no, actually. *Rock 'n' Roll* was cast adrift, rudderless and unpromoted, by its major label. It never entered the purview of teenage headbangers anywhere. By that time the band had a back catalog as rich, profound, and various as that of any outfit twice their age, but to little profit. They proceeded as they always had, by cargo van and word of mouth. The closest they ever came to an arena was an exhilarating show in Central Park that seems like yesterday but my calendar tells me occurred in 1991. They did have a strong following among critics, although rock critics—as cautious as politicians—are terrified of backing the wrong horse; being labeled a critical favorite is only tenable for about a year, after which it becomes a ticket to oblivion. Incredibly, the Mekons persisted, despite some of them migrating to Chicago, pursuing other projects, coming together at intervals, releasing records almost in secret. Some grand things ensued—the album *Curse of the Mekons*, the anthemic "Millionaire," chunks of *Pussy, King of the Pirates* (their collaboration with the late lamented Kathy Acker), and the odd song here and there—but over-

all the decade has not been kind to the Mekons. Parcels of oomph and conviction have been mislaid in dressing rooms and gas stations. They might have hit bottom with last year's borderline-unlistenable *Me*, on which they appeared to be toying with some kind of techno-ambient sterility that suited them like socks on a rooster.

The two volumes of *Hen's Teeth*—collections of outtakes, alternates, and B-sides—appear as a mixed signal. Such things get issued either when a band is stuck and wants to squeeze some dollars from the troops to tide it over, or by way of a last wave from the ocean surface before it clambers down to Davy Jones's locker. The cover photos, though, show lively Mekons cavorting merrily onstage within the last year or so, and at least one number (a properly hypnotic cover of the Kinks' raga-drone "Fancy") is brand-new. The first volume actually manages to be the best Mekons album in ages, doing justice to all facets of their complex personality. It's been in heavy rotation on my CD player for months now, although I note that the two best numbers, the propulsive "Orpheus" and the quietly devastating "Now We Have the Bomb," both derive from the 1996 CD-book package *Mekons United*, which I couldn't afford to buy (and which I only ever saw for sale at the anarchist bookstore on Avenue B). Other first-rate tracks, such as the typically rueful Greenhalgh number "Cowboy Boots" and the patented Timms faux-confession "The Ballad of Sally," seem to have been simply cast overboard in the late 1980s, when they were writing so many great songs there wasn't enough vinyl in the world to contain them.

So does *Hen's Teeth* represent a final garage sale of unclaimed artifacts? Is this, he gasped, the end of the Mekons? Being a fan of the Mekons has always entailed some identification with their story,

which is a story of self-invention but lacks those other Horatio Algerian qualities, notably piety and material success. It does involve continually being knocked down and getting back up again—not exactly masochism, or at least no more than everybody's workaday masochism. The Mekons have brought poetry, sexiness, and panache to the theme of getting by and making do, an adult theme if there ever was one and an appropriate development from the antiglamour self-determination of 1977. Given that the prevailing myth these days concerns the effortless acquisition of insane wealth, with the corollary that anyone without money is dirt, those of us who are dirt and are fated to remain that way can appreciate having a pop group to call our own, as a kind of home team. That said, you can't exactly blame the Mekons for wishing to win enough of a prize in the pop sweepstakes to live on and continue working. With rents being what they are, we may be witnessing the end of bohemia as we've known and loved it for 170-odd years; the Hobson's choice between day job and mass appeal will confront everyone sooner or later. But even furthest down on their luck, the Mekons have never broached self-pity. They've cursed and muttered and cracked jokes and philosophized, and done all these things rollicking and roaring. Their failure has come to look triumphant, and never more so than in the current climate of vile success.[1]

1999

[1] Despite the eulogistic tone here, the Mekons have persisted, releasing several long-players since then, one of them (*OOOH Out of Our Heads*) one of their very best.

I IS SOMEBODY ELSE

Be careful what you wish for, the cliché goes. Having aspired from early youth to become stars, people who achieve that status suddenly find themselves imprisoned, unable to walk down the street without being importuned by strangers. The higher their name floats, the greater the levy imposed, the less of ordinary life they can enjoy. In his memoir, Bob Dylan never precisely articulates the ambition that brought him to New York City from northern Minnesota in 1961, maybe because it felt improbable even to him at the time. Nominally, he was angling for Leading Young Folksinger, which was a plausible goal then, when every college town had three or four coffeehouses and each one had its Hootenanny Night, and when performers who wowed the crowds on that circuit went on to make records that sometimes sold in the thousands. But from the beginning Dylan had his sights set much higher: the world, glory, eternity—ambitions laughably incommensurate with the modest confines of American folk music. He got his wish, in spades. He achieved leading young folksinger status almost immediately, then

was quickly promoted to poet, oracle, conscience of his generation, and, in a lateral move, pop star.

Each promotion was heavily taxed. On "Positively Fourth Street" you can hear his half of a recrimination match with one or more former Greenwich Village competitors, once resentful and now obsequious. ("Fame opens up, first, every irony back onto one's past; one is abruptly *valued* by one's *friends*. Then actual envy and malice are hard to ignore. It is difficult just to be watched. There is injury to one's sense of rebellion. . ." —John Berryman on Stephen Crane.) The year of booing he endured after he started going onstage with an amplified band in 1965 is a familiar tale. In *Chronicles*, which is apparently the first installment of a memoir told in chronologically shuffled vignettes, he revisits the period after his motorcycle crash in 1966, after he had withdrawn from live performance and had only issued one, rather enigmatic record, *John Wesley Harding*, a year and a half later. His silence contributed to his mystique, and that in turn became the focus of a craving for direction and guidance on the part of beleaguered youth in that time of failed revolution. As a result:

> Moochers showed up from as far away as California on
> pilgrimages. Goons were breaking into our place all hours of
> the night. At first, it was merely the nomadic homeless making
> illegal entry—seemed harmless enough, but then rogue radicals
> looking for the Prince of Protest began to arrive

And a person named A. J. Weberman began going through the Dylan family's garbage and subjecting it to talmudic analysis. ("One night I went over D's garbage just for old time's sake and in an envelope

separate from the rest of the trash there were five toothbrushes of
various sizes and an unused tube of toothpaste wrapped in a plastic
bag. 'Tooth' means 'electric guitar' in D's symbology ") Dylan
was doubly consumable by his audience, at once the star on whose
image any fantasy could be projected and the sage whose gnomic ut-
terances could be interpreted to justify any feverish scheme. He had
become a floating signifier of the greatest order of magnitude.

Overwhelmed by the situation he had semi-wittingly created,
Dylan tried various means to escape it. In *Chronicles* he accounts
for what seemed at the time to be eccentricities or missteps; they
were, he says, intended to bore, mystify, or disgust his admirers so
that they would leave him alone. He recorded a country & western
album "and made sure it sounded pretty bridled and housebroken,"
employing a crooner's voice cleansed of all his lye and vinegar; had
himself photographed wearing a yarmulke at the Western Wall in
Jerusalem ("quickly all the great rags changed me overnight into a
Zionist"); started a rumor that he was enrolling in the Rhode Island
School of Design; failed to show up at any of the major countercul-
ture festivals. All the while he dreamed of "a nine-to-five existence, a
house on a tree-lined block with a white picket fence, pink roses in
the backyard." This sounds suspiciously like a line of dialogue from
the second act of an MGM musical, begging a question—is this
candor, hindsight, irony, spin, rhetorical flight, or some combina-
tion thereof?—not unlike those that attend virtually everything else
Dylan has written. He can't seem to help putting forth vivid images
equipped with yawning ambiguities. That means that even when he
has been at pains to make himself transparent, he has given grist to
the interpretation mills, which have rarely been idle in forty years.

It is perfectly possible that the succession of odd choices he made in the late 1960s and early '70s were meant as deliberate roadblocks to set in the way of overeager fans. It is equally credible, though, that crooning, Zionism, returning to college, cornball self-parody (aspects of the 1970 album *Self-Portrait*) and, later, born-again Christianity and a range of variously slick show-biz moves were matters he considered quite seriously, if only for a week or a year, as ways of escaping from the burden of himself. What seems to have happened is that he lost or at least misplaced parts of his power and inspiration without actually achieving serenity. Speaking to David Gates in the *Newsweek* interview that heralded the release of *Chronicles*, he went so far as to claim that his artistic drought lasted from sometime in the early '70s until 1998, when he issued his record *Time Out of Mind*. Gates bit his tongue: "He's talking about the twenty-five years that produced *Blood on the Tracks*, *Slow Train Coming*, *Shot of Love*, *Infidels* and its sublime outtakes, and—no. Let's not argue with the man who's in possession of what really matters." Everyone who paid attention to Dylan in that period will have a greater or lesser number of reservations about the quality of the work he did then, but his sweeping assessment is not altogether wrong. A majority of the songs from then are in some way at odds with themselves—compelling words hitched to perfunctory music, or strong ideas clumsily executed, or misfires caused by dunning self-consciousness, or well-conceived pieces sabotaged by their arrangement or production. Everywhere there is evidence of crippling internal struggle, of conflicting intentions that have arrived at a deadlock. It is telling that many of his best songs from that era were officially cast off and not released until much later, if at all.

It's not easy to identify with Dylan's predicament, since so few
people have had the experience of finding themselves appointed
prophet, and not having the assignment quickly washed away by
the tides of fashion. And fame, although significant, is only part of
the story. (Berryman on Crane, again: "One's sense of self-reliance
is disturbed. Under the special new conditions one behaves—at
best—at first as before; but this is not adequate. Also the burden of
confidence in oneself is to some extent assumed by *others*; and the
sudden lightness inclines to overset one.") An even greater burden
comes from being ceaselessly analyzed, as if one were the reviewing
lineup at a May Day parade and the rest of the world was com-
posed of Kremlinologists. And Dylan's audience does not merely
appreciate him; it wants things from him, particular things: insights,
instructions, answers to questions, a flattering reflection of itself, a
mind it can pretend to inhabit. The responses to *Chronicles* include
the common complaint that Dylan evades telling us what we want
to know. He doesn't explain how he wrote "Visions of Johanna," for
example, or what his emotions were during the process—he fails
to conduct a tour of his peak moments, and he does not specify
how he unbottles his genie. He doesn't discuss such major works as
Highway 61 Revisited or *Blonde on Blonde* or the huge, only partly
issued body of work known in aggregate as *The Basement Tapes*.
He doesn't mention *Blood on the Tracks*, either, although when he
writes, "Eventually I would even record an entire album based on
Chekhov short stories—critics thought it was autobiographical," it
would seem, by process of elimination, to be the record he is refer-
ring to. But is he serious?

The way *Chronicles* is structured suggests that it is primarily about

the interstices in Dylan's life so far, periods when he was attempting to find or retrieve his own voice. The third chapter describes that period around 1969 and 1970 when pressure on him was greatest and his wish to escape from it at its most acute. It reaches a non-climax with the recording of *New Morning*, which was a perfectly decent job of work, neither brilliant nor disastrous. The fourth chapter is concerned with the recording in New Orleans in 1989 of *Oh Mercy*, also a middling performance. Frustration and confusion are palpable there, too: he can't control the recording process; the songs come out sounding very different from what he had intended; he can have anything he wishes, and yet he is uncertain and adrift. The other three chapters, which bracket the work and comprise nearly two-thirds of it, are a very different proposition, because they focus on the period between his arrival in New York City in 1961 and the issuing of his first record just over a year later. Even if Dylan had not been thrust so quickly into a position of unwanted responsibility, and even if his most fecund period—the years 1965 and 1966—had not been an epic blur of such intensity and speed (in both senses of the term) that it was sure to end in some sort of crack-up, the eve of success, a sweet and achingly distant time, might well appear to him a career peak. Everything seemed possible then; no options had been used up and nothing had yet been sacrificed.

What Dylan describes in chapters one, two, and five is his education. For all the structural oddity of *Chronicles*, it is in many ways a very traditional sort of memoir, and nowhere more than in those chapters. We see the young man arrive in the city from the provinces, stumble around chasms and into opportunities, sit at the feet of the mighty, acquire necessary tools and skills, begin to be noticed, find a

home, fall in love, and then we leave him on the eve of success, full of expectancy but serenely unaware of what is about to befall him. The young Dylan makes an appealing nineteenth-century junior hero: crafty but ingenuous, wide-eyed but nobody's fool, an eager sponge for every sort of experience and information. As in the equivalent *Bildungsroman*, we are given a set piece, a soiree at which are gathered all the leading lights of the world he is poised to enter.

The occasion is a going-away party for Cisco Houston, a handsome ("looked like a riverboat gambler, like Errol Flynn") singer of cowboy and lumberjack and railroad songs and friend of Woody Guthrie, so mature and gracious and imposing that he does not let on that he is going off to die of cancer. The party is held in a "Romanesque mansion" on Fifth Avenue, in a top-floor apartment with Victorian furnishings and a roaring fireplace. Pete Seeger is there, and the manager of the Weavers, and Moe Asch (founder of Folkways Records), and Theodore Bikel, and Irwin Silber (editor of *Sing Out!*), and sundry cowboy artists, labor organizers, underground filmmakers, ex-Martha Graham dancers, Off-Broadway actors, and a passel of folk singers of greater and lesser importance. Dylan takes us around the room supplying thumbnail sketches of the cast, like a moving camera focusing briefly and then tracking on. He is able to look hard at them all because he is largely invisible to them, and he can provide details of their biographies because he is somewhat in awe of everyone. If this were a nineteenth-century novel, or its 1930s film adaptation, we might later be treated to a succession of scenes in which the hero conquers, supplants, wins over, or silences all the worthies in the room that night. That isn't necessary here.

Dylan isn't out to gloat or settle scores, for which it is far too late

anyway. On the contrary, he is keen to record his debts and appreciations, an accounting that takes in a wide range of personalities from the entertainment world of the early 1960s, including such unlikely names as Bobby Vee (for whom he briefly played piano when Vee was on his way up and Dylan was unknown), Tiny Tim (with whom he shared stages and meals in the coffeehouse days), Frank Sinatra, Jr. (for whose unenviable career as a shadow he feels tactful sympathy), and Gorgeous George (who fleetingly but memorably offered encouragement when the very young Dylan performed on a makeshift stage in the lobby of the armory in his Minnesota hometown). He knows that it will confuse his more literal-minded fans that he loves the songs of Harold Arlen ("In Harold's songs, I could hear rural blues and folk music"), polkas, Franz Liszt, "Moon River," Neil Sedaka, as much as he admires Thucydides, Clausewitz, Leopardi, Tolstoy, Thaddeus Stevens. He is proud that he has one foot in a vanished world:

> If you were born around this time [1941] or were living and alive, you could feel the old world go and the new one beginning. It was like putting the clock back to when B.C. became A.D. Everybody born around my time was a part of both.

Dylan's preoccupation with the past isn't only an incipient codger's gambol down memory lane. While he caused a big splash in the mid-'60s for his dramatic break with folk tradition as it was then understood, the ways in which he has always kept faith with tradition look arguably more radical today. In an interview, considering younger musicians, he once noted, "They weren't there to see the end

of the traditional people. But I was." Like his contemporaries, he witnessed the reappearance of various blues and country performers—Skip James, Dock Boggs, Son House, Clarence Ashley, among others—who had recorded in the late 1920s and had returned to obscurity when the Depression all but killed the recording of rural music, and who were tracked down by diligent young fans in the early 1960s and enjoyed a few years in the limelight of Northern stages at the sunset of their lives. Those people were embodiments of a past so far removed by technological and societal changes that they might as well have emerged from Civil War graves. While folk music had taken on a new, confrontational stance toward the world by then—a development for which Dylan was partly responsible—involvement in folk music still entailed an active engagement with the past. This meant that young performers, from the scholarly and meticulous New Lost City Ramblers to the slick and broadly popular Kingston Trio, saw themselves as carrying on a set of skills and themes and concerns and melodies and lyrics that had come down at least from the nineteenth century—even from the Middle Ages, with the earlier Child ballads.

The young Dylan believed fervently in the passing of the torch, the laying on of hands—he learned blues chord changes from Lonnie Johnson and Victoria Spivey, visited the paralytic Woody Guthrie in the hospital and played him his own songs (he doesn't mention here a more purely magical transference, when Buddy Holly looked directly at him from the stage of the Duluth Armory, a few days before his death in a plane crash in Clear Lake, Iowa). And while he was never as extreme as the folk purists—who were so involved with the past that they lived there, like Civil War reenactors who become experts

on nineteenth-century underwear—Dylan treated history in a way that was not uncommon then but is sufficiently rare now that some critics of this book have professed their suspicions. In 1961 the past was alive not just in the songs but in the city itself—everybody who played at the Café Bizarre on MacDougal Street knew the place had once been Aaron Burr's livery stable. Dylan tells us he made regular trips to the microfilm room of the New York Public Library, to read newspapers from the 1850s and '60s. "I wasn't so much interested in the issues as intrigued by the language and rhetoric of the times," he writes. But also: "The godawful truth of [the Civil War] would become the all-encompassing template behind everything that I would write."

The songs of the folk-lyric tradition were half truism, half enigma. The key to the latter could perhaps be found in the past.

All of these songs were originally sung by singers who seemed to be groping for words, almost in an alien tongue. I was beginning to feel that maybe the language had something to do with causes and ideals that were tied to the circumstances and blood of what happened over a hundred years ago. . . . All of a sudden, it didn't seem that far back.

Folk songs, no matter how distant or exotic, spoke with bare-bones candor and deployed blunt imagery much more immediate than the froth that came over the radio, telling of "debauched bootleggers, mothers that drowned their own children, Cadillacs that only got five miles to the gallon, floods, union hall fires, darkness and cadavers at the bottom of rivers" For a long time it didn't occur to him

to write his own songs (his first album only contains two, or maybe one-and-a-half: "Song to Woody" and "Talking New York"—the latter is more recitation than song). Few did so then, because the gravity of tradition had been created by the implacable, burning-eyed Anon. and not by tenderfeet from the suburbs. And anyway,

> It's not like you see songs approaching and you invite them in. It's not that easy. You want to write songs that are bigger than life. . . . You have to know and understand something and then go past the vernacular. The chilling precision that these old-timers used in coming up with their songs was no small thing.

When he did start writing, "I rattled off lines and verses based on the stuff I knew—'Cumberland Gap,' 'Fire on the Mountain,' 'Shady Grove,' 'Hard, Ain't It Hard.' I changed words around and added something of my own here and there. . . . You could write twenty or more songs off . . . one melody by slightly altering it. I could slip in verses or lines from old spirituals or blues. That was okay; others did it all the time." That is, in fact, a fairly exact description of the folk-lyric process as it was enacted until about seventy years ago by the fearsome and remote Anon.

Once Dylan got started writing songs, other influences were not slow in coming. There was Red Grooms, his girlfriend's favorite artist:

> He incorporated every living thing into something and made it scream—everything side by side created equal—old tennis shoes, vending machines, alligators that crawled through

sewers.... Brahman bulls, cowgirls, rodeo queens and Mickey
Mouse heads, castle turrets and Mrs. O'Leary's cow, creeps and
greasers and weirdos and grinning, bejeweled nude models....
Subconsciously, I was wondering if it was possible to write
songs like that.

The same girlfriend, Suze Rotolo, worked backstage at a "presenta-
tion of songs" by Kurt Weill and Bertolt Brecht. "I ... was aroused
straight away by the raw intensity of the songs.... They were er-
ratic, unrhythmical and herky-jerky—weird visions.... Every song
seemed to come from some obscure tradition, seemed to have a
pistol in its hip pocket, a club or a brickbat and they came at you in
crutches, braces and wheelchairs." And John Hammond, who signed
Dylan to his first recording contract, was then about to reissue the
neglected songs of the great Delta blues artist Robert Johnson,
whose

> words made my nerves quiver like piano wires. They were so
> elemental in meaning and feeling and gave you so much of the
> inside picture. It's not that you could sort out every moment
> carefully, because you can't. There are too many missing terms
> and too much dual existence.... There's no guarantee that any
> of his lines ... happened, were said, or even imagined.... You
> have to wonder if Johnson was playing for an audience that
> only he could see, one off in the future.

Around the same time, Suze Rotolo introduced him to the works
of Rimbaud. "I came across one of his letters called 'Je est un autre,'

which translates as 'I is somebody else.' When I read those words the bells went off. It made perfect sense. I wished someone would have mentioned that to me earlier." Dylan was now armed.

Of Dylan's many achievements, the most fundamental was his hitching together of the folk-lyric tradition and Western modernism, connecting them at the point where their expressive ambiguities met. The merger was not entirely unprecedented, maybe—there are glimmers in *The Waste Land* of Eliot's St. Louis-bred acquaintance with the world of "Frankie and Johnnie," and Robert Johnson can certainly sound like a modernist, especially, as Dylan suggests, by virtue of how much he omits. But no one had previously planted a firm foot in each and assumed an equivalence between them. Dylan did not do this to prove a point; he was naturally omnivorous, and he intuited the connection without worrying about pedigree. As a songwriter, he knew what played to the ear, and disregarded the fact that such effects don't always work on the page. His primary gambit was to take the blues or ballad form and some of its vocabulary and then expand it, or slash it, or smudge it, or make the literal figurative, or the figurative literal. He could, as in "A Hard Rain's A-Gonna Fall," take the ancient ballad "Lord Randal" and transform it into a Symbolist catalog of apocalyptic images, or he could, as in "From a Buick 6," take Sleepy John Estes's "Milk Cow Blues" and employ it as the frame for a collage of blues-lyric fragments that makes perfect emotional sense even as it resists parsing ("Well, you know I need a steam shovel mama to keep away the dead / I need a dump truck mama to unload my head").

In a revealing interview for a book called *Songwriters on Songwriting*, Dylan talks about the "unconscious frame of mind," the state of suspension he uses to bypass literal thinking:

[I]n the unconscious state of mind, you can pull yourself out
and throw out two rhymes first and work it back. You get the
rhymes first and work it back and then see if you can make
it make sense in another kind of way. You can still stay in the
unconscious frame of mind to pull it off, which is the state of
mind you have to be in anyway.

In other words, his use of rhymes is not unlike a Surrealist game
or an Oulipo exercise, a way to outsmart front-brain thinking, and
the same is true of his employment of folk-lyric readymades. When
Dylan hit mid-career, though, exhaustion and self-consciousness and
the weight of his own reputation pushed him into self-imperson-
ation, and he began to write songs that laboriously strove for effects.
He knows the difference. In the same interview he is asked about a
line from "Slow Train": "But that line. . . is an intellectual line. It's a
line, 'Well, the enemy I see wears a cloak of decency,' that could be a
lie. It could just be. Whereas 'Standing under your yellow railroad,'
that's not a lie." The former makes sense, in a stilted and poetistic
way, while the latter apparently makes no sense, but in context it is
inarguable (he misquotes it slightly): "And now I stand here lookin'
at your yellow railroad / In the ruins of your balcony / Wond'ring
where you are tonight, sweet Marie." The blanket dismissal of a quar-
ter century's work that Dylan offered to David Gates is of course an
overstatement, but it is a gauge of his realization that he had long
mistaken or overlooked his greatest strengths. The ability to hatch
an epigram—the way "To live outside the law you must be honest"
emerges right in the middle of "Absolutely Sweet Marie," between
two lines twisted from Blind Lemon Jefferson's "See That My Grave

Is Kept Clean" and the refrain—is a function of that unconscious frame of mind, that willed trance state, that educated lurching, not of the wish to construct an epigram.

Among the four-fifths of the Basement Tapes material that remains officially unreleased is a song called "I'm Not There (1956)." It is glaringly unfinished—Dylan mumbles unintelligibly through parts of it, and throws together fragments of lyrics apparently at random—and yet it is one of his greatest songs. The hymn-like melody, rising from mournful to exalted, is certainly one reason for this, and another is the perfect accompaniment by three members of the Band, but the very discontinuity of the lyrics, in combination with Dylan's unflagging intensity, creates a powerful, tantalizing indeterminacy that is suddenly if provisionally resolved by every return of the refrain.

> Now when I [*unintelligible*] I was born to love her
> But she knows that the kingdom weighs so high above her
> And I run but I race but it's not too fast or soon [?]
> But I don't perceive her, I'm not there, I'm gone.

The third line is clearly filler; what can be made out of the first probably contains an echo of a Stevie Wonder song played on the radio that same summer; the second, for all that it does not lend itself to reasonable interpretation, rings the bell, and it pulls the previous and succeeding lines along with it into relief and down to the last line, which includes the refrain. Every verse is crowned by one or more such glowing fragments, which materialize, linger briefly, and then vanish, like urgent dispatches transmitted by a spirit medium.

The song evades the intellect to address the emotions through underground passageways of memory and association—biblical, in the case of that second line—and it is a document of the artist in the very midst of the act of creation.

The song gives a sense of how Dylan works when he is tapping his richest vein: the form presents him with a container—a blues basket, a ballad box—which he fills with lines the shapes of which he can discern before he knows their specific content. Such a shape is not simply a measurement determined by meter—it is a ghost outline, maybe a half-heard utterance in which he can make out an emphasis here, a compressed cluster of syllables there, now and again an entire word, which he can use as a dowsing rod for the content. If the shape is not forthcoming, he can fill the space with a folk-lyric readymade. That he has been tapping this vein again is shown by every song on his most recent release, "Love and Theft" (2001). "Bye and Bye," for example, has a melody derived from "Blue Moon" ("You could write twenty or more songs off... one melody by slightly altering it"); its final verse is:

Papa gone mad, mamma, she's feeling sad
I'm gonna baptize you in fire so you can sin no more
I'm gonna establish my rule through civil war
Gonna make you see just how loyal and true a man can be.

The first and last lines are brazenly drawn from the common well, while the middle lines had to have been dispatched straight from the unconscious. The song's atmosphere is breezy and menacing; the first and last lines of each verse supply the breeziness, the mid-

dle two the menace. The printed lyrics do not, of course, account for Dylan's vocal performance, which, of a piece with the white suits and riverboat-gambler hats he has been affecting lately, renders un-cannily credible the grandiose rhetoric of the middle lines; nor do they convey the insouciant creepiness of Augie Meyers's roller-rink organ. Treating Dylan as merely a writer is like judging a movie on its screenplay alone.

Blood on the Tracks (1974) is cited by many as their favorite Dylan record—Rick Moody calls it "the truest, most honest account of a love affair from tip to stern ever put down on magnetic tape." It is, to be sure, quite an achievement, with a wealth of lived experience in its dense, intricately plotted songs. And yet, in comparison to the songs on *Blonde on Blonde* or *The Basement Tapes*—which are genuine, sphinx-like, irreducible, hard-shell poems whether or not the words can ever be usefully divorced from the music—such numbers as "Tangled Up in Blue" and "Idiot Wind" are prose. They are driven by their narratives, and their imagery is determined by its function.

> I ran into the fortune-teller, who said beware of lightning that might strike
> I haven't known peace and quiet for so long I can't remember what it's like
> There's a lone soldier on the cross, smoke pourin' out of a boxcar door
> You didn't know it, you didn't think it could be done, in the final end he won the wars
> After losin' every battle.

The smoke issuing from the boxcar door, which is there only to fill out the line and supply an end-rhyme, does come out of nowhere, but everything else seems cooked—the palmist is from central casting and her warning is generic; the soldier on the cross is on loan from an anti-war poster (he seems to be wearing a gas mask); the connecting lines are rhetorical and flat; it could, after all, be a lie. This is not to say that the song is bad, merely purpose-driven, with every verse hastening us along to the point, which is "We're idiots, babe / It's a wonder we can even feed ourselves." And that, in turn, is a great line from a note left on a pillow at dawn. Nothing on *Blood on the Tracks* hobbles in on crutches or speaks to the future or appears on the wall in letters of fire. It is a brilliant account of the vicissitudes of a love affair, an exemplary specimen of the confessional culture of the period, a remarkable work of emotional intelligence. It is so many people's favorite Dylan album in large part because it is the one that people can imagine themselves creating, were the muse to tap them on the forehead with a nine-pound hammer.

But who, on the other hand, could imagine coming up with "John Wesley Harding / Was a friend to the poor / He trav'led with a gun in ev'ry hand"? The outlaw looks like Shiva, a brace of guns in a brace of hands, the apotheosis of Western legend by way of an apparent awkwardness of syntax, and the impression endures even if we know that Dylan lifted those five words from Woody Guthrie's "Ludlow Massacre," in which the striking miners' women sell their potatoes and with the proceeds "put a gun in every hand." It takes an unusual mind to pick that unremarkable scrap from Guthrie's pocket and paste it athwart a completely different sort of genre piece, like Kurt Schwitters inserting a bus ticket into a

landscape.[1] Dylan drives critics mad, because while his vast range
of sources can be endlessly itemized and dissected, the ways in
which he puts things together teases rational explication before
finally betraying it. (Stephen Crane quoted by Berryman: "An art-
ist, I think, is nothing but a powerful memory that can move itself
through certain experiences sideways and every artist must be in
some things powerless as a dead snake.")

You can find almost anything in Dylan's lyrics, employ them as
balm for heartbreak or call to riot, engage in bibliomancy by sticking
a knife between the pages of *Lyrics* and divining fortune from the
line the tip has come to rest upon. You can find Dylan's rhythms
and word choices and as it were his fingerprints in literature that
predates him. Michael Gray, who is probably Dylan's single most
assiduous critic, turns up a quatrain by Robert Browning that the
mind's ear has no trouble hearing in Dylan's voice, and not only be-
cause the end-rhymes prefigure "Subterranean Homesick Blues":

> Look, two and two go the priests, then the monks with cowls
> and sandals
> And the penitents dressed in white shirts, a-holding the yellow
> candles
> One, he carries a flag up straight, and another a cross with
> handles,

[1]It is possible that the disguised quote, coming right after "was a friend to the
poor," combines with it to form a subliminal image of popular insurgency. The
album came out early in 1968, after all, and the most memorable and hotly
debated critical line concerning it has always been Jon Landau's contention
that, although it takes place entirely within the folk-lyric universe, it "manifests
a profound awareness of the war and how it is affecting all of us."

And the Duke's guard brings up the rear, for the better
prevention of scandals.

Dylan himself, in the *Songwriters* interview, cites a Byron couplet
that is equally convincing: "What is it you buy so dear / With your
pain and with your fear?" But then, as he told Robert Hilburn of the
Los Angeles Times, "It's like a ghost is writing [the] song. . . . It gives
you the song and it goes away. You don't know what it means. Except
the ghost picked me to write the song."

Dylan is a mystery, as he has been since his first record, made when
he was twenty, established his eerie prerogative to inhabit songs writ-
ten long before his birth by people with lifetimes of bitter experience.
The mystery has endured ever since, through fallow as well as fecund
periods, through miscellaneous errors and embarrassments and
other demonstrations of common humanity as well as unbelievable
runs of consecutive masterpieces. It has survived through candid and
guarded and put-on interviews, various appearances on film, and the
roughly two hundred concert appearances he has put in every year
for the last couple of decades. It is if anything enhanced by Dylan's
most astute critics (Greil Marcus, Sean Wilentz, Christopher Ricks,
Michael Gray) and untouched by the legions of nit-collectors and
communicants in the church of whangdoodle who unstoppably issue
treatises and skeleton keys. It will survive his disarmingly unaffected
memoir, too. The playwright Sam Shepard noted after observing
Dylan for months during the 1974 Rolling Thunder tour that

If a mystery is solved, the case is dropped. In this case, in the
case of Dylan, the mystery is never solved, so the case keeps on.

It keeps coming up again. Over and over the years. Who is this character anyway?

Dylan is a complex, mercurial human being of astounding gifts, whose purposes are usually ambiguous, frequently elusive, and sometimes downright unguessable. At the same time he is a sort of communicating vessel, open to currents that run up and down the ages quite outside the confines of the popular culture of any given period. That he is able to tune his radio to those long waves in a time of increasingly short memories and ever more rapid fashion cycles is not the least of his achievements.

Chronicles, which would appear to have been printed without editorial intervention,[2] is so fluid in its prose and alive in its observations that Dylan looks like a natural at the book game, although his previous experience was not so happy. *Tarantula* was the result of a much-trumpeted contract for a novel that Dylan signed with Macmillan in 1966. The book was not published until 1970, having in the meantime been bootlegged in several different versions. Nearly everyone was disappointed in the final product, which arrived behind the prow of a carefully hedged and rather condescending preface by its editor, Bob Markel. Ever since, the phrase "famously unreadable" has been attached to it, and persons who have wished to demonstrate that Dylan's vaunted verbal mastery was just so much hype have used it as a handy chair-leg with which to beat its author. It is, in fact, a mess, but it's a fascinat-

[2] This guess is based primarily on the fact that it doesn't seem to have been proofread, to judge by the presence of misspellings and inconsistencies in proper nouns, which a spell-checking program does not catch.

ing mess—it's what Dylan's automatic writing looks like when it doesn't have formal containers to shape it. The population of Dylan's world (Homer the Slut, Popeye Squirm, "Phil, who has now turned into an inexpensive Protestant ambassador from Nebraska & who speaks with a marvelous accent," etc.) hurtles hectically through a landscape of tanktowns and drunk tanks, all of the action telegraphically alluded to, at best, as if the book were a compilation of gossip columns from whatever newspaper Smokey Stover subscribed to. Although it is easily more entertaining than any of the automatic productions of the Parisian Surrealist crowd, it only clicks at odd intervals, when Dylan briefly finds a model for parody, such as the interspersed letters, which have something of Ring Lardner about them:

> cant you figure out all this commie business for yourself? you
> know, like how long can car thieves terrify the nation? gotta go.
> there's a fire engine chasing me. see you when i get my degree.
> i'm going crazy without you. cant see enough movies
>
> > your crippled lover,
> > benjamin turtle

Its one moment of transcendence is the only thing in the book that could have been a song, an ode to Aretha Franklin:

> aretha—known in gallup as number 69—in wheeling as the
> cat's in heat—in pittsburgh as number 5—in brownsville as
> the left road, the lonesome sound—in atlanta as dont dance,
> listen—in bowling green as oh no, no, not again—she's known

as horse chick up in cheyenne—in new york city she's known
as just plain aretha. . . i shall play her as my trump card

Here he's hit on a pair of riffs—the urban-hotspot shout-out of
'60s soul anthems such as Martha and the Vandellas' "Dancing in
the Street" and the shifting-name trope familiar from both cowboy
movies and doo-wop (e.g. the Cadillacs' "You know they often call
me Speedo but my real name is Mister Earl")—that he can set to
play off each other, arriving at a propulsive litany.

Chronicles works so well in part because in writing it he apparently
found a formal model to adhere to or violate at will, and if he did
not have in mind any specific nineteenth-century account of callow-
ness and ambition, maybe he conjured up a cumulative memory of
dusty volumes found on friends' bookshelves in Greenwich Village
or in the basement of the bookshop in Dinkytown he worked in
as a student. He also found an outlet for his inclination to counter
his audience's expectations. Readers, guessing on the basis of inter-
views and movies as well as the hydra-headed mythic image that
has grown around Dylan over the decades, might have expected
his memoir to be variously inscrutable, gnomic, bilious, confused,
preening, recriminatory, impersonal, defensive, perfunctory, smug,
or even ghost-written. Instead Dylan had to outflank them by exer-
cising candor, warmth, diligence, humor, and vulnerability. If there is
ever a second volume, he may have to contradict himself yet again.

2004

I THOUGHT I HEARD
BUDDY BOLDEN SAY

The Union Sons Hall stood at 1319 Perdido Street, between Liberty and Franklin, in the area of New Orleans known in the late nineteenth and early twentieth centuries as Back o' Town, which was among other things the unofficial black prostitution district, as distinct from the official white one, Storyville, a few blocks away. The hall was built sometime after 1866, when several "free persons of color" formed the United Sons Relief Organization of Louisiana and bought a double-lot parcel for its headquarters. The only known photograph of the place was taken in the 1930s, a decade or so after it had become the Greater St. Matthew Baptist Church, and by then it certainly looked like a church—although this being New Orleans it is not impossible that it always had a steeple and Gothic arched windows. Anyway, it was a church on Sunday mornings for much of its existence, originally leased to the First Lincoln Baptist Church for that purpose. On Saturday nights it was rented for dances which lasted until early light, so that the

deacons must have put in a hard few hours every week washing up spilled beer and airing out the joint before services. At night it was known as one of the rougher spots in a rough area. It was razed in the late 1950s, along with most of the immediate neighborhood, its site now lost somewhere under the vastness of the Louisiana State Office Building.

It is remembered solely because of those dances, and primarily because some of them featured Buddy Bolden and his band. Jazz is too large and fluid a category of music to have had a single eureka moment of origin, but just about everybody agrees that no nameable person was more important to the creation of jazz than Buddy Bolden. He was a cornet player, born in 1877, and he got his first band together sometime around 1895. He was known for playing loud—stories of how far his horn could be heard sound like tall tales, but are so numerous there must be something to them—and for playing loose and rowdy. He was by all accounts the first major New Orleans musician to make a virtue of not being able to read a score. You can begin to get an idea of how distinctive his band was from looking at photographs. The traditional brass bands of the era wore military-style uniforms, complete with peaked caps, as their parade-band successors do to this day. The getups proclaim unison and discipline, even if the New Orleans version allowed for more latitude than was the rule among the oompah outfits active in every American village of the time. The orchestras—the term was then applied to non-marching musical agglomerations of virtually any size or composition—dressed in mufti, but their sedate poses attest to rigor and sobriety. The John Robichaux Orchestra may have had a big drum, as shown in an 1896 portrait, but its legendarily

virtuosic members look as serious as divinity students, and by all accounts they played as sweetly.

Buddy Bolden's band, on the other hand, is clearly a *band*, in the sense in which we use the word today. In the only extant photograph, circa 1905, each member has chosen his own stance, with no attempt at homogenization. They all rode in on different trolleys, the picture says, but up on the stage they talk to each other as much as to the audience. Drummer Cornelius Tillman is unaccountably absent. Shy Jimmy Johnson disappears into his bull fiddle. B-flat clarinetist Frank Lewis sits gaunt and upright as a picket. Willie Warner holds his C-clarinet with the kind of delicacy you sometimes see in men with massive hands. Jefferson "Brock" Mumford, the guitarist, looks a bit like circa-1960 Muddy Waters and a bit like he just woke up fully dressed and out of sorts. Willie Cornish shows you his valve trombone as if you had challenged his possession of it. Buddy Bolden rests his weight on his left leg, holds his little horn balanced on one palm, shoulder slumping a bit, and allows a faint smile to take hold of his face. You could cut him out of the frame and set him down outside the Three Deuces in 1946, alongside Bird and Diz, and then the smile and the posture would plainly say "reefer." You could cut him out of the frame and set him down on the sidewalk outside right now, and passing him by you would think, "significant character, and he knows it, too," and spend the rest of the day trying to attach a name to the face.

You can't hear the Bolden band, of course. They may actually have cut a cylinder recording around 1898, but the beeswax surfaces of

the time were good for maybe a dozen plays, so it's not surprising that no copy has ever been found. And then Bolden suddenly and dramatically left the picture. In March 1906, he began complaining of severe headaches, and one day, persuaded that his mother-in-law was trying to poison him, he hit her on the head with a water pitcher. It was the only time in his life that he made the newspapers. His behavior became more erratic, he lost control of his own band, and then he dropped out of that year's Labor Day parade in mid-route—no small matter since the parade was an occasion for strutting that involved nearly every musician in the city.

Not long thereafter his family had him committed for dementia. His induction papers cite alcohol poisoning, although modern scholars suggest meningitis. He remained incarcerated and incommunicado in the State Insane Asylum at Jackson until his death in 1931, aged fifty-four. He missed the leap of the New Orleans sound to Chicago and beyond, the rise of Louis Armstrong (who, born in 1901, may have remembered hearing Bolden play when he was five), the massive popularity of hot jazz that finally allowed acquaintances and semi-contemporaries such as Freddie Keppard and Bunk Johnson to record, however fleetingly and belatedly. His name became known outside Louisiana only when white researchers from the North began knocking on doors in the late 1930s. He achieved worldwide fame as a ghost.

But let's get back to the Union Sons Hall. It's a Saturday night in July 1902, and the temperature is in the lower nineties, with eighty-three percent humidity. The hall is an open room maybe twenty by fifty feet, with no furniture besides a table for the ticket-taker

and long benches lining the walls, and no decor besides some old bits of bunting. There's a small raised stage at one end, with a few chairs and maybe Tillman's drums. People start trickling in around nine, teamsters and plasterers and laundresses and stevedores and domestic servants and barbers and sailors and cooks. Some pimps and prostitutes are in the company along with a number of persons of no account, bearing names that will be preserved only as marginalia in the police records: Grand Jury, Cinderella, Pudding Man, Hit 'Em Quick, Ratty Kate, Lead Pencil, Two Rooms and a Kitchen. Someone is selling glasses of beer from a keg in the corner, but many have brought stronger stuff in pint bottles. Within half an hour the room is already fetid with cigar smoke. As more and more people crowd in, the heat rises, and the air circulation slows to an ooze, and the air gradually becomes a solid, a wall composed of smoke and sweat and beer and rice powder and Florida water and bay rum and musk and farts.

By that time the band has been playing for a while. They have walked in through the crowd, carrying their instruments, jumped onstage and fallen to without fuss or fanfare. All of them are seated except Johnson behind his bass, but they stand to take solos, and then the footlights reflected by tin disks make them look distended and not quite real. They have begun, per tradition, with the sugary stuff, "Sweet Adeline" and "A Bird in a Gilded Cage." To our ears they're playing these chestnuts pretty straight, with none of your cubist reconfiguration of the standards—that will come a couple of decades later, with Satchmo—but the tunes are dense with embellishments and arabesques, and when Bolden plays you hear

not so much the perfection of technique as the full range of the human voice. After a while they start to want to rag it, so Bolden calls out his transition number, "Don't Go 'Way Nobody," and then they throw down with "My Bucket's Got a Hole in It," which maybe Buddy wrote. By now they are powerfully loud, and the inside temperature is unbearable, and the people on the floor are doing the Shimmy and the Ping Pong and the Grizzly Bear, shouting and stomping, losing articles of clothing, some of them dropping down cold along the wall.

But the band needs air. They need to fill their lungs to blow, and the air is a yellow soup. So Bolden stands up, slices laterally with his hand, and the music stops, abruptly, right in the middle of "All the Whores Like the Way I Ride." Then he stomps hard once, twice, three times to get the crowd's attention. "For God's sake open up a window!" he bellows. "And take that funky butt away!" The crowd laughs. People look around to see who the goat is or to shift blame away from themselves, as somebody with a pole topped with a brass hook finally pivots open the tall windows. Everybody knows that this will mean noise complaints and then probably a police raid, but nobody leaves. Finally Bolden blows his signature call, and the machine starts up again. Afterward, people straggling home keep hooting, "Take that funky butt away!" For days they shout it in the streets when they're drunk, or they approach their friends very seriously, then let loose: "Take that funky butt away!" Various Chesters and Lesters become "Funky Butt" for a week or a month, or for the rest of their natural lives. And then the hall, which everybody calls Kinney's, after the head of the Union Sons, starts being referred to

as Funky Butt Hall, and the name sticks.

A week later the Bolden band is playing a dance at the Odd Fellows and Masonic Hall, a couple of blocks down on Perdido and South Rampart. In the second part of the set, right after "Mama's Got a Baby Called Tee-Na-Na," Willie Cornish stands up and starts singing: "I thought I heard Buddy Bolden say / Funky butt, funky butt, take it away. . ." There is a silence from the crowd, and then pandemonium. People can't believe what they're hearing. And the song is more than a joke. It's a fully worked-out rag, immediately memorable on its own merits, while the words are a banner headline. If there were records available, and people owned record players, storekeepers would not be able to keep copies on their shelves. Soon dockworkers are singing it, and well-dressed young people are whistling it, and barbers are humming it, and drunks are caterwauling it. The tune is annexed by comedians and political campaigners and cabaret singers; versions are filthy, idle, topical. It long goes unrecorded on paper, since even its title is unprintable, until a ragtime publisher copyrights a wordless piano arrangement entitled, for some reason, "St. Louis Tickle."

For anyone who spent time at the dances and parades of black New Orleans at the beginning of the century, the song will remain Bolden's monument, his living memory for decades after he is first locked up and then dead. Bolden wrote other songs, some of them maybe more famous than he ever was, but "Funky Butt" is not merely his song; in alchemical fashion it has become the man himself. But no version of the lyrics was set down until an entire

generation and then some had gone by.

Jelly Roll Morton, the Ancient Mariner of New Orleans jazz, finally recorded it three times in 1938 and 1939, once with the all-star New Orleans Jazzmen (including Sidney Bechet, Sidney de Paris, Albert Nicholas, Wellman Braud, and Zutty Singleton) and twice solo, accompanying himself on piano. The first of the solo recordings was made at the Library of Congress, where Morton spent three weeks reminiscing, orating, quoting, and singing for Alan Lomax's disc recorder, laying down songs and versions of songs so lavishly obscene they were not released commercially until 1993. Morton copyrighted the song in his own name the next year, but for Lomax's recorder he paid tribute to Bolden—"the most powerful trumpet player I've ever heard, or ever was known." This was around the same time that Bunk Johnson was telling jazz researchers William Russell and Stephen Smith that he had played with Bolden (he had to fiddle with the dates a bit to make his case), and five years after E. Belfield Spriggins published, in the *Louisiana Weekly*, the very first serious article on jazz ever printed in the state, in the course of which he gave Willie Cornish's version of the origin of "Funky Butt":

> It seems that one night while playing at Odd Fellows Hall, Perdido near Rampart, it became very hot and stuffy and a discussion among members of Bolden's band arose about the foul air. The next day William Cornish, the trombonist with the band, composed a "tune" to be played by the band. The real words are unprintable but these will answer: "I thought I heard Old Bolden say / Rotten gut, rotten gut / Take it away."

Very little else has ever surfaced about the song or its origin. Russell and Smith's assertion that the number was "inspired by some 'low-life' women who worked on a boat with the band" may have been concocted by Bunk Johnson. Morton remains the only person to have recorded the song who had heard it played by Bolden's band. All three of his versions are consistent in lyrics and tempo—most contemporaries agreed that they are far too slow. There are reminiscences galore of the song's scatological variant lyrics, but none ever seem to have been published, and Morton's version, in a series of recordings notable for containing probably the most uses of the word "fuck" prior to 1987 or so, is remarkably chaste. Besides the main verse, which is all most people know—funky butt, take it away, open up the window, let the bad air out—there is a second one in Morton's published version and on his second solo recording, about Judge Fogarty sentencing somebody to thirty days' sweeping out the market (a frequent punishment for minor infractions then), and something about Frankie Dusen (a trombone player who took over Bolden's band when he became incapacitated) demanding his money. Edmond "Doc" Souchon, a local musician, recalled a version from his childhood: "Ain't that man got a funny walk / Doin' the Ping Pong round Southern Park / Black man, white man, take him away / I thought I heard them say." Bolden's biographer, Donald Marquis, suggests that the tune predated Bolden, that it was carried down the river, and he cites as corroboration words that do sound older than 1902:

I thought I heer'd Abe Lincoln shout,
Rebels close down them plantations and let the niggers out.

I'm positively sure I heer'd Mr. Lincoln shout.
I thought I heer'd Mr. Lincoln say,
Rebels close down them plantations and let all them
 niggers out.
You gonna lose this war, get on your knees and pray,
That's the words I heer'd Mr. Lincoln say.

Jelly Roll Morton's recordings, for all their testamentary aspect and intent, can actually be seen as marking the start of a second life for one aspect of the song. Although "funk" is a versatile word, with secondary denotations of fear and depression and minor thievery, the phrase "funky butt" would have clearly signified an odiferous posterior for at least a century before Bolden used the phrase, and in context it can still be so interpreted. In the glossary of hepcat jive that Mezz Mezzrow inserted at the end of his memoir, *Really the Blues* (1946), "funk" is defined as "stench," and "funky" as "smelly, obnoxious." In less than a decade, though, the meaning of the word had begun to turn, at least in jazz circles, particularly on the West Coast. The scat singer King Pleasure, backed by Quincy Jones, put out a record called *Funk Junction* in 1954, and 1957 saw the issue of *Creme de Funk* by Phil Woods and Gene Quill, and of *Funky* by Gene Ammons's All-Stars. In 1958 John Clellon Holmes employed "funk" in a strictly musical sense in his novel *The Horn*, and not much later the word was applied favorably to a performance by Miles Davis. By 1964 even the *New York Times* was throwing it around.

"Funk" was in general currency by the early 1960s as a musical term signifying some combination of authenticity, earthiness, greasiness,

muscularity, perspiration, and the presence of one or more of the following: fuzz-tone bass, hoarse cries produced by the tenor sax, a bottom-heavy drum style, and a particularly dirty sound obtainable on the Hammond organ. Another turning point came in 1966, when Arlester Christian wrote, and recorded with his band Dyke and the Blazers, the epochal "Funky Broadway," which was made into a huge hit by Wilson Pickett the following year. The way "funky" was employed in the lyrics did not refer to music, but it retained many of the meanings associated with musical use: authenticity, earthiness, greasiness, etc. All of these dovetailed with and enlarged usefully upon the word's original olfactory denotation, giving the word a room and a new suit without actually rehabilitating it. From there it was a short step to Arthur Conley's "Funky Street" (1968), Rufus Thomas's "Funky Chicken" (1970), Toots and the Maytals' "Funky Kingston" (1973), and "Funky Nassau" (1973) by The Beginning of the End. James Brown virtually bought the franchise, from "Funk Bomb" (1967) through "Ain't It Funky," "Make It Funky," "Funky Side of Town," "Funky President," "Funky Drummer," and scads more from all quadrants of meaning by a man who spent a year or two calling himself Minister of the New New Super Heavy Funk. He had no peers atop the funk pyramid, at least until George Clinton (of Funkadelic) concocted something like a theology of funk. (One of my proudest possessions is a T-shirt I can't fit into anymore that is emblazoned with the legend "Take Funk to Heaven in 77.") Clinton, in full evangelical feather, instituted a principle of spiritual surrender he termed "Giving up the Funk." This was *mana*, total communion with the life force manifested as a fried fish.

"Funk" has since climbed down from those heights. It has been devalued by George Michael's "Too Funky" and the Eagles' "Funky New Year" and "Funky Funky Xmas" by the New Kids on the Block, not to speak of the lingering memory of Grand Funk Railroad. But the word has not been shucked. It is still too valuable. It appears in hip-hop strictly as a place-marker (the Notorious B.I.G.'s "Machine Gun Funk," Too Short's "Short but Funky," OutKast's "Funky Ride," etc.), but it is a place-marker that will not go away soon. Payments are kept up on the word. Its license is renewed. The day will come before long when it is immediately necessary once again, when all of its putative substitutes have been tarnished and made risible, when "ghetto" has been redeveloped and "real" become irredeemably fake—when it will have acquired a previously undreamed-of nuance temporarily undetectable by the white middle-class ear. It awaits a further development of the process set in motion on the rickety stage of some fraternal hall in uptown New Orleans in the year 1902 or thereabouts. It permanently embodies the voice of Buddy Bolden, speaking through a cloud.

2004

THE INVENTION OF THE BLUES

1.

The blues, a form of music that seems as ancient as the emotions it conveys, is actually not much more than a hundred years old. Sometime in the mists of the late 1890s, somewhere in the South, some unknown singer first settled on the now-familiar three-line verse, with its AAB rhyme scheme and its line length of five stressed syllables.

> Hitch up my pony, saddle up my black mare,
> Hitch up my pony, saddle up my black mare,
> I'm gonna find a rider, baby, in the world somewhere.
>
> (Charley Patton, "Pony Blues")

Although the term "blues" came to be applied to any minor-key lament—in the 1920s and '30s to almost any kind of song—the

authentic blues songs are those that hew to this structure. While the sentiments, chord progressions, vocal and instrumental styles that came to distinguish the blues were all lying at hand in the black musical culture of the South, the form itself is just too specific not to have had a very particular origin. All we know of this origin is the result of a process of elimination. For one thing, the folk-song collectors who were already assiduously combing the country in the last quarter of the nineteenth century did not gather any works fitting the blues pattern until after 1900. Even more telling are the accounts of primary encounters with the blues left by black musicians who went on to become so identified with the music as to be credited with inventing it.

In 1903, W. C. Handy, dozing in the depot in Tutwiler, Mississippi, while waiting for a train that was nine hours late, was awakened by a ragged black man playing "the weirdest music I had ever heard," fretting his guitar with a knife to produce an eerie, sliding wail, and singing about "goin' where the Southern cross the Dog"—that is, matter-of-factly describing his impending trip to Moorhead, Mississippi, where the tracks of the Southern Railway cross those of the Yazoo line, also known as the Yellow Dog. A year earlier Ma Rainey was working a tent show in Missouri when "a girl from town" turned up to sing a "strange and poignant" song that galvanized the audience. When asked what kind of song it was, she said, "It's the Blues." Around the same time or a bit earlier Jelly Roll Morton, in New Orleans, heard a piano player and sometime prostitute named Mamie Desdoumes sing a lament that may have been a blues:

I stood on the corner, my feet was dripping wet,

I asked every man I met . . .
Can't you give me a dollar, give me a lousy dime,
Just to feed that hungry man of mine . . .

The earliest published description of what appears to be blues dates from 1903, from an account in *The Journal of American Folk-Lore* by the Harvard archeologist Charles Peabody, who transcribed many of the songs sung by the laborers he employed on an excavation in Coahoma County, Mississippi, in 1901. The folklorist Howard Odum, meanwhile, published field collections of songs sung by black country people in Georgia and Mississippi between 1905 and 1908, and these include quite a few that qualify as blues.

So often depicted as having seamlessly evolved from field hollers and beyond that from griot songs, the blues was actually a sudden and radical turn in African-American music. This is not to say that it materialized in a vacuum. Numerous strains of black folk music were current in the nineteenth century, from field hollers and ring chants to ballads and breakdowns, each leaving some mark on the blues, in lyrics or instrumentation, and many of them were carried on in the twentieth century alongside the blues, by the same musicians. Even "the blues," the term itself, was not unique to the blues. It may have derived from an Elizabethan term for depression, "the blue devils," and as a musical designation it existed at least as early as 1892, when Handy first heard "shabby guitarists" in St. Louis singing the song he baptized "East St. Louis Blues"—not a blues in structure but a proto-blues by virtue of its theme and chords, and one that, to add to the confusion, was subsequently recorded dozens of times over the years under nearly as many names: "Crow Jane," "Sliding Delta," "One

Dime Blues," "Red River Blues," "Jim Lee Blues."

Residing in the same itinerant songster's bag a century ago might be such equally anonymous foundation stones of American popular music as "Hesitation Blues" (also not actually a blues), "Alabama Bound" (also known under a dozen or more names), "Salty Dog," "C.C. Rider," "Stavin' Chain," "Boll Weevil," "Spoonful," "Careless Love," "Frankie and Albert," "Stagger Lee," "Poor Boy Long Ways from Home," "Gang of Brownskin Women," "My Bucket's Got a Hole in It," and "Make Me a Pallet on Your Floor." The origins of nearly all of these are lost to history (although "Stagger Lee" can be traced to an incident that occurred in Memphis in 1890 or thereabouts). These songs were carried from place to place by numerous hands, and accordingly altered, extended, abridged, and transposed, but each of them was also written by one or two people at a specific time and place.

Certain old popular songs have so infiltrated the collective unconscious that it may seem as if they were never actually composed, but rather that they mysteriously *occurred*, the way jokes and proverbs can seem as if they had fallen from the sky. The oldest and most durable elements of popular culture defy our notion of authorship, somehow suggesting a prehuman origin. There are, of course, true examples of collective creation, as when melody and lyrics come hurtling at each other from different directions, maybe different traditions, and join through some mysterious agency that resembles destiny. And there are also works, even in our own time, which despite possessing a known author and point of origin are so altered by a succession of interpreters as to exist almost in fluid form, as a constantly changing entity.

But there are also songs whose creation took place in the darkness of poverty and segregation and illiteracy, especially in the time before recordings, and whose authorship is attributed to "Trad." by default. This is so much the case with black music before 1920 that the exceptions are startling. The early history of jazz may be better documented than that of the blues or its analogues, but it is no less surprising to come upon such definite and exact statements of origin as Sterling Brown's assertion that the elemental "Shimmy She Wobble" was written by Professor Spencer Williams to celebrate the entertainments of Lulu White's bordello in New Orleans, or E. Simms Campbell's claim that "Tarara Boom Dee-ay" was composed in Babe Connors's house in 1894.

The origin of the blues occurred close to our time, within a historical corridor that makes it possible to place it among the early manifestations of modernism—between the automobile and the airplane, and not long after the movies, radio transmission, and cylinder recordings—but also in an inaccessible back street of history, so that we don't know who or when or how or why, just that it happened. Whoever first made up a blues assembled a number of elements at large in the black musical culture of the time, from the flatted intervals to the instrumental accompaniment to bits and pieces of lyrics, and put them together in a way that was not only new, but immediately reproducible as a form. It had the flexibility to yield itself to various kinds of originality, but the strength to remain itself in the process. The blues is at once a musical category as capacious as jazz or rock and roll, and a form as circumscribed as the tango or the samba. The former aspect may suggest a gradual evolution over time and by many hands, but the latter pins it down to a particular

occurrence. As Samuel Charters, whose *The Country Blues* (1959) was the first book on the subject, later wrote:"It is always important to emphasize. . . that there was no sociological or historical reason for the blues verse to take the form it did. Someone sang the first blues." Of this inventor's identity we possess not a whisper, not a hint, and we likewise have no idea whether the blues was initially rural or urban, or in what Southern state it originated. No recording of a genuine blues was made until Mamie's Smith's "The Crazy Blues" was waxed in 1920, by which time the music had spread to every hamlet in the South (and extensive recorded documentation had been made of, say, the polka). By the time it occurred to anyone to ask the question, the trail was cold.

There are many reasons why it was. Not only were the early blues musicians often illiterate, they were also mobile, and unpredictable in their traveling patterns. And they were generally disreputable, the places where they played unsavory—jazz may have emerged from the brothels of New Orleans, but its brasses and pianos lent it the kind of institutional gravity that mere guitarists could not achieve. The blues was fleeting, transient, if not actually furtive. Blues musicians were also fiercely competitive, and loath to acknowledge influence. The very success of the invention must also have militated against anyone knowing who was responsible. Even if a front-porch guitarist was responsible, rather than an itinerant songster, it is easy to imagine that within twenty-four hours a dozen people had taken up the style, a hundred inside of a week, a thousand in the first month. By then only ten people would have remembered who came up with it, and nine of them weren't talking. And then, too, the first researchers with an interest in the origins of the blues did not especially concern

themselves with authorship.

John A. Lomax and his son Alan were not the first song collectors to travel through the South with recording equipment, but they were without any doubt the most influential. Starting out in 1933, when Alan Lomax was seventeen, they recorded a breathtaking variety of work songs, game songs, barrelhouse songs, field hollers, ballads, reels, and blues, working under the auspices of the Library of Congress, which not only preserved those works but lent its formidable sanction to the idea that American music was at least as much black as it was white. The Lomaxes, Texans, were at ease with both races, and thus they were able, often but not always, to talk their way into prison farms, plantations, and the like, institutions that extended the premises of slavery and kept their black inmates isolated and unheard. Their work started not a moment too soon, because the 1930s was the very last time when there would be a significant body of folk music at large that had developed without the influence of radio, recordings, and sound films. They were thus able to corral numerous specimens of vanishing breeds, such as black country musicians who employed banjos, fiddles, and accordions, and played a kind of music that for most of the twentieth century would be exclusively identified with whites.

Many of the artists the Lomaxes recorded were farmers or prisoners or road-gang workers or migratory street-corner entertainers, and the recordings constitute all that is known about them. But the Lomaxes recognized a major artist when they heard one, and they brought a number of them to light, beginning with Huddie Ledbetter, aka Leadbelly, whom they first met in 1934, when he was an inmate of the Louisiana State Penitentiary at Angola, do-

ing six to ten for assault with intent to kill. Leadbelly had a penetrating voice, played driving twelve-string guitar, and possessed a huge repertoire that covered nearly every aspect of black popular music. He was, as he later came to be called, a "people's jukebox," and along with his memory for the songs, he commanded the lore that went with them and the context in which to situate them—he was a folklorist's dream. But he could also draw upon the tradition for songs of his own, and after his release from prison was able to parlay his performing skills into a commercial career with increasing success until his death in 1949. Leadbelly was not an innovator, but he was a particularly protean songster, which is to say, just the sort of major artist the Lomaxes sought and were equipped to appreciate. He was not a bluesman, either, although he had various blues in his repertoire, having spent time in Dallas in the 1920s playing with the blues pioneer Blind Lemon Jefferson. Leadbelly was, in other words, a folk musician—one who gathered, extended, and disseminated songs from a living tradition.

But could the blues truly be said to be folk music? The Lomaxes simply assumed that it was, and proceeded with their researches accordingly. Alan Lomax's book *The Land Where the Blues Began* exemplifies this assumption. For Lomax the blues is primarily a collective expression, with a core of African music that has been bent and shaped by the pain of slavery, of peonage, of prison, of Jim Crow. This account is not untrue, of course, but it has an obvious limitation. As Samuel Charters writes, "It is always difficult to resist the temptation to continue to look for social influences instead of the individual performer behind the development of the blues."

If the blues materialized so recently, suddenly, and specifically, it

seems at best sentimental to attribute it broadly to "the people." For Stephen Calt and Gayle Dean Wardlow, the contentious biographers of the radical blues innovator Charley Patton, the notion of a "blues tradition" is an affront. The Mississippi Delta blues, they point out, lasted as a vital form for less than sixty years, hardly long enough for a tradition to develop. Furthermore, "The rejection of blues by what former jukehouse owner Elizabeth Moore termed 'good people' ... illustrates that blues had no standing as 'folk music,' unless one takes the position that respectable blacks formed a socially deviant element of black society during the blues era." Part of the confusion, they suggest, derives from the fact that there is in the blues a great deal of collective material, especially in the lyrics—phrases and couplets and entire verses that migrate from song to song, sometimes without obvious relevance to the balance of the lyrics, sometimes indeed deriving from pre-blues sources: the great body of ambient tropes known collectively as the folk-lyric. This is in fact an element of oral tradition, but this aspect of the blues leads to a false syllogism:

Blues musicians play collective material.
Folk musicians play collective material.
Therefore, blues musicians are folk musicians.

For Lomax, the essence of the blues is pain, and as such the form is merely a particular organization of the field holler or the levee-camp holler. He offers a personal illustration:

As a youngster, I tried to sing whatever we recorded, with varying success, of course, but I could never do a "holler" to

my own satisfaction. I tried for years and finally gave up. Then
came a moment when a holler spontaneously burst out of me.
It was the evening of the day I had just been inducted into
the army. . . . When I had been yelled at, put down, examined,
poked at, handled like a yearling in a chute, I drew KP. It was
a sixteen-hour assignment. . . . I had never been so miserable
in all my life, and there were still two hours to go. At that mo-
ment, without thinking, I let loose with a Mississippi holler.

Wondering why this should be, he recalls Leadbelly saying, "It take
a man that have the blues so to sing the blues." Lomax divides blues-
men into two camps, those from stable families and those from
broken homes—their vocal styles give away their origins. Listening
to Sam Chatmon, a former member of the Mississippi Sheiks and
one of the large and talented clan that also produced Memphis Slim
(Peter Chatmon) and Bo Carter (Bo Chatmon), among others, he
writes: "He sang about the bitterness of Delta love in a rather mat-
ter-of-fact voice, without either the keening of a Robert Johnson, the
ironic merriment of Eugene Powell or Papa Charlie Jackson, or the
rage of Son House. Perhaps he is too old to care, but I suspect that
because he came from this stable family background, the anguish of
the blues did not touch him as deeply as it did others."

He comes to a similar conclusion about Muddy Waters (né
McKinley Morganfield), whom he was the first to record, in 1941
("He learned to play the guitar only three years ago, learning pain-
fully, finger by finger, from a friend," say the original liner notes). He
doesn't disparage Muddy, but suggests that his "rich, relaxed vocal
style" lies some distance away from the shrieks of those abandoned

early in life. This index of misery is a commonplace that nearly every-body associates with the blues. It dates back at least to W. C. Handy's account of composing the "St. Louis Blues":

> While occupied with my own miseries during that sojourn, I had seen a woman whose pain seemed even greater. She had tried to take the edge off her grief by heavy drinking, but it hadn't worked. Stumbling along the poorly lighted street, she muttered as she walked, "Ma man's got a heart like a rock cast in the sea."
>
> The expression interested me, and I stopped another woman to inquire what she meant. She replied, "Lawd, man, it's hard and gone so far from her she can't reach it." . . . My song was taking shape. I had now settled upon the mood.

Handy set down this version of events in his autobiography, *Father of the Blues*, published in 1941. Closer to the date of the song's composition (1914) he had however written, "The sorrow songs of the slaves we call Jubilee Melodies. The happy-go-lucky songs of the Southern negro we call blues." Calt and Wardlow believe that the despair quotient in the blues was Handy's invention, later taken up by Tin Pan Alley songwriters producing generic blues. As an example they contrast an early lyric of Charley Patton's:

> Gonna buy myself a hammock, gon' carry it underneath
> through the tree
> So when the wind blow, the leave[s] may fall on me.

with a commercial product of slightly later vintage:

> Got myself a brand new hammock, placed it underneath a tree
> I hope the wind will blow so hard the tree will fall on me.

Somehow, though, all attempts to make categorical statements
regarding the blues wind up sounding reductive. It is important to
consider both the richness of the blues songs that have come down
to us, and the haphazard nature of their means of transmission. For
all the brilliance of the early blues as they exist on record, an un-
known quantity of performers and songs at least equally brilliant
were never recorded, and even their rumor has not survived. Most
writers on the blues, beginning with Charters, have for example sim-
ply assumed that the blues was born in the Mississippi Delta. But
this deduction is based on little more than the fact that an unusually
high number of exceptional performers came from there. According
to Stanley Booth's elegiac *Rythm Oil:*

> If you describe on a map a circle with its center at Moorhead,
> Mississippi, the place where the Southern cross the Yellow Dog,
> lying within a hundred-mile radius are not only Como and
> Hernando, but also Red Banks, Helena, Lyon, Leland, Rolling
> Fork, Corinth, Ruleville, Greenville, Indianola, Bentonia,
> Macon, Eden Station, West Point, Tupelo, Tippo, Scott,
> Shelby, Meridian, Lake Cormorant, Houston, Belzoni, Bolton,
> Tunica, Yazoo City, Lambert, Vance, Burnett and Clarksdale,
> whence come Gus Cannon, Roosevelt Sykes, Son House,
> Jimmy Reed, Muddy Waters, Fat Man Morrison, Charley

Patton, B.B. King, Albert King, Skip James, Bo Diddley, Emma Williams, Howlin' Wolf, Elvis Presley, Mose Allison, Big Bill Broonzy, Willie Brown, Jimmie Rodgers, Robert Johnson, Bukka White, Otis Spann, Bo Carter, James Cotton, Tommy McClennan, Jasper Love, Sunnyland Slim, Brother John Sellers, and John Lee Hooker.

"Among others," he might have added, since this prodigious list is equally striking in its omissions (Memphis Minnie, Elmore James, Robert Jr. Lockwood, Big Joe Williams, Big Boy Crudup, Robert Nighthawk, Johnny Shines, and both Sonny Boy Williamsons, to name a few). Nevertheless, there is no proof the blues began within this circumference, no matter how rich the musical soil. The circle, which takes in a good third of the state of Mississippi and chunks of southeastern Arkansas and northeastern Louisiana, is entirely rural, excluding Memphis, Tennessee, by fifteen or twenty miles. Anecdotal evidence suggests that the blues had a rural origin, since whenever they were heard, early on, in cities like New Orleans or Memphis or St. Louis, they always seemed to have been imported there by country people. On the other hand, the indefatigable Calt and Wardlow interviewed scores of Delta old-timers in the 1960s and were unable to find any who recalled hearing the blues before 1910. The blues might still have originated there, or its birthplace might have been New Orleans, where it would have been only one of a number of competing marvels. Eclipsed by the success of jazz, it might have come into its own in the country, where it lent itself naturally to juke joints and guitars, ad hoc venues and portable instruments.

Urban blues, known more accurately in the 1920s as vaudeville blues, were the first to be recorded, and they were most frequently sung by urbane and knowing women, most of them young. The received idea that these blues were somehow slicker and less authentic than the rural sort merely reflects a provincial bias, perhaps originating with white beatnik enthusiasts in overalls. It is also true that the Delta is rivaled for fecundity in the earliest times that we know of by east Texas and western Louisiana. Could the blues have begun in two places at once? Blind Lemon Jefferson, arguably the most influential blues guitarist of the 1920s, was from Texas, as was the man who sang on the corner opposite his on Deep Ellum in Dallas, the scary, rasp-voiced gospel bluesman Blind Willie Johnson, as well as the primordial moaner Texas Alexander. Henry "Ragtime Texas" Thomas, born in 1874, was the oldest of the rural songsters recorded in the brief period between 1926 and 1928—his repertoire, which he had entirely acquired before 1900, contained no blues as such. From rural Louisiana came Joe Holmes, an itinerant who went by the name King Solomon Hill. His records are among the strangest in the blues; although they are inarguably blues, they do not hold to the form. The beat of "The Gone Dead Train," for example, varies constantly—each vocal line is of a different length, as are the guitar fills. His metric anarchy, startling in popular song, evokes the kind of unscannable but audibly dynamic music you find in the most rigorous free verse. Was his originality a historically late development or an early one? Is the fact that he was a hobo a relevant historical issue?

For that matter, a distinct chapter in the history of the blues' transmission would concern sawmills and turpentine camps throughout

the forests of the deep South, settlements featuring barrelhouses, whose upright pianos engendered a particular style of keyboard blues that led directly to boogie-woogie. But the story always seems to come back to Mississippi. There is no denying that, from the middle 1910s to the late 1940s, the northwest quadrant of that state saw an astonishing conjunction of original talents amid surroundings that are at best unprepossessing. A wayside like Drew or Robinsonville begins to sound like Paris in the same period.

2.

Robert Johnson is the most famously mysterious of all the Delta blues artists. He died in 1938 at the age of twenty-six, leaving behind forty-one recordings, twenty-nine different songs and alternate takes. Little is known about him; even his surviving contemporaries— friends and traveling companions—describe him in frustrating generalities. He was shy, footloose, aloof maybe, neurotically concerned with hiding his hands when playing if other guitarists were around. He comes late enough in the blues genealogy that his influences can be enumerated, and they range from one end to the other of the recorded blues of his time.

He was somehow both obscure and legendary in his own lifetime. The story was that he was an adolescent nuisance hanging around older musicians, banging around ineptly on their instruments when they set them down; then he went away for a while and came back a phenomenon. It was noised about that he had made a pact with the devil, but that was the same story that had been circulating

concerning the older and unrelated (and very different) Tommy Johnson, so that it was either misheard or just possibly Robert's own press-agentry. He played juke joints and street corners in places that ranged all the way to Chicago and New York City, traveling on freights and by hitchhiking. His big break came when the promoter John Hammond sought him out for his "From Spirituals to Swing" concert at Carnegie Hall in December 1938, intending to present him as the first Delta blues singer to appear before a white big-city crowd, but unfortunately he had been murdered several months earlier. By the time the first LP of his songs came out, in 1961, the situation could be summed up by Frank Driggs in his liner notes: "Robert Johnson is little, very little more than a name on aging index cards and a few dusty master records in the files of a phonograph company that no longer exists."

There is a little more now, but not a huge amount. Peter Guralnick's *Searching for Robert Johnson* contains, in sixty-eight pages not counting bibliography, just about everything, or at least everything that's been brought to light. This does not include the name of his murderer, who was evidently last seen in Key West in 1975 (see Mack McCormick's letter to the editor, *78 Quarterly* #6, 1991) or the third of the three known photographs of Johnson, not yet made public at that time. The pictures weren't found until 1972 and were promptly copyrighted by a researcher; none was published until fifteen years later. In the meantime, Johnson captured the imagination of the world. His *Complete Recordings* won a Grammy in 1990, and the set is presumably owned by many people who have no other acquaintance with acoustic blues.

He is esteemed for his influence in rock and roll, to be sure (most

notably, the Rolling Stones' versions of his songs "Love in Vain" and "Stop Breaking Down") and for his function as a sort of historical funnel (reflecting what went on in blues before him and anticipating much that would happen after his death), but it is the intertwining of his art and his enigma that makes him indelible. It is hard to separate one from the other. During his lifetime he was best known for "Terraplane Blues," an extended car-as-sex metaphor and the direct ancestor of Chuck Berry's "Maybelline," and his performance repertoire is known to have included Bing Crosby numbers, hillbilly yodels, novelty songs, "My Blue Heaven"—like every itinerant blues performer of his generation and the ones before, he was functionally a songster. The songs for which he is remembered, though, are devil-haunted, death-obsessed. His lyrics seem to bear out the rumor of his demonic pact and foretell his shadowy end (he was poisoned by a jealous husband), not that the words can really be set apart from the alternating growl and sigh of his delivery and the fatalistic way he echoes his lines. In his book *Mystery Train*, Greil Marcus says he finds Johnson the appropriate background music for reading Jonathan Edwards and portrays him as inheritor of the Puritans' devil, "the Puritan commitment to extremes, the willingness to live in a world where the claims of God and the devil are truly at odds." This Manichaean tension shows up often in American popular music both black and white, a significant element in the lives and works of, for example, Ray Charles, Jerry Lee Lewis, Little Richard, Hank Williams. But those artists all belong to a later era, and all must have been somehow informed by Johnson, who was the first to be explicit about the duality. Johnson was a startling blues poet, a wrenching performer, an eclectic and elastic guitarist, and he was also a figure

whose brief life and meager recorded output manage to embody the spirit and contradictions of the blues. He is the landscape's most redoubtable ghost.

His ghostly presence has been magnificently captured in Alan Greenberg's film script, *Love in Vain*, first published in 1983 and announced as imminently entering production many times since. As difficult as it is to depict the life of an artist in movie form without tumbling headlong into ridiculousness, Greenberg has done it by, first of all, not attempting to explain anything. His Johnson is a changeling, flesh-and-blood but mutable and secretive, and he dwells in a world of workaday magic. His first meeting with the devil takes place in a moviehouse, below a screen showing a western, and Charley Patton's funeral turns into a ferocious soul-claiming contest between Johnson and the Rev. Sin-Killer Griffin. Greenberg not only evokes Johnson in a way that actually enlarges our understanding of him, he also depicts the blues world of the time, from Mississippi to Texas, in all its variegated splendor and misery. He makes a point of bringing in the most original and singular musicians, from the flamenco-inflected Buddy Boy Hawkins (who employed "Spanish" tuning, capoed to a different absolute key in every one of his eight recordings) to the sublime gospel hymnist Washington Phillips (perhaps the only recorded player of the dulceola, a massive, harplike instrument referred to as a "plucked piano"), and he ranges beyond music to include a great range of the voices of the black South: chanting street vendors and train callers, itinerant preachers, German-speaking black cowboys in Texas. Through details and suggestions he succeeds in showing both how this rich culture fed Johnson, and how Johnson assimilated and transcended it.

The search for Robert Johnson was also the initial point of departure for the series of expeditions into the Delta that Alan Lomax describes in *The Land Where the Blues Began*. He gives a moving account of hearing the sad news of Robert's death, in Bogalusa, Louisiana, from his religious ecstatic of a mother, Mary Johnson, at her shack in Tunica County. Unfortunately, Johnson's mother's name was Julia Dodds, and he died outside Greenwood, Mississippi. There is also some confusion about the timing: Lomax implies that John Hammond put him on to the search, but the recording trip seems to have taken place in 1941, by which time most interested parties knew of Johnson's death. The point may seem academic, but the muddle is not untypical of Lomax's book, which despite its many virtues is permeated by a haze of factual uncertainty.

He repeats, for example, the old canard that Bessie Smith bled to death in the wake of a car crash after having been denied admission to a white hospital (in fact, no ambulance driver would have taken a black person to a white hospital in Mississippi in 1937; she died of shock in the Afro-American Hospital in Clarksdale). Perhaps it is that the deaths of blues musicians are particularly subject to dubious or imaginative retelling. Lomax quotes Big Bill Broonzy on Blind Blake, who he says slipped and fell late at night during a blizzard in Chicago "and, by him being so fat, he couldn't get up and he froze to death before anyone found him." But the only extant photograph of Blind Blake shows him looking rather trim, and the blizzard-demise tale is usually told about Blind Lemon Jefferson, who is fat in the only picture we have of *him*. In any event, no documents have ever been found concerning the death of either man.

Lomax may not have found Robert Johnson, but he did find the

young Muddy Waters, whom he recorded in an important series of performances on Stovall's Plantation near Clarksdale in 1941 (and who would go on to Chicago and the invention of the electric blues later in the decade), and through him he found Son House, who had known and played with both Johnson and Charley Patton. But while he thus had a pipeline to the most important strain of the Delta blues, Lomax was more interested in the work songs and ring chants, the African survivals in the black music of the South. Although many well-known names crop up in his book—Lomax was also the first to record Fred McDowell and David "Honeyboy" Edwards, and in 1946 he taped an extraordinary session in which Broonzy, Memphis Slim, and Sonny Boy Williamson talked frankly about racial oppression and its role in the music—the narrative is much more concerned with the anonymous many who sang part songs while hoeing rows as convicts on Parchman Farm, or hollered for the benefit of their mules while building levees, or entertained their neighbors in obscure back-country settlements without any thought of recording the songs they made up. His populist faith is absolute, and while it can have a leveling effect, making the deliberate decisions of innovative artists indistinguishable from the inherited or instinctive moves of people following tradition without questioning or altering it, there is no denying the power of what it led him to find.

But then he was combing the Mississippi Delta and its surrounding hills. Lomax's view on the origin of the blues is shared widely, even by those who, like Samuel Charters, insist on the role of a single innovator. The blues had to have begun in Mississippi, they claim, because for complex and not altogether explicable reasons that state

retained more unassimilated African traditions than any other part of the country. (The proponents of east Texas as the point of origin, meanwhile, argue that it was the last place in the United States to receive slaves directly from Africa.) Those traditions include dietary, linguistic, and domestic matters—such as the survival of the raked dirt yard—but the amount of musical culture is staggering. As recently as the 1960s, Lomax and others were turning up previously unsuspected vestiges of ancient traditions. Among these were the use of pan-pipes (called "quills"; note, however, that Henry Thomas had recorded many sides using quills in the late 1920s) and the significance of fife-and-drum bands in the culture of the state's arid hills. Lomax's primal scene for the blues involves the Delta-based conjunction of two other phenomena: the holler and the diddley bow, a single-stringed instrument that can be assembled quickly and mounted on any surface, including the side of a house, making the whole house its resonator. It is not difficult to hear that vocal style and that instrument in the chilling wail and slide guitar of Son House's "Death Letter," for example, or even in an electric, full-band number such as Howlin' Wolf's "Moanin' at Midnight." The holler and the diddley bow do not constitute the blues, but they are at least its table setting.

Charley Patton's biographers, Calt and Wardlow, are singularly unimpressed by the search for the deep origins of the blues, and seem to view as sentimental any approach to the music that is geared to anything but individual talents. They do not mince words. John A. Lomax, they write, was "obtuse and unimaginative," an "ideologue" whose researches were determined by his "*idée fixe*. . . to document the survival of the 'field holler' and the work song." They judge

Lomax Sr.'s spending four days recording convicts at Parchman Farm in 1933, while ignoring Patton, who was still alive nearby, to have been the height of irresponsibility. To appreciate their indignation in context, it is important to realize that we are lucky to have any recordings by Patton, or of any other early blues artist, at all. The first wave of recordings of Delta musicians does not precede 1927, peaks around 1929, and gradually peters out in the early years of the Depression. The commercial recordings made by black Mississippians during this period were made possible by just two men, Ralph Lembo of Itta Bena and H. C. Speir of Jackson. There is no question that each possessed an exceptional ear, and that Speir in particular took extraordinary chances on difficult and unobvious talents, but nevertheless the potential to slip through the cracks was large.

The recording companies presented their own set of obstacles. Country blues records were generally intended for sale only to black people, primarily in the South, and they were not engineered, manufactured, or marketed with the greatest care. One of the chief producers of "race" records in that period was Paramount, a division of the Wisconsin Chair Company of Port Washington, Wisconsin (and no relation to later companies bearing the Paramount name). The Wisconsin Chair Company—which began a recording sideline as a natural extension of its manufacture of Victrola cabinets—went "race" only because the sound quality of its records was so inferior that white record store owners would not stock them. The records were so cheaply made that they would sometimes wear out after just fifty plays; at the then-exorbitant price of seventy-five cents a throw this was a thankless proposition. Small wonder, then, that the

records themselves have become such rarities. Since unsold records were destroyed, only the very biggest hits have survived in appreciable numbers. Numerous are the legendary sides known today only as listings in company catalogs. Only one copy is known to exist of a major Son House number, "Preachin' the Blues," and its condition is so bad that even on digitally remastered CDs it is barely listenable.

Charley Patton was sufficiently popular in his own day that all the records that were issued under his name have survived in at least one or two copies, most of them in reasonably good shape. The unissued titles, however, are gone forever (although four unissued takes of known songs have recently surfaced), as are the master recordings, so that what we are left with is the equivalent of a great painter's entire corpus being known exclusively through black-and-white reproductions. And Patton, scarcely a household name even these days, was without question a great artist, a fully conscious experimentalist and a highly sophisticated formal innovator, a genuine modernist despite the fact that his address was pretty much always in care of some plantation or other in Sunflower or Bolivar counties, Mississippi. Patton remains a star, specifically one of those stars that are more distinct in peripheral vision than when you look directly at them in the night sky. One photograph of Patton survives (the bust alone was known for years; the full-length version, which shows how he held a guitar, only came to light within the last few years), along with a handful of documents (he was a champion serial monogamist who got married at least eight times), and a fund of oral recollections by a variety of witnesses—some of them contradictory, many of variable reliability. Other obstacles to full understanding include the fact that he came in a localized, even provincial package, which means among

other things that his pronunciation and many of the allusions in
his songs are difficult if not impenetrable for listeners who do not
happen to have lived in the Mississippi Delta in the first half of the
twentieth century. Add to this the increasingly compelling sugges-
tion that Patton was primarily interested in process, so that his re-
cordings are just as semi-improvised as, and no more definitive than,
any performance he executed at a given fish fry in 1917 or 1926 or
1932.

Calt and Wardlow depict Patton's life as both hectic and con-
stricted: he played music, took up with women, got into fights, mi-
grated around a patch of the Delta. More recent evidence, however,
demonstrates that Patton was literate, a spontaneous if intermittent
preacher, maybe the only Southern black man at the time with in-
fluence on record company A&R, and a self-sufficient professional
musician, who toured widely, earned respectable amounts of folding
money, and drove new cars. It seems probable that both versions ex-
isted side by side. Patton was a sophisticated professional who was
nevertheless handcuffed to the social system into which he was born,
and he got into trouble. He survived having his throat slit by a jeal-
ous husband at a house frolic in 1933, only to die of heart failure the
following year, at the age of forty-three.

Nearly everything known about Patton comes from oral testimo-
ny, which is naturally subject to human vulnerability. Besides that,
Patton himself undermines the always sorry business of trying to
find a portrait of the artist in his work. His tangible anger in combi-
nation with his abrasive guttural roar and his variably decipherable
pronunciation persuaded certain white listeners that he had climbed
out of the ditch to make his recordings. Like a poet, he seems to

have sometimes employed the first person singular to relate the experiences of others—"A Spoonful Blues" has a different narrator in every line. Like many male poets he was a tomcat; the fastidious Son House didn't like Patton's free-associative methods nor his acrobatic guitar stunts. Patton was tremendously influential—nearly every Delta bluesman of the 1920s and '30s attempted some variation on his "Pony Blues"—but for all of that inimitable. Calt and Wardlow:

> He was seemingly the only blues guitarist of the age who could completely rearrange material. He recorded the only blues song ("Screamin' and Hollerin' the Blues") with a basically improvisatory melody, the only dance blues without a constantly repeating melody ("Pony Blues"), and the only dance song that had appreciable instrumental variations ("Screamin' and Hollerin'," with its three bass lines).

Patton was angry. Patton gargled with lye and gravel—his singing sounds rough except on the numbers he nearly croons, so that the roughness must have been deliberate. Patton sang about things he saw and felt and also, like many of his contemporaries, threw in verse after verse of readymade folk-lyric filler. Patton played blues—he probably learned blues from the first generation of musicians to employ the twelve-bar template—and he also played ballads and rags and white country breakdowns and Tin Pan Alley tunes. He enjoyed turning out variations on the blues trick of making the guitar take over the vocal part; he made his guitar talk and shout and pray. He cut and folded songs into other songs, made collages of fragments—"Prayer of Death," for example, is woven from at last four

distinct elements. According to a contemporary, "He had one piece he used to play a stanza out of every song he played, each song; put it together, and make a song out of that." He could play lead, rhythm, and bass all at the same time. On the evidence of the unissued takes you strongly suspect that he seldom played a number the same way twice. You figure that in performance he thrived on interruptions and spontaneous dialogue with the audience, so that when he played alone in the studio he had—as in "High Water Everywhere"—to supply the voices of imaginary interlocutors. As an entertainer at house frolics and juke joints he was remembered by some of his contemporaries chiefly for his "clowning"—playing his guitar behind his back or over his head.

He was an all-around entertainer and he was also an oracle. He was haunted. He summoned spirits from the vasty deep. He managed the trick of asserting control while expressing lack of control. His voice can be so threatening it makes that of his disciple Howlin' Wolf sound avuncular by comparison. He has seen devastation, disaster, horror, anguish. He has been buffeted by winds, traveled outside his body, glimpsed heaven for a minute, died many times before his hour came. And he conveys all this while getting people up on the floor to dance.

Calt and Wardlow are appropriately tough in their defense of Patton, alert to the many ways in which he has been or can be lumped or dismissed or even praised. They simply will not accept any guff about his having been a folk musician, part of a tradition, a participant in collective creation, etc. They have done the research, invested the legwork, subjected the evidence to analysis, refused to indulge in airy generalities. Unfortunately, they also seem to feel that

Patton cannot be given his due without every other Delta musician being correspondingly brought down several pegs. Maybe none was the equal of Patton, but all have their particular quality: Tommy Johnson had a delicate, sinuous delivery with a hypnotic edge; Skip James was simply ineffable, suggesting his structures with the most minimal strokes; Howlin' Wolf's voice was, in the words of Sam Phillips, "where the soul of man never dies." All of them are variously dismissed by Calt and Wardlow; Wolf is called a "parasite."

Howlin' Wolf (Chester Burnett) is the outside man in this series, a late bloomer. A contemporary of Robert Johnson's and a resident of Dockery's Plantation, where Patton spent much of his life, Wolf farmed with his father until he was nearly forty. He moved not long after becoming a professional musician and came into his own in Chicago in the 1950s. For others, the spin of the Delta policy wheel was not as fortunate. Tommy Johnson hung on until the age of sixty despite a bad drinking problem, but he never recorded again after the early 1930s. Skip James and Son House both disappeared from view, James after a single recording session in 1931, House after having been lost and found a couple of times. Both were tracked down by enthusiasts in the 1960s and along with a number of other elderly blues artists were able to ride the fads of that era and live out their lives as professional musicians. Many others are just names, such as the leading musicians of the generation before Patton: Henry Sloan, D. Irvin, Mott Willis, Cap Holmes, Jake Martin, Jack Hicks, or Robert Johnson's teacher Ike Zinneman. Or there are those who recorded only two or three sides, which hint at things we'll never know: Garfield Akers, Rubin Lacy, William Harris, Elvie Thomas, George "Bullet" Williams, Louise Johnson, Freddie Spruell, Kid

Bailey, or Geechie Wiley, whose "Last Kind Words Blues" is one of the singular masterpieces of the Delta blues, and cannot have been a fluke.

The 1960s came too late for them. For those aged blues musicians who benefited from the revival, the experience must have nevertheless been disconcerting. When a collector showed up at the house of Mississippi John Hurt in 1963, saying, "We've been looking for you for years," Hurt, who was the gentlest of men, thought his visitor was an FBI agent, and said, "You got the wrong man! I ain't done nothing mean." The Sixties revival came about as a result of the conjunction of the civil rights movement, the coffeehouse folk scene, and the efforts of a generation of enthusiasts, particularly the collectors who canvassed door-to-door in black neighborhoods in the South, looking for rare Gennett or Black Patti or Paramount 78s. Those people combined their avidity with disinterested scholarliness, in most cases, and they managed to have a largely positive effect on the lives of the musicians whose careers they resuscitated. Still, as Calt and Wardlow demonstrate by example, the thirst for ownership was never entirely absent. Calt and Wardlow's defense of Patton against all comers is understandable, given his true stature and the neglect and distortion his reputation has suffered, but their monomania begins to sound proprietary. If they were writing about a Romantic poet or a Surrealist painter it might sound just as proprietary, but there is no getting away from the fact that they are whites writing about a black figure, marginal in his own day.

The white fascination with the blues, especially the country blues, has always been vulnerable to accusations that it represented a kind of colonial sentimentalism. While perhaps unjust, this idea was cer-

tainly borne out by some of the grotesqueries of the 1960s and '70s, when pimply devotees misunderstood the music in an elephantine way, unable to distinguish between tribute and ridicule. Affected Mississippi accents and pointless guitar noodling, which Nick Tosches aptly characterized as "minstrelsy," were the norm among suburban epigones. "They got all these white kids now," the ever-generous Muddy Waters told Robert Palmer, "Some of them can play *good* blues. They play so much, run a ring around you playin' guitar, but they cannot vocal like the black man." (There were exceptions. The white musicians who did the most honor to the blues were generally those, like Captain Beefheart, who took the largest liberties with the form.) Other white enthusiasts were, instead, tormented by guilt. The blues scholar Bruce Bastin writes: "At the time of the death of the eccentric but undeniably brilliant Guitar Shorty from North Carolina, a friend remarked that she would be glad when she could no longer hear music like his, as it would mean that the social context that gave rise to it was gone."

In one stroke, this deeply fatuous statement lays bare all the ambivalence that attends the blues in the United States, an ambivalence in which Alan Lomax's book, for example, is drenched. If the blues is a form of music based on human suffering, then enjoyment of the blues is tantamount to enjoyment of suffering. The only appropriate attitude for listening, therefore, is guilt. And if the blues is the direct result of the racism of past decades, then it must follow that subsequent forms of black music, indeed of black culture, are likewise the results of racism, since racism has only changed in its manifestations. And if this is so, then black culture is one-dimensional and exists only in response to white culture.

This is why the apparently academic question of where and when and how the blues began is important. The blues was not a reaction or a spontaneous utterance or a cry of anguish in the night, and it did not arise from the great mass of the people like a collective sigh. It was a deliberate decision arrived at by a particular artist through a process of experimentation, using materials at hand from a variety of sources. It was taken up by others and expanded to encompass anguish as well as defiance, humor, lust, cruelty, heartbreak, awe, sarcasm, fury, regret, bemusement, mischief, delirium, and even triumph. It grew to be the expression of a people, but not before it had become as diverse and complicated as that people. It, too, ranges beyond the monochrome of its name.

1994–2002

THE OCTOPUS BEARING
THE INITIALS V.H.

Victor Hugo (1802–1885) has fallen into a curious sort of limbo for English-language readers; he is famed the world over for two major literary works—*Les Misérables* and *Notre-Dame de Paris*—but both are largely unread these days and known only by way of a vastly commercial musical or a Disney cartoon. Collected editions of his works in translation, published around the turn of the last century, languish in book barns, their high-acid-content pages disintegrating as you turn the previously unopened pages. The most memorable allusion to his stature is André Gide's reply, upon being asked who was the greatest poet of the nineteenth century, "*Victor Hugo, hélas!*" It is the "alas" that sticks. Thus Hugo might appear a grandiloquent hack, a sagging balloon leaking the tepid air of dated pomposity, a flyblown plaster bust placed somewhere with Dumas *père* and Dumas *fils* in the panorama of nineteenth-century French literature, certainly well below those enduring monuments, Balzac and Flaubert. While unjust, this assessment nevertheless contains

some truth. Hugo was indeed a grandiloquent hack, but that is only one of the myriad job descriptions to which he answered in his improbably long and varied career. In the context of his time and place, Hugo is so vast a figure that no lens can frame him. If we can call Balzac the novelist as department store—the overstimulated encyclopedist of petit-bourgeois pretensions and miseries—and Flaubert the anguished miniaturist—insomniac on his fainting couch as he hesitates for weeks over a single word—Hugo lends himself to no such caricature except by slices. He was the boy poet long before Rimbaud (teenage *Odes* published to fanfare at twenty, in 1822), the inexhaustible Gothic-serial manufacturer (*Han d'Islande* and *Bug-Jargal* before he hit twenty-five), the fevered Orientalist (*Les Orientales*, 1829), an instigator of the 1830 July Revolution (the staged battle at the premiere of his *Hernani*), the Fagin of the very first bohemians (the Jeune-France decadents, including Nerval and Gautier, whom he conscripted for his riot). He was a stolid bourgeois, an Academic, a friend of royalty, a peer of the realm, a wind-filled speechifier in the Chamber, and at the same time a Romantic visionary, a coiner of phrases, a deviser of enduring Gallic commonplaces, a tormentor of schoolchildren, who were made to memorize his alexandrines at great length. Before he was fifty he was known as an infamous philanderer, a scandalmonger, an opponent of authority, an increasingly militant leftist, an exile. In old age, after his return upon the fall of his enemy Napoleon III in 1870, he became epic. The nation soared on the wings of his triumphs, was racked by the grief of his many bereavements. By the time he died in 1885 he was virtually France itself. His catafalque was pharaonic, nearly filling the span of the Arc de Triomphe, which

was hung with enough crepe for an army of mourners—appropriately enough since the funeral, which lasted seven and a half hours, drew a crowd of half a million. His memory was preserved by heroic statuary of all distinctions; his face appeared on crockery, on soap wrappers, on ink bottles, on meerschaum pipes. It is safe to say the world will never again see a mere writer attain that sort of overwhelming fame in his own time.

Hugo—"great, terrible, as immense as a mythic being, Cyclopean" (Baudelaire)—embodied every contradiction of his century. Although his plays have aged badly, his prose and especially his poems continue to be rediscovered. It might be argued that he wrote so much that his work could hardly fail to contain something for perpetual reinterpretation, but Hugo's posthumous reputation runs the whole range from the mothballed to the evergreen, touching every point along the spectrum, and this could not be happenstance or a mere by-product of excess. His poetry in particular is by turns bathetic and austere, populist and Olympian, whimsical and illuminated, pedestrian and transcendent, and appears to contain somewhere in its great mass the seeds of nearly everything that was to occur in French verse in the ensuing century. Rather than reading as the work of one man, it encapsulates the collected breath of national cross-currents. Accounting for Hugo as a totality is a task that has beggared the best minds.

On top of this we are confronted with Hugo the visual artist. Though far from being the only poet who ever painted, Hugo stands out as a uniquely self-created entity, even allowing that a poet's visual expressions will generally be more original and idiosyncratic than the Sunday daubings of politicians or popular singers. Hugo

approached visual art as if he himself had made up the concept out of whole cloth. Scholars may well have found antecedents for his method. Earlier visionaries may also have thought that painting could involve, for example, the use of soot, black coffee, fingerprints, fingernails, matchsticks, inkblots, stencils, sprays of water, the impression of cloth textures, of lace, of stones, but we can be reasonably certain that rather than researching the matter, Hugo simply acted, employing whatever materials and techniques came to hand. Even if he did not invent his aleatory procedures, he might still have invented the readymade more than half a century before Marcel Duchamp—his signing and dating of pebbles found on the beach certainly has no useful precedent. And he presumably did none of those things to earn himself a niche in the history of art, since his productions were intended solely for his own pleasure or that of his children, mistresses, or friends.

Those pebbles do offer one perhaps misleading key to his art. Hugo could sign and date objects found in nature because they came into being when he looked at them. He was not making a statement about the illusory nature of the work of art or engaging in a debate about the relative value of attribution—he simply owned the world. He might even have said, a century before Jackson Pollock, "I am nature." The word "ego" seems pedantically small and flat in regard to a man who did not stop at identifying himself with Shakespeare and Dante—among the only mortals he regarded as peers—but felt quite at ease seeing through the eyes of God and Satan. Hugo's self-regard was sculpted on a titanic scale, and was inevitably self-fulfilling. "Vanity" seems an imprecise term as well; it is a word for movie actors and financiers. We know that Hugo was fond of being photo-

graphed, and that in his exile on the islands of Jersey (1852–55) and Guernsey (1855–70) he would go out with his son Charles almost daily, posing on promontories and in front of dramatic ruins. If this seems comical to us, it is only because we have been made jaded by a century and a half of promotional photographs and satiric snapshots. Hugo's poses stemmed directly from conventions of portrait painting, by Delacroix for instance, but photographically there was little precedent. The stone porches and menhirs and crags were for him the furniture of the demiurge—no more than his element.

So Hugo's paintings and drawings might be seen as coming from the same source. Many are indeed of titanic subjects, grandiosely depicted. It does not require much of a leap to imagine his numerous dark towers, enshrouded in mist and poised alone on unscalable peaks, as being in some measure self-portraits. Of course, the grandeur of Hugo's vision, and the idea he had of his own importance, is to a certain extent a product of the Romantic ideal he exemplified in France. The cascading vertical forms, the storms and torrents, shipwrecks and caves and black suns were almost Romantic boilerplate by the time of Hugo's most sustained period of artistic production, during the nearly twenty years of his exile. The atmosphere of many works, paintings especially, is manifestly the same extreme world of heights and abysses first suggested by Mannerism, brought to term by Romantics from Caspar David Friedrich to Thomas Cole, and reaching its nearly absurd apotheosis with the *Last Judgment* canvases of John Martin (the eccentric who died on the Isle of Man in 1854, during Hugo's highly charged tenancy on Jersey). But Hugo's vainglory did not stop at identifications with landscape: his name itself looms overwhelming in a number of works, not all of which

were studies for frontispieces to his books. The octopus that traces his initials with its tentacles might be another sort of alter ego.

If Hugo's paintings risk appearing at first glance as further expressions of an insatiable self finding itself too restricted by mere words— so that his very originality of method could be called into question as yet more arrogation, as if conventional procedures might chance equating Hugo with beings as ordinary as simple painters—various contradictions do present themselves. There is the homeliness of his materials, the childlike playfulness of many of his sketches. And there is the fact that in so many of his visual works Hugo appears to have been groping for a way to elude his own conscious control. A quest for untrammeled spontaneity seems a likely explanation for his idiosyncratic methods. He did not plan or scheme—he attacked, as one witness after another has recorded. "Any means would do for him," wrote his friend Philippe Burty, "the dregs of a cup of coffee tossed on old laid paper, the dregs of an inkwell tossed on notepaper, spread with his fingers, sponged up, dried, then taken up with a thick brush or a fine one. . . . Sometimes the ink would bleed through the notepaper, and so on the reverse another vague drawing was born." If the constituent elements of a given work sound vaguely like the makings of an alchemical recipe, the procedure itself is difficult to imagine taking place before the 1920s. It was aggressive and receptive at once: action painting.

Not coincidentally, it was during his exile in Jersey—after his flight in the wake of the upheaval of 1848 and until his expulsion and removal to neighboring Guernsey in autumn 1855—that Hugo immersed himself, for an increasingly feverish two years, in an aleatory procedure of another order: communication with the spirit

LUC SANTE

world. In the autumn of 1853, at the instigation of the medium Delphine de Girardin, the Hugo family and their entourage engaged in "table-turning" sessions, in which Victor Hugo was at first a bemused onlooker and gradually an ever more active participant. The sessions appear to have begun as an attempt to make contact with the ghost of Léopoldine, Hugo's elder daughter, who had drowned at twenty-one along with her husband on a boating expedition ten years earlier. In these activities the Hugos were in the vanguard, since the phenomenon of table-rapping and table-turning had begun only in 1848, with the Fox sisters, aged twelve and fifteen, at their family's farmhouse in Hydesville, New York. The herald among French mediums, Allan Kardec (born Léon Rivail), did not publish his *Livre des Esprits* until 1857.

The extent of Victor Hugo's belief in the manifestations that occurred at the sessions remains questionable. He seems to have swung from one extreme to the other. At the beginning he took the whole thing as a joke, engaging via the table in a dialogue with the indisputably alive *"petit Napoléon."* (As well as making the table shift from side to side—as opposed to actually turning—the spirits would appear to have spoken through the agency of a ouija board principally manipulated by Charles; their loquacity, which increased as time went by, must have made for some very long evenings.) But Hugo seems to have been genuinely shaken by the communications from Léopoldine, who had already been appearing to him in dreams for some time. At length and after various monosyllabic encounters with a series of fairly obscure specters, he conjured up appearances by a whole pantheon: Dante, Shakespeare, Molière, Aeschylus, Galileo, Moses, Jesus Christ, St. Augustine, Voltaire, Marat, André

Chenier, the Ocean, and Death itself. Their replies become increasingly elaborate until they begin speaking in verse. This verse tends, notably in cases such as those of Dante and Shakespeare, to resemble the style of Victor Hugo more than that which they themselves had employed in life.

In the transcripts there are reams of nonsense, petulant snipings, strictly topical disquisitions, esoteric vagaries, and great lyric outbursts. There are evenings such as (to choose one at random) that of April 23, 1854. Charles and his mother are holding down the table; Théophile Guérin is manipulating the planchette. They have made contact with the Ocean, whose replies are brief, not to say perfunctory, and threaten to break off altogether. The Ocean has previously dictated a piece of music, and the questioners are asking it about the key, since they are attempting to arrange a transcription for flute. Then Victor Hugo enters, and suddenly the Ocean is aroused to tumbling paragraphs:

Your flute pierced with little holes like the ass of a shitting brat disgusts me. Bring me an orchestra and I'll make you a song. Take all the great noises, all the tumults, all the fracases, all the rages that float free in space, the morning breeze, the evening breeze, the wind of night, the wind of the grave, storms, simooms, nor'easters that run their violent fingers through the hair of trees like desperate beings, rising tide on beaches, rivers plunging into seas, cataracts, waterspouts, vomitings of the enormous breast of the world, what lions roar, what elephants bellow with their trunks, what impregnable snakes hiss in their convolutions, what whales low through their humid nostrils,

what mastodons pant in the entrails of the earth, what the
horses of the sun neigh in the depths of the sky, what the entire
menagerie of the wind thunders in its aerial cages, what insults
fire and water throw at each other, one from the bottom of his
volcanic yap the other from the bottom of his abysmal yap, and
tell me: here is your orchestra—make harmony from this din,
make love from these hates, make peace from these battles, be
the maestro of that which has no master.

It might be said, as at least one commentator has noted, that
Victor Hugo was channeling Victor Hugo. Death advised him, "Be
the Oedipus of your life and the Sphinx of your grave." The most
useful of the spirits proved to be the "Shadow's Mouth," who dictated
a sibylline revelation in six hundred verses, which Hugo went on to
publish essentially intact as "What the Shadow's Mouth Says" (*Ce
que dit la bouche d'ombre*)—without, however, revealing its nominal
source (the table-turning sessions were not acknowledged in print
until Gustave Simon published a selection in 1923). Not that there
would have been particular grounds for suspicion—the epic voice
and themes bear Hugo's unmistakable mark; the verses are akin to
the vast, posthumously published poems *Dieu* and *La Fin de Satan*.
Had the sessions been publicized, they would have sparked ridicule
(as did Simon's book retrospectively when it was published), but
Hugo was sufficiently self-aware to have known that, for himself
at least, the occult folderol was only cosmetic. He had discovered a
means of overriding conscious control of his verse.

In addition, a certain amount of "spirit drawing" went on in the
table sessions, effected by means of a pencil replacing one of the legs

of the planchette. These bear a family resemblance to other such productions, such as the drawings of the celebrated Swiss medium Hélène Smith (born Elise Mueller), whose mental excursions later in the century were studied by the psychologist Théodore Flournoy in *From India to the Planet Mars* (1899). While in the trances that took her first to "India" and then to "Mars," Smith wrote and spoke in the languages of those places, and drew pictures that are variously childlike, ornate, and pictographic. The latter resemble the planchette drawings of Jersey, in some cases echoing the effect of the pencil never being lifted off the page. Flournoy was interested in Smith's productions as fruits of the unconscious mind (a linguist who studied her emanations in the Martian language found that all but two per cent consisted of altered French), while, naturally, devotees pointed to the drawings as proof that her discorporate being had actually visited those places.

Trance art of all sorts appears to have consistent features—a primitivism of conception, for example, allied with an obsessive rendering of intricate vegetal-architectural details. From the depiction of "Mozart's house on Jupiter" set down by the French theatrical personality Victorien Sardou in a nine-hour trance in 1858 to the three-dimensional "Ideal Palace" in Hauterives, France, built over many years by the mailman Cheval, along with numerous examples of the art of the insane, much spontaneous artwork is driven by rhythm and repetition. Line breaks down into smaller and smaller constituent elements; bauble and flourish multiply. Hugo, already possessed of Orientalist-architectural inclinations, made notebook drawings which, while rapid and cartoonish, are distinguished by a trancelike line that can best be described as fractal, its curves inter-

rupted by a constant insectlike zigzagging.

We do not know whether Hugo's hand was indeed being pulled along by an imagined force that merely used it as a mechanical extension of the pencil, as in the recorded cases of drawing mediums. Does the doodler talking on the telephone have any more control over what issues from his hand? Though Hugo failed to leave any kind of manifesto or chronicle, his years on the Channel Islands, during which he was bored and dislocated, trying out one venture after another—science, witchcraft, play—are powerfully evoked.

The séances ended suddenly and without explanation in the summer of 1855. Maybe Hugo no longer required their trappings. His paintings from the Jersey era generally adhere to the brooding Romantic landscape vein he had already occasionally been mining for some time, although his first use of stencils also dates from the same period. In Guernsey, after the séances had stopped, his visual work became looser and freer; lace, inkblots, and coffee stains now determine subjects as well as textures. Though now channeling matter, Hugo never truly departs from the realm of the spirits, either in his writings or his paintings. So it was with work that tapped the unconscious in the nineteenth century. Eidetic imagery and the occult ran in tandem, if without any pretense that spirits or astral presences were in control. This applies to Goya's black paintings and *Caprichos*, the engravings of Grandville (including many of his satires), and the hallucinatory black drawings of Odilon Redon. There are rhymes and correspondences between various of these and Hugo's paintings. The hangover of Romanticism, the lingering Gothic, the subliminal power of Catholicism that extended even to the rejection of Catholicism—all contributed to a vocabulary of

ritual and mystery, eyeballs and darkness and ghost ships and swirl-
ing stars.

What cleared the decks, finally, was Surrealism. André Breton's
program called for a harnessing of unconscious energies while elimi-
nating all the attendant mystification. Breton recognized Hugo from
the start, including him among the predecessors of the movement.
"Victor Hugo is Surrealist when he is not stupid," he wrote—an un-
charitable assessment, maybe, but not untrue. At times in his work,
Hugo seems to be inches away from discovering the first Surrealist
principles, but then he blows it through his massive and grotesque
sentimentality. Breton called the Jersey sessions "productions... of
an astounding naïveté" in "The Automatic Message," the essay he
published in *Minotaure* in 1933 in which he distinguished between
automatism and spirit channeling, and which he illustrated with
Hugo's tiny drawing "*Aube.*" Not long before this, the group had gone
through its own period of séances, in which Robert Desnos would
fall into a trance and emit lyrically disconnected phrases in response
to questions. (The Surrealists were as fascinated with the trappings
of the occult as they were repelled by its premises; many of their
publications bear the pedantic appearance of the *Revue Spirite* and
its counterparts, and the Bureau of Surrealist Research was a virtual
parody of the various bureaus of psychic researches.)

At the same time, the Surrealists were employing inkblots, rub-
bings, decalcomania, the exquisite corpse, and sundry other au-
tomatic methods, extending Hugo's experiments. Leonardo had
famously counseled his apprentices to stare long and hard at ruined
walls, whose cracks and stains contained an abundance of images
free for the taking. Hugo, innocent of any academic training, had

gone further and done actual violence to his materials in order to uncover the images they concealed. He did not succeed in liberating himself from the more operatic conventions of his time but he discovered, perhaps despite himself, that the road to transcendence runs through coffee grounds. We can only surmise what he could have accomplished had he foresworn imagining himself as an immortal. Maybe his case defines genius—the triumph of the canny unconscious over the most dubious premises of the conscious mind. Hugo's feet were stuck in the ether, but his vision kept touch with the ground.

1998

THE DETECTIVE

We know from photographs and eyewitnesses that René Magritte, throughout his entire career, did his painting in a corner of the dining room, and that he went about his work invariably dressed in suit and tie. The dining room presumably began as his studio during the lean years, when it was the least inconvenient possibility, but it continued to serve until the end of Magritte's life, when the room was filled with expensive formal furniture. The suit is documented in the two paintings he made of himself at work: *Attempting the Impossible* (1928), in which he is shown in a literal sort of way painting into existence Georgette, his wife and principal model, and *Clairvoyance* (1936), in which he is depicting a bird while studying an egg. In David Sylvester's *Magritte: The Silence of the World*, there is a photograph of a very young Magritte, in his student days at the Académie des Beaux-Arts in Brussels, applying a decorative pattern of what look like Art Nouveau leaves to a large canvas; his jacket and trousers do not match, but they are correct, and he is wearing a necktie.

Now, this is a bit extreme, even if we sometimes think of the en-

tire past, prior to 1968 or so, as an era in which men were never seen without suits and ties. It is difficult to imagine many other twentieth-century painters being so insistent on mundane formality; only Mondrian comes readily to mind. Even before Jackson Pollock, the archetype of the modern painter was a spattered and disheveled figure whose principal concession to appearances was an encrusted smock. Magritte's contrary propensity is not very surprising, even if we know little about him, in part because it is natural to think of his work as having been executed by his alter ego, the bowler-hatted man. This character, of course, is Magritte's signature motif, occurring over forty years of his career; seen from the rear, or frontally but with his face obscured, or in multiples. Magritte's relationship with this figure is ambiguous—he is more often the painter's homunculus than his self-representation. But Magritte now and then decided to inhabit his trademark, notably during the last years of his life, when he permitted Duane Michals to take numerous photographs of him wearing his bowler. He was also photographed wearing a bowler in 1938, nearly three decades earlier, and in this picture he is next to *The Barbarian* (1927), his painting of Fantômas either emerging from or melting into a brick wall. He is striking the exact same pose as Fantômas, a chin-on-hand lean that somehow contains a swagger, but while the master criminal sports evening dress, with a topper and a domino mask, the painter wears a sober dark suit, and that hat.

The effect manages to be one of defiance. Magritte could be posing as Juve, the implacable adversary and celestial twin of Fantômas. Or he could be proclaiming his adherence to Flaubert's commandment: "Be methodical in your life and as ordinary as a bourgeois,

so that you can be violent and original in your work." Or he could be demonstrating the excellence of his camouflage, superior even to that of his subject. In a sense he is doing all three. Magritte makes a rather ambivalent detective, but that is the best kind. He was fifteen years old when the first of the Fantômas books appeared, and along with the rest of his generation he was suckled on the adventures of Nick Carter and other dime-novel heroes. He commemorated one of them, Nat Pinkerton, in the journal he issued on postcards, *La Carte d'après nature*, in 1953. This account of a day in the life of the fictional detective (whose name was borrowed from that of the real-life private-eye agency founded by Allan Pinkerton) is entirely without drama. The detective goes to his office, smokes a cigar, writes a letter, enjoys lunch in a fancy restaurant, reads a book, while his lieutenant does all the actual work.

> He returns home at nine-thirty. His wife and his mother-in-law are waiting for him in the dining room and together they eat some meat and some vegetables. The detective does not speak about his work in front of his family. He busies himself with his wife and mother-in-law, writing a play with suitable roles for both of them, since they are actresses. At bedtime he kisses them and then makes for his private bedroom for a night of restorative sleep.
>
> (translation by Suzi Gablik from her *Magritte*, 1970)

Although there was no actual mother-in-law in the picture, and no acting career—or any other—for Georgette, the tone here is probably not too far removed from that of the Magritte household. All

the struggles, the emotions, the pangs, the discoveries take place between the lines.

But they take place nevertheless. What makes Magritte a superb detective (the resemblance of his name to that of his compatriot Simenon's Maigret is, by the way, entirely fortuitous) is his methodical, persistent, and subtle nature; what makes him an ambivalent one is his relation to the law. Marcel Mariën, a younger Belgian Surrealist writer and the publisher of the influential review *Les Lèvres Nues*, claimed in his autobiography that he and Magritte successfully conspired in a series of art forgeries in the 1940s, with Magritte imitating the likes of Picasso, de Chirico, and Ernst, and Mariën selling them off to unsuspecting Belgian bourgeois, the proceeds going to finance books and magazines—some of them manifestly expensive to produce)—that the two issued at the time. The only trace of these fakes that David Sylvester was able to turn up is a work signed "Klee" that emerged among Georgette's effects, which is an obvious fraud and may have been a reject. Magritte certainly had the aptitude for this sort of work, as is demonstrated by the knowing pastiches of Picasso and de Chirico that show up in less deceptive contexts in his paintings, and the pursuit would not have been out of character.

Belgian Surrealists are sometimes mistakenly thought of as more tame than their French counterparts, a reputation that likely came about because of their inability to hew to André Breton's dictates for very long. Magritte's own rupture with the Surrealist commissariat came about when Georgette refused to remove a pendant cross, which had been given to her by her grandmother, on a visit to Breton's apartment. Breton, who collected totems, Kachina dolls, and every other sort of sacerdotal icon but could not tolerate sym-

bols of the Roman religion, took badly to this; the Magrittes, who were no more Christian than he was, walked out. Painter and poet later made up, but Magritte was never again a signatory of collective publications emanating from Paris. He did, however, sign proclamations every bit as subversive, if often less pompous, issued by the Brussels group, which included Paul Nougé, a poet and ideologue who did not have quite the hold of a Breton over his colleagues; Camille Goemans, a writer and art dealer; Louis Scutenaire, a poet known as Jean Scutenaire during his daytime life as a lawyer; and the collagist and poet E. L. T. Mesens, who also dealt in Magritte's work, with the result that the two had a frequently acrimonious relationship that lasted nearly fifty years. These men do seem to lack the color of the Parisian set. For one thing, several of them had actual jobs (Nougé was a biochemist, for example); for another, they failed to possess much in the way of marketable eccentricities. They did not include a somnambulist like Robert Desnos, or a matinee-idol visionary like Antonin Artaud, or a performing flea like Salvador Dalí, or anyone who looked as Harpo Marxian as Yves Tanguy.

Being Belgian was, in any event, something of a handicap. Sylvester reports that Magritte's friends solemnly advised him, during his attempt to live in Paris during the 1920s, that he should work on minimizing his Walloon accent, although he apparently enjoyed deliberately emphasizing it. And there was and is a certain grayness and inconspicuousness built into the Belgian character, an indisputable boon for a philosophical detective like Magritte, enabling him to blend in with his surroundings and make his style seem like an absence of style. Magritte grew up in the most industrial part of the Hainaut, the most industrial province of Belgium. Lessines and

Charleroi, where he lived until late adolescence, are monochromatic places marked by a lot of uniform brickwork and surrounded by slag heaps, smokestacks, and the open flames of refineries and glass works. And yet they are not merely monotonous—Charleroi has tall, curving arcades and gratuitous colonnades and a certain sinister grace to it. But grayness does predominate, and so it is not surprising that one of Magritte's dominant modes is the grisaille. The series of paintings he made in the mid-1950s, in which figures, background, and even the sky seem to be made of gray stone, might be tributes to the landscape of his youth, although they might just as well refer to the grisaille backs of the shutters of Nederlandisch triptychs. And Magritte's bowler-hatted man, the equivocal citizen of the twentieth century, is also the middle-class Belgian, an agent who works in such deep cover that he may not be aware of it himself.

Magritte's primary activity as a detective is, naturally, solving problems. These problems have the routine missing-necklace or kid-napped-heir conundrums faced by Nick Carter and Nat Pinkerton beat by a mile. Neither they nor Juve or Maigret ever had to contend with such matters as *What happens to the human face if it can be broken like an eggshell?* or *Can we assume that the window is merely a passageway to a landscape, and not its actual location?* or *Who says the sky can't be sectioned up into cubes like cheese?* One of Magritte's advantages is that he can both propose and dispose—sometimes the problem is the interesting thing, sometimes the solution is. *What would be the result of interbreeding between a bottle and a carrot?* mere-ly sounds like a feeble set-up for a dirty joke, but the pictured result (*The Explanation*, 1952) is troubling and potent. On the other hand, there are works like *Hegel's Holiday* (1958), in which the premise (a

dialectical object, effortlessly embodying a contradiction) is far more enticing than the rather pedestrian manifestation (a glass of water sitting atop an umbrella). But then, such works as this—smoothly iconic images without much "painterly" interest, which occasionally seem to be as much highly refined products of Magritte Enterprises, Inc., as they are the results of disinterested speculative activity—are often deceptively bland. All those images that have been commodified as designs for posters, greeting cards, coffee mugs, T-shirts, record jackets, corporate logos, etc., ad nauseam, are broad and simple in a way that links Jasper Johns's use of the flag and Andy Warhol's representations of Brillo boxes with Alfred Hitchcock's famous statement that when he wished to depict Switzerland in a movie, he showed the Alps, watchmakers, and chocolate, and if he wanted to show Holland he used windmills and tulip fields. Those pictures were conceived as advertising images, in other words, even if they were not really intended to advertise anything but their own limitations.

But it may be that this aspect of Magritte's work has become altogether too familiar; we've seen the picture of the pipe that announces it is not a pipe so many times we no longer register it. The second-hand uses of that and other images have just about overtaken the originals. On the other hand, we can now look freshly at Magritte's "vache" period of the late 1940s, for which he was castigated at the time. This is the work that is so blatant in its imagery, so frantic in its brushwork, so overloaded in its coloring that it must indeed have given everyone in the solemn art world of the time a splitting headache. Plaid was a big motif in this period of his, followed closely by nose-as-penis. The work looks like nothing so much as the miss-

ing link between James Ensor and Zap Comix. It followed closely on another series, equally unpopular in its time, in which Magritte painted garishly sexual Surrealist tableaux more or less in the manner of late Renoir. The failure of such wild formal deviations led him into his last phase, which took up most of the rest of his life, in which he established problems, sought solutions, and manufactured numerous variations—his lifetime output approaches some two thousand canvases, not counting gouaches, drawings, and collages.

Part of the reason for this was sheer economic necessity. Although he was famous, Magritte in the late 1940s had an income roughly equivalent to a mid-level employee's, but without the job security. But another major factor must surely have been his need to produce, to issue goods into the world in a way that befitted his sober and industrious persona. It may now have become a bigger puzzle than any of those proposed in the paintings themselves, this notion of a painter who pretends to be a minor commercial functionary, an aesthetic and sometimes political radical who comported himself as if he were a police official. We are perhaps so inured to the idea of artists decorating and displaying their own lives that the notion of one who shirks this sort of activity seems shockingly unusual. More likely, though, Magritte's life-as-art conceit was so seamless, and ran so deep, as to be nearly impenetrable. He became his own disguise.

1994

THE CLEAR LINE

In a corner of my office, on top of a bookcase, lies a hunting horn—a sort of bugle, curved in the manner of a French horn. It has occupied a place in my inner sanctum wherever I've lived since childhood. Such horns are not hard to find secondhand in the Ardennes Mountains of southern Belgium, since these days there's not much call for them by hunters of the stag and the boar. The reason I talked my parents into buying me this horn can be found in the fifth panel on page four of the sixth adventure of Tintin, *The Broken Ear*. The panel shows Tintin visiting an artist's garret, a low skylit room with a bed on the floor amid a panoply of artistic bric-a-brac: a plaster bust, a horseshoe, a sixteenth-century helmet, a skull, a few paintings and sketches, and, directly above the pillow, a hunting horn. Since I wanted to be an artist at an age when most kids want to be firefighters, I knew that I would one day live in a room just like that, and wanted to get started accumulating the props. Possession of such a horn would ensure my future as an artist. The Tintin albums were never wrong about such things. Had I wanted to be a

sea captain instead, I would have pestered my mother into knitting me a blue turtleneck sweater with an anchor motif on the chest, the kind worn by Tintin's friend Captain Haddock. The sweater would automatically have conferred upon me the authority to command a vessel.

But if the adventures of Tintin were my guide to life (and worryingly, perhaps, they still are; just a few years ago I bought a floor lamp at a flea market because it looked like the sort of thing Tintin would have in his living room), they were also the reason I wanted to be an artist. I was not alone. Because of Tintin, kids in Belgium, where the series and I both originated, aspire to draw comic strips the way their American counterparts want to start rock bands. I was typical: as soon as I could draw recognizable figures, I started working on a comic strip featuring an adventurous lad and his faithful dog. But even Belgians with no discernible talent have incorporated Tintin and his world-view into the fiber of their beings. The boy reporter made his debut in 1929 in the children's supplement of a Catholic newspaper, crudely drawn at first, but with his personality and that of his white terrier Milou (called "Snowy" in translation) fixed almost from the first panel of *Tintin in the Land of the Soviets*, the first adventure. That he was an ageless kid, of less than medium height and of an uninsistent modesty despite his many accomplishments, answered to the best aspects of the suffering Belgian self-image. Overnight, or almost, he became a national icon.

Tintin is of indeterminate age; he can drive a car and shoot a gun but is said at least once by another character to be "hardly more than a child." He is invariably called "the boy reporter" in the fictional newspaper and radio accounts that are quoted within the panels,

but is never seen doing any reporting or writing nor is any such work ever otherwise alluded to. He has a nice apartment and a substantial library although no apparent income; his constant travel might be paid for by law-enforcement agencies—Interpol, maybe—since the trips always lead to the solving of some crime or other, but he is never seen being assigned, debriefed, supervised, or compensated. He has no parents or any other relatives unless you count the all-male elective family he accumulates over the course of the series: Captain Haddock, the eccentric Professor Tournesol ("Calculus" in translation), and the twin detectives Dupont and Dupond ("Thompson" and "Thomson"). Milou (I can't bear to call him "Snowy") goes with him everywhere, including to the moon, where he has his own four-legged spacesuit. Tintin has a little tuft of blond hair sticking up in front, and unless he is in costume or disguise he wears the clothes of a jaunty youth of the 1930s, including plus-fours with argyle socks. My father, who was short, blond, and usually wore plus-fours, was called "Tintin" by his friends back before the war, although by the time I knew him his hair had turned black.

I began absorbing Tintin before I learned to read. I know that my father's mother gave me a subscription to the Tintin weekly magazine before she died, which was sometime around my fourth birthday. I'm pretty sure the magazine was then serializing *Tintin in Tibet*, the twentieth of the twenty-three volumes—twenty-four if you count the one left in rough sketch form by the death in 1983 of Georges Rémi, known as Hergé, who wrote and drew the series and refused to consider a successor. Hergé attained his peak of productivity in the '40s, right in the middle of the war, when he published his strips in the Brussels daily *Le Soir*. The paper from those years is

referred to as *Le Soir volé*—the stolen *Soir*—because it was overseen and censored by the German occupiers. Unlike most collaborators, Hergé got little more than an administrative slap after the war, and hardly any public opprobrium, because it was so clear he was an innocent by nature. His ideology was conservative, but it was molded for all time by the Catholic Boy Scouts. His world-view was that of a serious-minded twelve-year-old.

A serious-minded Belgian twelve-year-old in, say, 1939 would think of the colonial subjects in the Congo as simple, happy people who derived enormous benefits from being colonized. You couldn't expect them to understand complex matters, but at least you could send in the White Fathers to convert them to the Roman religion and stop them from eating each other, or whatever it was they did. *Tintin in the Congo*, book number two, makes for painful reading today, and not only because Tintin is so determined to bag every sort of big game that, unable to shoot a rhinoceros, he blows it up—although he uses too much powder and is left with just the horn. The caricatures of foreign cultures in the Tintin books are hardly virulent, just indicative of a smug ignorance pervasive throughout the Western world then, but the treatment of the Congolese is shocking because its grotesque simplifications had to have been based on self-serving firsthand accounts by the colonizers. To confirm this, all I have to do is look in my family album. My Uncle René, a drunken ne'er-do-well who lived in the Congo in the 1950s, is pictured with a much more mature-looking African gentleman standing a few paces behind him; this man is identified on the back as his "boy." The English word was used to mean "manservant" for obvious reasons—it wouldn't do to think of the Congolese as adults. Tintin is not an adult, either; he is

the champion of youth, fighting the scary and corrupt adults of the world on their behalf. In the Congo these inimical adults are nearly all white, while the natives belong to Tintin's constituency regardless of their ages—it is the only country he visits where everyone recognizes him. When he leaves, the people cry.

Possibly the most striking thing in the Tintin universe is the almost complete absence of women. Of the 117 characters pictured in the portrait gallery on the endpapers of the hardcovers, only seven are female. Women are thin-lipped concierges or very occasionally the silent consorts of male characters; few have more than walk-on parts. The only significant or recurring female character is the overbearing diva Bianca Castafiore, who periodically appears to sing the "Jewel Song" from Gounod's *Faust*, a performance that has the effect of a gale-force wind. This is not so much misogyny as, again, the perspective of a nerdish pre-sexual twelve-year-old. There are no young girls, or attractive women of any age, because the frightened boy is determined not to see them. Tintin has been psychoanalyzed voluminously—the critical literature is vast, and canted upon every sort of postmodern theoretical framework—so that I'm certain that some academic somewhere has already suggested how much Tintin's family, as it were, resembles the Holy Trinity: the boy reporter as Jesus, Captain Haddock as an irascible Old Testament Jehovah, and Milou—small, snow-white, and ever-present—as the Holy Ghost. You might still expect women to hover on the periphery of consciousness as mothers and whores, although both would distract from the serious business of adventure and crime-fighting, and introduce all kinds of unwanted ambiguity. Hergé, ever the Boy Scout, simply excised them.

Hergé redrew the first several stories (with the exception of the irredeemably crude *Land of the Soviets*) for their postwar publication in album form. Nevertheless, they are set in a period that, while undefined, necessarily predates May 1940, when the Nazis invaded Belgium. Even the later stories seem to take place in the 1930s, although none of us kid readers of the late '50s and early '60s minded or even noticed, since until the "economic miracle" of 1964, postwar Belgium itself effectively lived in the prewar era, at least with regard to technology. The world of Tintin's adventures is one in which servants wear livery, savants wear long beards, men emerge from fights with their false collars jutting out, and the lower orders are identified by their caps. The world is big enough to include little-documented countries you've never heard of, although no subject is so obscure that there isn't in Brussels some smock-wearing expert who knows all there is to know about it, and possesses the book- and artifact-stuffed apartment to prove it. It is a cozy world in which every detail is correctly labeled and filed away on the appropriate shelf. The world may contain its share of evil, but it is regularly swept and, like Belgian sidewalks, washed every week. There are no areas of gray. Villains—they are most often drug smugglers, sometimes counterfeiters—look and act like villains, and if heroes have their share of human failings (Captain Haddock's alcoholism being the major case in point), there is nevertheless no doubt about the purity of their souls. Sex, of course, would mess up everything.

The clear moral line is beautifully expressed by Hergé's graphic style, which is in fact called "clear line." This method of rendering the world accurately, sensuously, and yet very simply by distilling every sight down to its primary linear constituents derives most obviously

from the eighteenth- and nineteenth-century Japanese popular woodblock-print style called *ukiyo-e*, and its masters Hiroshige and Hokusai. Those graphic artists were introduced to European eyes in the late nineteenth century, when their work had a particular impact upon the French Impressionists, especially Manet and Degas, who learned from them the value of cropping and of visual shorthand. Hergé absorbed not just those lessons; he swallowed their style whole. He enclosed every particle of the visible, no matter how fluid and shifting, in a thin, black, unhesitating line; made that line carry the burden of mass and weight without modeling; and endowed the line with an accomplice in the form of pure, clear, emphatic but not garish color. The style makes the world wonderfully accessible, in effect serving as an analogue to its hero's mission: just as Tintin, a mere boy, can travel the world and navigate its dark passages and defeat its oppressors without himself succumbing to corruption, so you, too, whether you are seven or seventy-seven (the advertised age-range of the weekly), can confront the overwhelming various-ness of the perceptual universe and realize its underlying simplicity without sacrificing your sense of wonder. And that is the core of Hergé's genius: to mitigate his young audience's fears and convert them into sensual delight.

When Tintin, menaced by Chicago gangsters in *Tintin in America*, must exit his hotel room through the window and make his way to the next one by inching his fingernails and shoe soles along the mor-tar between the bricks, the young reader prone to acrophobia (me, that is) can translate his trepidation into pleasure at the magnificent geometry of those many unyielding rows of windows as depicted very precisely from a dizzying oblique angle. The terror of suddenly

coming into an entirely foreign landscape—notably, Shanghai in
The Blue Lotus—can give way to joy at the immense panels of streets
crowded with very individual pedestrians and surmounted by over-
lapping ranks of colorful banners and signs filled with intriguing if
indecipherable Chinese characters. (For this volume Hergé sought
the advice of a young Chinese artist then resident in Brussels,
Chang Chong-Jen—who became a character in the story—so that
the details possess particular authenticity.) The great heights, deep
cold, and blinding snows of Tibet; the *horror vacui* of the featureless
Sahara; the threat of a tempest at sea as experienced on a raft; even
the empty and unknowable surface of the moon (circa 1955)—all of
these can be not only managed but appreciated. To say that Hergé
domesticated those locations and experiences would be putting the
emphasis in the wrong place. What he did was to bring them into
the child's compass, not only through the heroic surrogate of the boy
reporter, but also visually, by scraping away murk and muddle and
purifying it, revealing the world as an awe-inspiring but comprehen-
sible series of planes.

In every way but the visual it is easy to dismiss the simplifications
of the series. They are the legacy of the comfortable world view that
rationalized colonialism—that complacently taught African children
in French possessions to remember "our ancestors, the Gauls." They
are of a piece with the creed of scouting as devised by Baden-Powell,
with pen-pal clubs and ham radio and collecting stamps, which
Walter Benjamin said were the visiting cards left by governments
in children's playrooms. They belong to the same branch of litera-
ture as the Rover Boys and Tom Swift and the travels of Richard
Halliburton. They are predicated on nostalgia for a world in which

strength rested upon ignorance, and this was so even in the ostensibly simpler times in which Hergé conceived them. Their world is the cosmos of childhood, after all, and childhood past is what all nostalgia refers to, even if wrongheaded adults insist on situating it within historical coordinates. The visual, by today's lights, might be diminished just as easily, you might think, considering by contrast the dark abstract tangles that represent the world in many of today's strips, including some of the better-known superhero adventures, or noting that the heirs of the clear line, most famously Joost Swarte, have applied it to an ironically jolly delirium in which there are not only no moral certainties, but not even any definite up or down or inside or outside. That the adventures of Tintin remain unsullied by maturity or experience allows them to preserve their power as a visual primer. They are an Eden of the graphic eye, in which every object—each shoe, each road, each flame and book and car and door—is in some way the first, the model that instructs the beholder on the nature of the thing and makes it possible to grow up knowing how to cut through fog and perceive essentials. What Hergé did is as serious and as endlessly applicable as geometry. Small-minded, reactionary, immature, he is not the Rembrandt or the Leonardo or the Cézanne of the comic form—he is its Euclid.

2004

THE HUNGER ARTIST

The photographs Walker Evans made of the small-town, dirt-farm American South in the 1930s for the Resettlement Administration and the Farm Security Administration and for *Let Us Now Praise Famous Men*, his 1941 collaboration with the writer James Agee, are definitive and so characteristic that today it might almost seem as if he not only made the pictures but, like a novelist, invented their subjects as well. Conversely, because the pictures are so rigorously plain, you might think that he just got lucky, happened to be there with a lens and a shutter, as if anybody remotely awake in that place at that time could have done the same. But there were other photographers working the same beat then, and their pictures don't look much like Evans's. Either they strove for the messages and sentiments and aphorisms that Evans barred from his work, or else they allowed themselves a style. At his peak, Evans possessed a conjuror's genius for making art that appears neither to be art nor to have been consciously made.

His work embodies a way of seeing that at once is entirely Evans's

and stands independent of him. You can go out, even now, into the villages and the slums and the dead factory towns of America and find scenes and views and details that might as well carry Evans's copyright. Evans did not invent those things, obviously, any more than William Harvey invented the circulation of blood. What Evans discovered was the ability to see them, and to see them as art. He was not the first person ever to photograph a billboard or a tar-paper shack or a heap of refuse, but he absorbed all his predecessors and put them retroactively in his debt, and he likewise indebted anyone following him who would photograph any of those things. Since "those things" refers to such a vast pool of sights, such a comprehensive inventory of the hand-made, worn-out, jury-rigged, lost-and-found, inadvertent, make-do, hand-me-down, faded-glory, Mulligan-stew aspects of America, he perforce owns a very large portion of the national legacy.

This business was lying around for all to see, touched upon but generally unclaimed, waiting for someone to define it, and Evans came along and carried it away. What quality did he possess that enabled him to do this? It was a combination of three factors: he was impeccably Middle American in provenance, born Walker Evans III in St. Louis in 1903 and raised in Kenilworth, Illinois; he was of an age and temperament that allowed him to collide with European modernism at its apogee, in Paris in the late 1920s; and he was a collector, magpie, pack rat, and scopophiliac of the first water. The circumstances of his birth and upbringing steeped him in his subject matter; his culture and travels enabled him to see it with fresh eyes, through the lens of a movement that sought to reevaluate the whole world; and his acquisitive instincts impelled him to claim it for himself. But who

was Evans? Was he merely an eye, an appetite, an accretion of histori-
cal conjunctions? The figure detailed in biographies is distressingly
human: prickly, snobbish, selfish, cold, more than a bit narcissistic.
The character who in his later career, in the 1950s, fit all too well
into the corporate culture of *Fortune* magazine, who seemed primar-
ily interested in joining clubs and affecting English mannerisms and
collecting Lobb shoes, just doesn't seem big enough for his work. We
might resort to thinking of Evans as some free-floating ocular orb,
or a particular current floating through American culture from the
mists of the Jacksonian era straight across to our day, or, like a charac-
ter out of Borges, an eternally recurrent Evans, a three-dimensional if
barely incarnate sensibility not unlike Borges's notion of Kafka as an
author whose body of work begins with Zeno's paradox—even if he
didn't begin accruing biographical details until 1883.

You can find avatars of Evans in the work of the great Civil War
photographers; in pictures by Alexander Gardner and Timothy
O'Sullivan and William Henry Russell and George Barnard you
can see Evans's plain style, his head-on approach, his interest in
vernacular architecture, his fascination with rhyming and repeat-
ing shapes. Those traits can be found in profusion in the work of
small-town professionals of the late nineteenth and early twentieth
centuries. The most remote whistle stops, Corn Belt county seats,
isolated range-country crossroads all had their photographers, who
were called upon not only to produce portraits of the prominent, the
newborn, the newly married, and the newly dead, but also to record
aspects of daily life ranging from livestock to disasters, barn raisings
to shop interiors, fair exhibits to record hailstorms. When their work
came to be disseminated beyond their separate bailiwicks by the rise

of the photographic postcard as of 1905, it became evident that they shared a style, distinctly American and a pole away from that of the art photographers in the major cities, the ones who might publish in Alfred Stieglitz's *Camera Work*. Any random sampling of this folk photography presents numerous examples prefiguring Evans's mature style, sometimes in startlingly literal ways. The art photographers loved mist and murk, ambiguous light, unusual angles, and they avoided the vulgar and the ephemeral, signs and displays, loungers and crowds. The rural photographers did just the opposite on every count, not for theoretical reasons but out of practicality and instinctive inclusiveness. Evans only needed to have been alive in the middle of the country in the decade before World War I to have been exposed to this semi-accidental aesthetic.

Evans came from a line of unexceptional businessmen. He grew up in a Chicago suburb in which all the streets were named after people and places in the novels of Sir Walter Scott. His own childhood bore a greater resemblance to the works of the Indiana novelist Booth Tarkington (*Penrod*, *The Magnificent Ambersons*), at least up to the point when Evans Sr. dumped the family to move in with his favorite widow. He was a largely indifferent student who climbed a rickety ladder of secondary institutions, after which he spent a year at Williams College and that was that. His future career seems nowhere foreshadowed. He actually had vague literary ambitions which culminated in the standard year in Paris. This failed to produce the standard novel, although his literary ambitions remained in evidence as late as 1932, well into his photographic career—he produced paragraphs and pastiches at irregular intervals and translated part of Blaise Cendrars's novel *Moravagine*, publishing an excerpt in the

New York-based little magazine *Alhambra*. If he did not return from Paris with a manuscript, he did return with some precocious snapshots, interesting if not unprecedented street scenes and studies of the shadow of his silhouette. Upon his return in 1927 he made friends with a German boy who had a Leica and they went around photographing New York City.

Evans's pictures were serious right away. He had absorbed European modernism, and 1927 was a good year to apply it in New York—the skyscraper boom was on. Had he fallen off a parapet in 1928 he would hardly be a household name, but he would still rate mention in larger histories of American photography. Although his pictures of construction sites and midtown canyons and high-rise clusters may not be the last word in originality, they are strong and jazzy, full of self-confident shadows and blanks. Moholy-Nagy or Rodchenko on site could hardly have done better. He also took dramatic, looming pictures of the Brooklyn Bridge, three of which were used in the first edition of *The Bridge* by Hart Crane, a friend of his. Few of these photographs of architecture would be immediately identifiable as Evans's in a blind test, but recognizable elements of his burgeoning style appear remarkably soon.

His lifelong preoccupation with signs, for example, starts showing up as early as 1928. Maybe the words are at first artistically truncated, as in his delicate little cubistic studies of Coney Island, which dance around "Luna Park" and "Nedick's" without ever rendering either name in full. Before very long, though—and all we can do is conjecture the sequence, since few of the early pictures are reliably dated—he is sufficiently confident, or entranced, to serve up a four-square image of workmen unloading an enormous sign from a

truck; "DAMAGED," it says. Around the same time he made "Times Square," a darkroom montage of colliding neon words that has to be one of the most self-consciously arty things he ever produced, and yet today its artiness itself looks pop. It could easily be a process-shot still from an early Hollywood musical, the blur of signage that dazzles Betty or Ruby as she gets off the bus from Sioux Falls. There was something about Evans that could not stay rarefied for long. By that time he was collecting faces, too, many of them as bluntly frontal as Paul Strand's 1916 "Blind," the one photograph Evans admired in the entire run of *Camera Work*, and indeed the only image in that forum that could not have been handled more directly in a popular medium. His earliest iconic image, "42nd Street" (1929), is a twofer. Stage center is a stout black woman in a cloche and a huge fur collar, taxis rushing by behind her; to the right are the steps of the elevated train station, with "Royal Baking Powder" on the riser of each step. Either just before or just after making that picture he made a study of the steps by themselves.

But at the time he was still casting about, trying on different photographic hats, making Umbo-like or Rodchenkoesque perpendicular shots of pedestrians on the street below, middle-period Paul Strand domestic interiors in which unassuming lamps or chairs are pinned to the wall with giant shadows by a megawatt flash, Man Rayish double exposures presumably portraying the subconscious existence of his raffish-looking subject Berenice Abbott. Abbott had just returned from a lengthy sojourn in Paris, during which she had redirected her ambition from sculpture to photography. One of the principal reasons for this change was her encounter with the person and the work of Eugène Atget, and when he died in 1927 she suc-

ceeded in purchasing a large portion of his archives. Seeing Atget's
work must have given Evans a jolt. In Atget, as his biographer Belinda
Rathbone writes, "all of his latent instincts were combined: a straight
cataloguing method imbued with an inscrutable melancholy, a long
look at neglected objects, and an unerring eye for the signs of popular
culture in transition."

His chance to take up Atget's lead came soon. In 1930 Lincoln
Kirstein, who had already published some of Evans's work in his
journal *Hound and Horn*, decided to collaborate with the poet John
Wheelwright on a book about American architecture. Evans was to
illustrate it. He was trying out the 8x10 view camera, having received
instruction from the photographer Ralph Steiner (who with his in-
terest in signs and front-porch bric-à-brac and his head-on method
of portraying them was something of a proto-Evans). The book was
never written, but Evans took pictures of Victorian houses, grave or
preposterous, with a directness and a hush often worthy of Atget.
Evans was sure of himself by then, and his interest in decay clashed
with Kirstein's mission; he was concerned neither with nostalgia nor
with preservation. In a review in *Hound and Horn*, Evans had pro-
posed that photography's task was to catch "swift chance, disarray,
wonder." Even more to the point is what he wrote thirty years later
in an unpublished note: "Evans was, and is, interested in what any
present time will look like as the past."

This notion, maybe not so precisely articulated, must have been in
his head by the early 1930s. As of 1932 or so all the derivative striv-
ings are gone from his work, and instead there is an urgent drive to re-
cord, combined with an eerie detachment—the eye of the future. He
was photographing doorway sleepers, park-bench sitters, truckers,

anonymous crowds, torn posters, painted signs on buildings. There is no apparent style by this point, and yet the pictures could be no one else's. Meanwhile, Berenice Abbott was herself walking around New York City under the spell of Atget, photographing newsstands and grocery-store sidewalk displays and geological strata of torn posters, among other things, but you seldom mistake her work for Evans's, or vice versa. Generally speaking, Abbott's pictures are three-dimensional—her newsstands and fruit stands have an illusionistic power that makes you want to reach in and pick something up—whereas Evans's are most often flat, nailed to the picture plane somehow even when the subject is presented in three-quarter view. Evans, determined to strip his pictures of affect, could turn his subjects into specimens, his street scenes into friezes, his portraits into "Wanted" posters. He could be dispassionate to the point of cruelty, which is one reason his portraits from this period can be so affecting: their subjects' emotional projection feels unusually hard-won.

In 1933 Evans went to Cuba to take pictures to illustrate Carleton Beals's book *The Crime of Cuba*, an exposé of the then-current dictatorship. He followed his own inclinations, aesthetic to the detriment of outrage. Not that this made his pictures appear superficial or disdainful or dandyish—his eye sought the elite, but he found its membership everywhere. He wasn't interested in just any crude handmade signs, for example, only the ones with style, whether or not the style was intentional. His people are never grotesques—even his cops and landlords have a certain flair about them, and his peons and beggars and idlers are seldom less than beautiful. The studies he made of grime-encrusted Cuban dockworkers have an impossible panache; each is wearing a different hat, and each one wears it definitively. In

the Cuban portfolio can be seen a précis for the work he was to do a few years later for the FSA. The themes are all struck one after the other: the elegant bystanders, the curbside loungers, the uncertain crowds, the ironically garish movie posters, the ad hoc enterprises, the accommodations of architecture, the poetry of display. As a bonus he threw into the package pictures—of riots and corpses and wreckage—that he found in the files of local newspapers. Except that he seldom if ever photographed action, nearly any of them could be his work, not that he was trying to fool anyone. The desire to possess was never far from the surface with Evans, and you get the feeling he rarely photographed anything he wouldn't have been happy to have made himself.

Wherever he went, Evans thought of himself, consciously or not, as documenting Pompeii just before the volcano blew. He knew that the monuments would be excavated and restored. What would be obliterated were those small and handmade or loud and disposable objects—advertising, whatever its less savory qualities, is always highly perishable. It's not that he wanted to save those things from obliteration, exactly. He loved decay, entropy, ruin, and he liked nothing better than to witness its progress. It was an ongoing activity on the part of nature that could be considered art, that created even as it destroyed. He prized the vulnerable human gesture equally for its heedless bravery and for its unavoidable doom. He preserved it in photographs not because he wanted to arrest its disappearance, but because he wanted to participate in its making.

Beginning in 1935, hired by Roy Stryker of the government's Resettlement Administration (later the Farm Security Administration) with a shifting mandate to document misery, its

engineered relief, and ultimately the sundry details of daily life as he found them, he worked his way down through Pennsylvania and West Virginia, eventually to Louisiana and Mississippi and Alabama and the Carolinas. As a government employee he was difficult, demanding, headstrong, arrogant, uncommunicative, late, and sometimes extravagant; he also made many of his most famous, most lapidary pictures. He photographed the things he was interested in and pretty much ignored orders, direct or otherwise. He was not about to produce propaganda. For that, Stryker could call upon Arthur Rothstein, Russell Lee, Marion Post Walcott, John Vachon, the brilliant and very committed Dorothea Lange, or Evans's old friend Ben Shahn, who was equally committed. He traveled with several cameras, and often took the same picture twice, or with a minor variation, sending one to Washington and keeping the other for his own files.

Evans took pictures of factory towns, car dumps, antebellum mansions, Civil War memorials, movie theaters, soil erosion, store interiors, gas stations, shanty towns, Negro churches, billboards, photographers' window displays, minstrel show posters, flood victims. He also took pictures of the Tengle, Fields, and Burroughs families, tenant farmers and half-croppers in Hale County, Alabama, for a joint project with James Agee that was to be called "Three Tenant Families" and published by Agee's employer, *Fortune* magazine. It ended up instead as *Let Us Now Praise Famous Men*.

The two spent the summer of 1936 with the three families, Agee actually living in the Burroughs cabin and writing by lantern light on the porch, Evans repairing to a hotel at night. The article stretched and then burst its bounds, and was predictably turned down by *Fortune*. Agee's text is tortured, biblical, self-recriminating, exhaus-

tive, exhausting, and (some still disagree) magnificent. He systematically picks through every conceivable aspect of the families' lives, and ceaselessly worries at his relationship to them, all the while explaining that the book is a mere preface to a larger and fuller treatment. Along the way he makes an inventory of every single object in the Burroughs house, in effect writing a parallel to Evans's photographs. The photographs, of course, possess the immediate advantage of letting you see, for example, all four calendars in the Tengle parlor at once, along with the multiple copies of holy pictures and the dime-store die-cuts and the copy of *Progressive Farmer* that also adorn the wall, and the ink and patent-medicine bottles, the scarred mantelpiece, the mottled wall itself. But the two parts of the book (Evans's portfolio precedes the title page and contains no captions) do function as partners. Agee supplies the dimension of time, for one thing, not to mention moral debate, and each man seems to have pushed the other past his normal limits. In Evans's case, that includes an intimacy with his human subjects he seldom attained, or sought, before or after. The book sold some six hundred copies in its first year and was thereafter remaindered for as little as nineteen cents a copy.

But Evans was then just past the summit of his career. In 1938 the Museum of Modern Art, which had given him his first one-man show (of Victorian architecture) in 1933, allowed him free rein with the conclusively titled *American Photographs*. The show, which included one hundred photographs, marked that summit. The catalog, which has been reprinted many times, is an established classic. Evans rehung the pictures on the eve of the opening, recropping many of them, gluing all of them to cardboard and sometimes gluing the cardboard directly to the wall. The pictures in the catalog function

in time, one after another with a blank page facing each. In the show they were allowed to sweep across space in a breathtaking continuous reel, organized entirely by affinity while chronology and geography and conventional logic were overridden, each image seeming to suggest the next, the overall effect one of overwhelming Cinemascope and not too far from Surrealism.

That same year he painted a camera matte black and put it under his coat, its lens between two buttons, rigged a cable release down his sleeve, and rode the subway, accompanied by the young photographer Helen Levitt, snapping surreptitiously whomever happened to be sitting across the aisle. The result, not published until 1966 (as *Many Are Called*), is one of the greatest representations of New York City. You get the messengers, the housewives, the nuns, the dockwallopers, the wiseguys, the dandies, the domestics, the crooks, the anal retentives, the shopgirls, the immigrants, the sailors, the troglodytes, the common pests—in other words everybody—all of them unposed and unguarded, large as life and twice as natural, in the darkness of the old brown trains with their incandescent lights. Each figure is isolated and all of them are linked together, equalized by the circumstances, strangely beautiful in their absorption.

After that, Evans went to work for Time-Life, initially as a critic for *Time*, a wartime fill-in job, and later for *Fortune*, as a photographer with a measure of autonomy. Some of the work he did there was solid—a corrosive photo-essay on Chicago, for example, with its neighborhoods of formerly posh row houses reduced to freestanding ruins, and some pieces on other cities where he parked himself alongside a building and took pictures of people as they passed, like a street photographer working on spec. But he also went south again

in 1948 for an essay on Faulkner's Mississippi and found himself re-plowing old ground, minus the passion. He was a professional then, able to take pictures up to the very highest standards of magazine journalism, pictures that could be mistaken for the output of any capable and entrenched employee of the Luce empire.

But Evans wasn't finished yet. He began photographing in color at *Fortune,* and characteristically he achieved his freest and truest expression in color when he began observing its deterioration. At the end of his life, long after he had quit *Fortune* and had retired from teaching in the department of photography at Yale, he found a tool that might have been made for him, the Polaroid SX-70. He had never been a camera snob or even, although he was a superb printer, much concerned with the mechanics of his art (once when a student asked him what camera he had employed to take a par-ticular shot, he became irate, declaring the question tantamount to asking a writer what sort of typewriter he'd used). In his last years he made portraits of friends and students, studies of accumulations of objects (eggbeaters, umbrellas, beer-can pull-top rings), signs and portions of signs, and of course debris and decay. The SX-70 allowed for immediate gratification, and it allowed him to look at ever smaller details of scrawls and stencils, to contemplate the voluptuousness of cheap orange dye and the subtle gradations of rust. Beginning in the 1960s, he began spending increasing amounts of time looking down, at the street itself and the gutter. The crushed candy wrappers and the bottlecaps ground into the asphalt speak of their time the way the field of paper litter guarded by the uniformed backs of band mem-bers, in his earliest dated American photograph, tells us everything we need to know about the Lindbergh Day parade in 1927. Rubbish

was a primal element in Evans's lineage of subjects, the final filtration of the artifacts of humanity, the bottom layer of ruins.

Evans carried with him memories, like the ones we all carry, of how things had looked when he was first aware of the world in early childhood and how he had been confused and excited by those sights. He could see how such remnants of that world as still existed were no longer sharp and shiny but cracked, crazed, foxed, tattered, rusted, bent, and how those marks of time and weather and entropy carried their own highly transient beauty. He knew that a large component of the beauty those things displayed when they were new had resided in their imperfection and how the action of decay had only highlighted that imperfection. He might not have been entirely aware of how attractive imperfection is to the artist because it suggests an unfinished state that invites participation and thus appropriation. He was certainly aware of how vigorous and American imperfection is, since it suggests that the maker had no models to work from, was in fact building the first church or painting the first sign, an Adam dispensed from the weight of tradition whose mistakes will be richer than the successes of ten thousand perfected imitators. He knew very well that nearly everything he photographed would be gone in a few years or decades and be replaced by equivalents displaying all the self-consciousness their predecessors lacked. He was obviously aware that the objects he photographed would be so closely and unavoidably identified with him that it would be as if he had made them himself, but he might not have wanted to examine that fact too closely since spelled out it would have sounded like his obituary.

1998

THE DEPARTMENT OF MEMORY

1.

Michael Lesy's *Wisconsin Death Trip* caused a sensation when it came out in 1973. Nobody had ever seen anything quite like it: a book composed almost entirely of old photographs, without captions or comments, assembled in seemingly random groups separated by clusters of old newspaper items. There was text at front and back, the former tersely expository and the latter vaguely philosophical, but the connective tissue had to be supplied mainly by the reader's imagination. Furthermore, although the subject and setting were the stuff of traditional Americana—the rural town of Black River Falls, Wisconsin, and its surroundings approximately between 1885 and 1900—the book did not exactly cater to the market for nationalistic nostalgia. Rather, its focus was relentlessly morbid. The newspaper excerpts spoke of insanity, murder, arson, infanticide, suicide, vandalism, fraud, starvation, ruin, and epidemic disease. The pictures—of haunted, blasted faces incongruously decked out in the

252

fancy dress of the day—seemed to bear out the stories. You could look at the evidence in one of two ways: either Black River Falls was some weird, plague-stricken hole in the otherwise unblemished American tapestry, or else the whole notion of America's proud past was a myth.

Black River Falls is the seat of Jackson County, roughly in the middle of the state. In the late nineteenth century its inhabitants were mostly farmers, along with the usual complement of artisans, professionals, and marginal characters. Superficially, at least, it epitomized everything we imagine when we think of the American small town of the past. Its chroniclers of the period were the photographer Charles Van Schaick and the father-and-son team of Frank and George Cooper, newspaper editors. To assemble *Wisconsin Death Trip*, Lesy dug through the thirty thousand surviving glass plates of Van Schaick's archive and the microfilmed collection of the *Badger State Banner*, the Coopers' paper. He doesn't specify which trove first came to his attention; chances are it was the pictures, and that something about them compelled him to research their context.

Received ideas of Victorian propriety and tales of robber-baron excesses notwithstanding, the 1890s were a fairly grim period in American life, straitened and pocked by a succession of financial crashes. Life in the small towns of the period was harsh and often violent. Black River Falls suffered from the Panic of 1893, which shuttered banks and vaporized savings, as well as from farm failures and disease, diphtheria in particular. These disasters in turn led to other, more intimate disasters, such as madness and murder. Was Black River Falls exceptional in any of these matters? Not particularly. Is it possible that a similar book could be compiled about

another small town of the same era? Almost certainly.

Van Schaick was a competent professional photographer with no distinct style of his own, some of whose pictures attain memorability by virtue of what they document, some because of their unschooled and incidentally modern-looking plainness. The morbidity in his work seems striking today—the elaborate funeral floral arrangements that rated solo shots; the postmortem portraits, especially of babies. These, however, were standard subjects for the time. Many people were never photographed in life, particularly babies, and there was almost a moral obligation to preserve their mortal features before they returned unto dust. Many of Van Schaick's living subjects look tormented, even grotesque, but so do a large percentage of nineteenth-century photo subjects, especially rural ones. People didn't learn to smile for the camera until after World War II, and determined solemnity often comes across as dyspepsia (of course, many of Van Schaick's subjects might actually have *had* dyspepsia).

Lesy thumbs the scale, too, more than a little. The most surprising aspect of the book now is the fiddling to which Lesy subjects the photographs. He idly enlarges details, sticks in bits of engravings, chops up pictures to make montages, assembles kaleidoscopic tableaux of mirror-image duplications. Some of these effects look borrowed from psychedelic light shows and some from Terry Gilliam's animations for *Monty Python* (which in turn were derived from Harry Smith's films). Not all the pictures are thus treated, but those that are seem chosen at random, and the alterations serve no evident purpose except to disorient the reader. That, however, undermines Lesy's enterprise. The unmodified slices of life—the dwarf walking toward the saloon, the group portrait in white tie and blackface, the

amputee showing off his prostheses, the grim-faced family oblivious to the rowboat prop they are sitting in—set us down in terra incognita without any help needed, and their eloquence makes Lesy's scissors-and-paste exercises look all the more silly and forced. One reason *Wisconsin Death Trip* caused such a commotion in 1973 was that Americans weren't much used to mundane images of the past appearing anywhere but in their own family albums. But interest in historical arcana has grown steadily ever since, spurred in part by this book. Also, inhabitants of the mid-twentieth century automatically thought of the Victorian era as comical, the way we tend to think of the 1950s and '70s, and Lesy's book arrived as a corrective. People were also less willing to consider the imagination as a tool for examining history (it is significant that Warren Susman's preface invoked Walter Benjamin, then known primarily to graduate students); today, however, the notion of investigating the past like a detective sifting through clues has become commonplace. The revisionist approach to American history was not yet the fashion in 1973, either, and the idea that a small middle-American town in the decades after the Civil War might have exhibited signs of anomie and breakdown carried considerable shock value. Few then (or now) had read Charles Reznikoff's monumental two-volume poem *Testimony: The United States (1885–1915)*, a devastating catalog, compiled from court transcripts, of misery, cruelty, debauchery, and insanity that should be read to anyone who uses the phrase "traditional values."

It is understandable, then, that Lesy felt he had to exaggerate his case. From a commercial standpoint, at least, he was not entirely mistaken. Reviews of the book presented Black River Falls as a mystery,

a sinkhole of sickness and vice that had enigmatically appeared in the Currier & Ives landscape, like a medieval town gone crazy all at once from hallucinogenic ergot in its bread. When a few years later Lesy published *Real Life*, a collection of commercial photographs of Louisville in the 1920s that are no less corrosively revealing, but which are presented straight, with no creative monkeyshines on his part, it did not attract nearly as much attention. *Wisconsin Death Trip* was very important for the influence it exerted on attitudes toward vernacular photography and the American past, but it has now, unfortunately, outlived its usefulness.

2.

Anyone who cares about photographs has heard of the FSA—the Farm Security Administration—an obscure bureau tucked away in the skirts of the Department of Agriculture during Franklin Roosevelt's years at the helm of the American government. From 1935 to 1943, the FSA (originally the Resettlement Administration) served as the base for a vast project of photographic documentation that first covered the plight of farmers in the turmoil following the Depression, then gradually widened its focus to take in almost every aspect of American life. A number of the photographs taken under its auspices have become iconic: Dorothea Lange's "Migrant Mother," for example, or Walker Evans's view of Bethlehem, Pennsylvania, as a series of collapsed tiers—smokestacks succeeded by rowhouses succeeded by gravestones.

Such iconic photographs have stolen the show, giving the impression that the project—"The File," as it was called by its makers—was

a vehicle of protest, exclusively concerned with rural misery. Few are aware of its overwhelming ambition and scope. Michael Lesy's *Long Time Coming: A Photographic Portrait of America, 1935–1943* will correct misimpressions. Lesy, who made his name with the pioneering but flawed *Wisconsin Death Trip*, has been nibbling away at this theme for years, in the process assembling his own File, based on the archives of small-town photographers, postcard agencies, and government surveys. All of his books could be subtitled "A Photographic Portrait of America," and all of them can now be seen as leading up to this one. *Wisconsin Death Trip* was marred by psychedelic shenanigans, and *Bearing Witness*—in part a dry run for this book—by an excess of page design, but *Long Time Coming* is both sober and appropriately grand. And despite Lesy's laconic penchant for allowing period documents to serve as his text, he turns out to be an incisive writer, capable, for example, of disentangling the vexed history of the American farmer in a couple of lucid paragraphs.

Nearly all the pictures in the book are unfamiliar; many have never before been published. Quite a few, surprisingly, show scenes of urban life, and an entire heretofore unsuspected series documents Puerto Rico. There are naturally a great many shots of blight and destitution, but there are also pictures that span the spectrum of middle-class life. The selection allows you to traverse the country in the years before the Second World War. There are only a few pictures by the FSA's most famous photographers—four by Evans and maybe a score by Lange—and the only well-known picture in the book, a stark shot of a black man climbing the outdoor stairs to the "colored" section of a Mississippi moviehouse, is by Marion Post Walcott, a fine photographer but one whose name does not

instantly come to mind.

The rest of the pictures are less known in part because they are not immediately memorable. Few of them possess the graphic or editorial power of the iconic shots, which convey volumes of social drama in a quick glimpse. What they represent instead is patient and often subtle bricklaying. They were intended not as virtuoso turns but as members of the chorus. The FSA was headed by Roy Stryker, previously a minor adjunct in the Columbia University social sciences faculty; his qualifications consisted of his having once found illustrations for a textbook. He approached his task with the panache of a teaching assistant and the charisma of a bureaucrat, assigning his photographers laborious preparatory readings and presuming to instruct his one black employee, Gordon Parks, on the topic of racism.

He hired his photographers more or less by accident. Evans got in through family connections; Lange and Ben Shahn were transferred from other New Deal projects; Arthur Rothstein was a former student of Stryker's who knew how to use a camera but had no intention of pursuing photography as more than a hobby; John Vachon was a graduate student in English who had never before taken pictures. Stryker gave the photographers "shooting scripts": they were to go to Wisconsin to photograph the beet harvest, or to Indiana to find split-rail fences and pot-luck suppers, or to the West to shoot treeless plains, foreclosure auctions, community sings. He rode herd on his people, constantly pestering them for more and more specific documentation, sending urgent memos demanding more front porches, more bonfires of autumn leaves, more people sitting on nail kegs in general stores.

Stryker was a petty tyrant who for the first five years punched holes through whatever negatives he thought unworthy of printing. He was interested in content, not expression, and had little patience with artistic temperaments, so it is remarkable the project so consistently occasioned work of high quality. In 1938 he hired the photographer Edwin Rosskam as photo editor, but by then he had fired Evans and Lange—both of them twice over, in fact. Small wonder Lange sent all her film to California for processing, or that Evans worked with two cameras: one roll destined for Stryker and the other kept for himself. In the meantime, though, Stryker's ambitions were quietly expanding. Not only was the scope of the project growing—the work was originally intended to document agriculture and its ramifications, but urban themes crept in when the waves of migration inevitably brought destitute farmers to the cities—but Stryker dreamed of an all-encompassing File. He imagined a governmental agency—a Department of Memory—that would absorb photos from the news agencies, magazine photographs, advertising and publicity pictures, even family albums. Appropriately, Lesy begins his final chapter with epigraphs from *1984* and from Borges's "Tlön, Uqbar, Orbis Tertius": "[He] burst out laughing at the modesty of the project. He declared that in America it was absurd to invent a country and proposed the invention of a whole planet."

Seen in this light, the File—its name sounding a bit more ominous—becomes not a portfolio of shame-inducing images of humans cast adrift by economic machinations, not a portmanteau alibi for art photographers to go and exercise their eye among the artifacts of the populace, but a gigantic commonplace book, a visual American *Anatomy of Melancholy*. These are scenes through the window of

the nostalgia train that is the United States—a youngish country forever in thrall to a semi-imagined past because it has been literally and continually in motion since the beginning, so that "roots" consist of whatever lies just out of reach. The simple pleasures of childhood, the four-cornered town center, the generations united in backyard chores, the harmony of human toil and arable land, the terror and ecstasy of country religion—all the eternal reference points of political rhetoric are present here, many of them waving a wan farewell as they surrender earthly existence to a future of highways and suburbs and alienation. That they are depicted so beautifully makes them seem all the more arcadian and distant. The photographers were assigned to find types and they located them without cheating—the mountain funeral is the definitive mountain funeral, the carnival sideshow barker the epitome of his species—but it is as though the ancient primitive fear were realized: the camera stole their essence and translated it forevermore to the realm of imagery.

2000, 2002

THE PERFECT MOMENT

Robert Mapplethorpe's work is difficult to see, which is not the same thing as saying it is difficult to look at. It is certainly not difficult to view. In the six and a half years that have elapsed since Mapplethorpe's death from AIDS at the age of forty-two, it has gotten much more diffusion and publicity than it ever did during his life. But that publicity is itself one of the major reasons his work is now so difficult to see. A tangled foliage of appended context, of headlines, slogans, editorials, legal and moral and political judgments, has arisen to obstruct the sight. During his life, Mapplethorpe's photographs were judged, for better or worse, on their own merits. Since his death—or more specifically since four months or so after his death, when a series of events shrouded his work in controversy and publicity—his photographs have become symbols or symptoms, even for their admirers.

Mapplethorpe went to his grave an esteemed photographer, famous in the art world if not widely known outside it, lightly but not uncomfortably notorious for his depictions of sadomasochistic

practices. *The Perfect Moment*, a traveling retrospective of his work, had, at the time of his death on March 9, 1989, been circulating for four months. It might then have been expected that the exhibit and its catalog would constitute his principal public memorial, even if scholars would produce the eventual monographs and a biography would perhaps appear somewhere down the road. But then the landscape changed entirely. Fearing an outcry, the director of the Corcoran Gallery, the show's venue in Washington, D.C., canceled its appearance two weeks before the opening on July 1. Jesse Helms, Republican of North Carolina, destroyed a copy of its catalog on the Senate floor. The following April, after having been shown without incident in Hartford and Berkeley, *The Perfect Moment* was closed by the police in Cincinnati, and the sponsoring museum and its director were indicted for pandering obscenity and child pornography. By then, Mapplethorpe had become known to everyone within range of a television set, although less as an artist than as a shibboleth.

The fruits of this unintended surge of fame are evidenced in various ways by the current harvest of books about him. *Mapplethorpe*, published in 1992, a collection of his black-and-white photographs much more lavish than the exhibit catalog, has been succeeded by *Altars*, an equally sumptuous if necessarily thinner compilation of his less profuse work in color, and the former's critical essay, by Arthur Danto, has been published as a separate book, *Playing with the Edge*. Patricia Morrisroe's *Mapplethorpe* is the authorized biography and a point of entry for the curious and the perplexed. And Jack Fritscher's *Mapplethorpe: Assault with a Deadly Camera* is a personal memoir, a polemic, and several other things besides.

The great differences among these books, at least among the

three texts, begin to suggest the width of the divide across which Mapplethorpe's name has been flung. If Mapplethorpe were alive and on trial, Danto would be an expert witness for the defense, Morrisroe a journalist covering the case for a glossy if sensational publication, and Fritscher an opinionated acquaintance holding forth on the courthouse steps day after day for anyone who would listen. What the three books share is the sense that Mapplethorpe *is* on trial. Even Danto, who set out to treat his subject on purely artistic grounds, cannot avoid sounding as if he were addressing a jury.

The case is fairly straightforward. Mapplethorpe stands accused of having represented in his works subjects considered offensive by a portion of the population. No one would deny this, least of all Mapplethorpe himself. He was no propagandist, though; he was not moved by a need to make viewers confront his subjects in the name of realism, or acknowledge them in the name of tolerance. He was an aesthete, who saw beauty in his subjects and sought to make this beauty manifest. Many of his opponents would like to eliminate from the world those subjects that offend them, homosexuality in general and sadomasochism in particular, and many more are dismayed by the idea that these could be considered fit subjects for art.

However, since the city of Cincinnati lost its case against the sponsors of *The Perfect Moment* (thanks in part to a lineup of critics and other art-world professionals who convinced a largely working-class jury that Mapplethorpe was no mere pornographer), the opposition's rhetoric has ceased to emphasize definitions of art. It is perhaps backhanded recognition of Mapplethorpe's devout aestheticism that has caused him to posthumously become a symbol for a campaign against government funding of the arts that often sounds

LUC SANTE

like a campaign against art itself. "Mapplethorpe" has thus become a synecdoche, standing in some minds for freedom of expression and in others for a bewildering elitist contempt for prevailing standards of taste. He makes an odd candidate on both counts.

Also contributing to the difficulty of seeing Mapplethorpe and his work free from the interference of slogan and judgment is the fact that his career appears almost absurdly foreshortened. This is partly because he died young, obviously; a short life can seem like a straight line, denied the contours and complexities that time brings into relief. But Mapplethorpe's work is so continuous from one end of his career to the other that he might appear to have sprung into being one day around 1970, his aesthetics and preoccupations fully formed. This was in fact nearly the case. Even without the bizarre, bedeviled weight of his posthumous fame, his life's work might look like a single action rather than a forking path of possibilities.

His actual beginnings were more messy and painful. He was born in 1946 in Floral Park, Queens, to parents of Irish and English extraction who had recently ascended to the lower middle class. Although his father was himself an amateur photographer, he discouraged his second son's artistic inclinations, evident early on, and propounded a family doctrine of muscularity, obedience, and Catholicism. Robert did his best to comply, apparently contorting himself in the process, so that in high school he joined a macho Catholic fraternity called the Columbian Squires, and in college, at Pratt Institute in Brooklyn, he underwent hazing to enter the ROTC honor society, the Pershing Rifles. Morrisroe supplies a photograph of him in the uniform of this latter outfit: he looks dazed, rabbity, unsteady, his clothes somehow too big and too small at once.

He extricated himself from this posture with assistance from the climate of the early hippie era, and within a short time was wearing other kinds of fancy dress, such as capes. Shortly afterward he met Patti Smith, a strange young woman from South Jersey, given to visions, uncomfortable with her gender, in the early stages of assembling a complex personal mythology from elements of the lives of rock stars, film stars, and dead French poets. The two immediately recognized each other as kin, and the friendship was to become perhaps the most important of Mapplethorpe's life. They lived together for a few years in fleabag hotels and ratty lofts, working at barely remunerative bookstore jobs, cadging drinks at Max's Kansas City, and tentatively making art.

Smith's work began as doodles that grew text that evolved into poems, which were rhythmic and lent themselves well to public performance, for which she proved to have a particular gift. Mapplethorpe, for his part, was dabbling at collages and assemblages in a desultory sort of way. Somewhere along the line he recognized his homosexuality, and he threw himself into the gestures and accoutrements of leather-bar culture. His collages began to feature pictures clipped from gay porn magazines, and the already fetishistic character of his assemblages was only slightly redirected, pieces of clothing and bondage trappings joining a repertory that continued to run heavily to Catholic and satanic imagery.

In 1970, a friend of Smith's and Mapplethorpe's named Sandy Daley made a short film, *Robert Having His Nipple Pierced*, that functioned as something of a rite of passage. More important, she gave him her Polaroid camera. Mapplethorpe appears to have almost instantly found his calling. The subjects and basic approach

he adopted in his photography at that time would remain constant for the remainder of his life. From the very beginning, this involved simple, hard images posed against neutral backgrounds: portraits, self-portraits, flowers, figure studies, and bondage tableaux. Only a protracted study of artificial lighting lay in the future. He sublimated his bricolage in the process, building frames for his pictures and assembling triptychs using photographs and mirrors.

He also began to get interested in the history of photography, even at that late date a relatively scorned subject, and he was assisted in this pursuit by John McKendry, curator of prints and photographs at the Metropolitan Museum, who opened the museum's archives to his perusal. McKendry, a fascinating and rather tragic figure who was shortly to die from cirrhosis caused by multiple substance abuse, also gave Mapplethorpe a new and better Polaroid camera. Mapplethorpe's extraordinary success at finding angels to help him construct his career reached its apex when he met Samuel Wagstaff, a collector and heir who had lately been a curator at the Detroit Institute of Arts and before that at the Wadsworth Atheneum in Hartford. Their relationship was to be an enduring one. Wagstaff bought Mapplethorpe a loft on Bond Street in NoHo and, eventually, a Hasselblad. And Mapplethorpe encouraged Wagstaff to begin collecting photographs; the result was one of the world's great collections.

In 1977 Mapplethorpe mounted two shows to open simultaneously. The one uptown at the Holly Solomon Gallery featured portraits and studies of flowers; the one downtown at the Kitchen contained sex pictures. The advertisement paired two photos of Mapplethorpe's hand writing the word "Pictures." On the left the

hand is emerging from a striped dress shirt, the wrist encircled by a Cartier watch; on the right it is clad in a black leather fingerless glove and the wrist is cinched by a heavy toothed-metal bracelet. The Kitchen show was the first exhibition of the sort of photographs that were to cause the uproar after his death. The bulk of his pictures of sadomasochistic displays were in fact taken around this time, in the black-leather era of the late 1970s. Not long after, Mapplethorpe met the bodybuilder Lisa Lyon and photographed her in various attitudes and costumes, the work collected in 1983 in his first book, *Lady, Lisa Lyon*. Then he began photographing black men, in whom he was becoming increasingly interested sexually, as well as formally, with regard to body structure and the effects of light on skin tones.

Mapplethorpe began to exhibit symptoms of AIDS at an undefined point in the mid-1980s. Sam Wagstaff, with whom he was no longer sexually involved but who remained both mentor and more than a bit of a father to him, died of AIDS in 1987. Toward the end, Mapplethorpe increasingly shot still lifes, primarily of classical statuary, in part because he was mesmerized by their perfection and in part because he was rapidly losing mobility. He reached the summit of his ambitions with a retrospective at the Whitney Museum in July 1988. He attended the opening in a wheelchair and was afterward devastated by paparazzi photographs that showed him looking frail and several decades older than his chronological age. He predeceased his mother by less than three months and his ashes were later buried in her coffin, but his father refused to allow his name to be engraved on the headstone.

It was a short life and a rather unexamined one, its progress in its last two decades marked off by exhibitions and publications and filled

out by gossip. Patricia Morrisroe, whom Mapplethorpe authorized as his biographer at her request seven months before his death, tells the story as an apparently impartial journalist with a nose for good copy. In practice, this means that her book is rather unsympathetic. She undoubtedly did not set out to expose or attack her subject, but on the other hand she has an instinct for highlighting every shred of conflict in her material. The tone is set, if you are one of those who upon cracking open a biography immediately make for the photo insert, by a portrait of a cherubic Robert at perhaps two years of age that is captioned: "Robert Mapplethorpe revolted against everything his parents represented. Here he poses for Harry's camera—one of the few times father and son ever saw eye to eye." She is constantly editorializing, constantly pitting her subject against others, constantly seeking everyone's basest motives. Her narrative emphasizes foreshadowing and simple irony, boiling her subject down to a consistent set of tics and foibles. She pounces on his mother's recollection that Mapplethorpe as a young boy killed his pet turtle by impaling it on his finger, and, rather more seriously, on the rumor that he continued to engage in unprotected sex after he knew he was infected with the AIDS virus—that, in fact, he was seeking revenge on black men, believing that a black man had infected him. And she does more than just pass along the report, writing, "He approached his task like an avenging angel, picking up one black man after another with offers of cocaine, then baiting them with the word 'nigger.'"

Mapplethorpe was of course no paragon. The fact that he did require his African-American lovers to permit themselves to be called "nigger" is confirmed by Jack Fritscher, an ex-seminarian who commissioned Mapplethorpe to shoot a cover for the gay S&M magazine

Drummer and was for a time his West Coast paramour. Fritscher is probably a reliable witness; he seems too obsessive to have deception in mind. His book is physically exhausting to read, consisting for the most part of lapidary pronouncements hammered out in one- or two-sentence paragraphs, arbitrarily organized and repeated copiously. (So repetitive is his book that its photo insert twice includes a portrait of Mapplethorpe by the New Orleans photographer George Dureau, albeit with different croppings and captions.) He regularly inventories his cherished ideas, some obvious, some addled, some shrewd, one of them being the irony of Mapplethorpe's censure at the hands of "Republican Southern religionists" with whom he shared many beliefs about the status of blacks, women, and indeed gays.

Mapplethorpe emerges from Fritscher's rant barely more attractive than from Morrisroe's exposé—Fritscher's Mapplethorpe has a certain rough intimacy, but Morrisroe's version, against all odds, retains a shadow of a frail, sensitive, lost boy somewhere within. Perhaps Mapplethorpe was grasping, vulgar, deceitful, disloyal, inconsiderate, exploitative, shallow, calculating, vain, cruel, racist, anti-Semitic, and so on, but then, too, perhaps his biographer and his memorialist are complying with current convention, which prescribes brutal candor rather than reverence in treating the recent dead. This stricture might actually be a new spin on the denial of death, particularly in regard to AIDS; piety entombs its subjects, but malicious gossip does tend to keep them in the room. The charges beg an answer—the mirror they hold up is maybe meant less to reflect a face than to pick up a faint fog of breath.

In any event, Mapplethorpe lives on in his photographs, which articulate more of his complicated personality than either book can

begin to suggest. He was a perfectionist who exercised complete control over his images, so that the vast majority of his pictures were taken in austere studio settings where no element of chance was permitted, and yet he undertook his apprenticeship in this mode using Polaroid cameras and natural light. Nearly all his photographs are of faces, bodies, or their analogues—statues, anthropomorphized flora—but most of them present their subjects architecturally. He is most famous for depicting erotica, or at least its signs, symbols, and by-products, but his depiction is invariably ice-cold. He emerged from the social and artistic fringe to present himself as an exemplar of a nearly forgotten classicism, and he upset the art world less by his graphically sexual subject matter than by his closure, his symmetry, his deliberateness, his polish—his frank pursuit of beauty. He may be denounced today as a symbol of rampant moral relativism, but he was on his own terms an absolutist.

And he was or became perhaps the most famously homosexual artist of all time, though unlike his predecessors, including George Platt Lynes and Andy Warhol, he never bothered with code or camp, except to poke fun at the notion with his penile orchids and scrotum-like grapes.

Nevertheless, his deepest, sexiest, most emotional photographs were of women, or rather of one woman, Patti Smith. In Mapplethorpe's work as in his life she is the exception that tests the rule. She is the exception, too, in Morrisroe's biography, virtually the only party who emerges intact, and she seems suffused with a certain saintly aura even in the account by the forthrightly misogynist Fritscher. In their youth Smith was Mapplethorpe's twin, mother, protector, lover until he abruptly announced that he was gay, col-

laborator until she retired from public life to get married and have children. In the meantime her poems had evolved into songs, her readings had become concerts, and she had become a rock star. Mapplethorpe financed the annual Rimbaud's birthday events that launched her career, financed her first single, and took the jacket photographs for all but one of her albums. His photographs of her are diverse, and all of them are compelling. While the principle of beauty in his other portraits and figure studies—including those of women, such as Lisa Lyon and Lydia Cheng—is contingent on ideal forms and cultivated physiques, Smith's beauty includes the sum of her imperfections. Her scrawniness, coltishness, vulnerability that is only heightened when she adopts a tough pose, her asymmetry and blemishes all contribute to a beauty that is not separable from the personality they enclose. The photographs of her in Mapplethorpe's corpus, including such a late one as the 1987 cover shot for her comeback album, *Dream of Life*—a sorrowful portrait which Fritscher aptly terms a picture of the artist's "soon-to-be widow"—point out the road that Mapplethorpe chose not to take, in art as in life.

The path he did choose led to the hard, impregnable, stainless surface. "Beauty" is actually an equivocal notion in Mapplethorpe's aesthetic. "I am obsessed with beauty. I want everything to be perfect," he told an interviewer in 1982, but then he once told Smith, "I'm not after beauty, I'm after perfection, and they're not always the same." This was after all the man who in his late phase photographed reproductions of classical statues because the originals tended to be chipped or spotted. He did not arrive at what he took to be perfection overnight, even though the impulse is detectable from the beginning of his career. The Polaroids show him at his most spontaneous:

the earliest photo in *Mapplethorpe*, a self-portrait, is actually blurred (he is obviously holding the camera with outstretched arms), and a couple more are parodies of shoddy 1950s studio porn, with a visible electrical outlet and a zebra-pattern backdrop that retains its creases. The three-panel "Head Stand, 1974" is the earliest manifestation of what will become a signature motif—the headless and limbless torso converted into a sort of Edward Weston pepper—but not only is it taken with natural light, it is posed against drywall with conspicuous spackling.

His quest for perfection really begins its ascent with his acquisition of the Hasselblad, in 1976, although it is prepared for by the large-format Polaroids of the previous year or so. Roland Barthes, an early admirer, saw it clearly. Discussing in *Camera Lucida* (1980) the striking self-portrait of 1975 in which Mapplethorpe sprawls grinning into the frame with arm outstretched, he writes: "[T]he photographer has caught the boy's hand (the boy is Mapplethorpe himself, I believe) at just the right degree of openness, the right density of abandonment: a few millimeters more or less and the divined body would no longer have been offered with benevolence (the pornographic body shows itself, it does not give itself, there is no generosity in it): the photographer has found the *right moment*, the *kairos* of desire."

This half-sentence, written when Barthes was likely to know of Mapplethorpe's work only the thirteen reproductions that appeared in the French journal *Creatis* in 1978 (including some notorious ones that were not to be published in the United States for another decade) virtually summarizes his subsequent career. Barthes's translator's nuanced use of the word "divined" alludes to the fact that the

hand in question is precisely calibrated not only for abandon, but also for crucifixion. Pleasure and sacrifice are of course entwined in Mapplethorpe's conception. Arthur Danto rightly notes that while numerous critics have referred to Mapplethorpe's "Catholic" aesthetic with regard to his love of symmetry (and he himself often talked of "making altars"), such construction is merely generally sacerdotal. "What is finally Catholic is the abiding mystery of spirit and flesh," Danto writes. What he means is that the most profoundly Catholic images are those of sadomasochistic ritual.

The infamous "X Portfolio" is represented in *Mapplethorpe* by a selection marked off by red pages of light card stock (so that, perhaps, cautious parents can tape them shut). "Jim and Tom, Sausalito, 1977," which was famously characterized at the Cincinnati trial as a "figure study," and shows a leather-hooded man urinating into the open mouth of another man, evokes for Danto the classical theme of "Roman charity" (the daughter offering her breast to her shackled and starving father). It might more simply be said to refer to holy communion: the standing donor, half-extending his arm, stands over the supplicant, who kneels and presents his upturned face, eyes reverently closed. The two are surrounded by darkness but streaked with a light that comes from above. Whatever one's visceral or acculturated reaction to the act depicted, there is no denying that the picture conveys a hush, a powerfully concentrated peace that overrides the menace of the leather hood and the sordidness of the grimy bunker.

Other pictures are less comforting. Some bristle with the hardware of chains and straps and ropes and pulleys, and refer the viewer to a thousand gruesome fifteenth- and sixteenth-century panels

of saints' martyrdoms as well as, in their head-on and deliberately ugly lighting, the artless brutality of photographs in true-crime magazines. "Helmut and Brooks, N.Y.C., 1978," the "fisting" picture that prompted an expert witness in Cincinnati to natter on about "the centrality of the forearm," is a sculptural enigma that entirely excludes the viewer, any viewer. After you have figured out what is going on, you are immediately expelled by the monstrous arm and buttocks that devour all space. It is not a privileged display, not a window onto anything; it is an aggressive, even hostile declaration of limits. They are breaching theirs; you are confined to your bubble.

Sharing a spread with this picture is "Richard, N.Y.C., 1978," which is likewise calculated to shred all the niceties of critical palaver. It shows a penis and testicles lashed cruciform to a board, no more and no less. The viewer here is simultaneously pushed into outer darkness and forced to experience vicarious pain, a palliative middle distance being only marginally achievable by dryly considering the relative textures of wood, metal, cord, pubic hair, and stretched, blood-engorged, capillary-striated skin.

Here as elsewhere, it is difficult to assess just how Mapplethorpe intends his title to be taken. Danto founds his case for Mapplethorpe on the principle of consent—that Mapplethorpe was not a voyeur like Garry Winogrand or a stalker (his word) like Cartier-Bresson or a betrayer of confidences like Diane Arbus. This is true enough; all his published pictures feature fully informed models who signed releases, and all that they depict was carefully staged (they are not photographs of sex, but of sexual displays). But Danto cites Winogrand's kamikaze shots of nameless women on the street as products of a predatory tactic that is tantamount to rape-by-lens (neglecting to

mention that Winogrand operated identically when photographing society people, ranchers, politicians, writers, cars, lampposts, parking lots), and contrasts their heartless anonymity with Mapplethorpe's respect for his subjects as demonstrated by his titles: "Even when all we are shown is a nude torso, cropped, like that of Lydia Cheng, at the knee and neck, so that the body looks altogether impersonal, it is given an identity and an owner: it is the body of a particular woman who consented to be shown nude."

Perhaps this is so, although it is disconcerting that of all the many pictures he took of Lydia Cheng, not one shows her face (according to Morrisroe, he thought her Asian facial features would be distracting). When it comes to his pictures of individual precincts of male anatomy, the message seems more deliberately mixed. A penis can be simply "Cock," or it can be "Lou" (according credit to its namesake for the hair-raising feat of inserting his little finger past the first knuckle into his urethra), or it can be "Mark Stevens" (a celebrity phallus). Or it can be "Richard," which seems to mean (besides any considerations of the fact that Richard might not want his face and his tortured member to appear in the same shot, however proud he may be of it) that Richard is equivalent to his trussed penis, that his spirit resides within it, that he is thereby exceptional among the endless parade of nameless meat in the back room.

There is cruelty in this assignment, and there is humor, too. Mapplethorpe is seldom given credit for being funny, but the self-parody of "Eggplant, 1985," in which that dark vegetable is posed in chiaroscuro, whipped by the shadows of a venetian blind, is hard to miss. And "Man in Polyester Suit, 1980" (an instance in which anonymity was granted at the urgent request of the model, whose

name Morrisroe helpfully supplies) is not simply a portrait of a massive penis protruding from an open fly; it is also—in its carefully neutral lighting and its subject's artificial pose, quarter-angled, arms bent just slightly—a parody of men's fashion photography of the Sears catalog school. Mapplethorpe's humor is perhaps also evident in his pictures of flowers. When his flowers are not resembling "body parts," in his phrase, they are strident, overbearing art objects, as if their own beauty had been deemed insufficient and some industrial order of beauty imposed on them.

On the whole, Mapplethorpe's quest for perfection serves him best when it steers him away from beauty. His sex pictures include some stunningly lit anatomical features and regions and some strikingly plastic poses, but most of the strongest photographs among them are strikingly unbeautiful, even allowing for differences of taste. Their harshness, which seems so jarringly at odds with Mapplethorpe's habitual refinement and elegance, demands explanation. The key is provided by the notion named by Barthes and taken up as the title of that circulating retrospective. It is "the perfect moment" that is the quarry of these pictures—not the point of orgasm, which the deliberately posed subjects of the pictures may or may not be about to experience, but an analogous feeling occurring within the photographer, in his function as photographer. This is an ocular and cerebral version of sex, requiring its objects to be visually aggressive but physically out of reach, the feeling Mapplethorpe got from pornography as a teenager and attempted to reproduce all his life. Harsh lighting, squalid settings, even imperfect bodies are erogenously specific, not only as sadomasochist totems but because they represent the contrary of Mapplethorpe's taste.

The viewer is doubly a voyeur, not only looking at the scene depicted but also witnessing Mapplethorpe's ambivalent role in the proceedings. Mapplethorpe's attraction to what he shows hinges on the danger emanating from the scene, which might be a pantomime danger in physical terms but represents a real threat to the delicate side of his personality. Like the macho laws enforced in his youth by all males beginning with his father and brother, sadomasochism laughs at his frailty, his sensitivity, his unerring good taste—he will have to conform to its requirement of toughness or be destroyed. In photographing sadomasochist displays he is submitting to the S&M aesthetic against his own aesthetic inclinations, and he wants to be seen thus submitting himself, being in a sense destroyed.

But just as no sadist can help also being a masochist, and vice versa, so these pictures are two-bladed knives. Mapplethorpe wants both to thrust the scene upon a viewer as cultivated as himself and make that viewer submit, and to expose the scene to a viewer tougher than himself and have that viewer, in turn, judge and ideally condemn Mapplethorpe's own shortcomings in its light. The pictures do not show sex as much as they enact it, locating the act in the exchange between the photographer and whoever looks at his work. The viewer is pressed into service as proxy partner, top and bottom at once. The reactions of Jesse Helms and his ilk would no doubt have given Mapplethorpe satisfaction—their horror only proves that he succeeded in getting them into bed with him. But no one, at least nowadays, can fail to react strongly to these pictures. Everyone who gives them more than a glance, like it or not, is drawn in by them, and the circularity of the exchange is so polished and smooth it exemplifies Mapplethorpe's highest formal standards.

LUC SANTE

When he set about depicting easily understandable beauty, however, he tended to glaze it, in fact to beautify it. Like his flowers, his male nudes are astounding physical specimens. In their case, too, he exerted himself so much in showing them to advantage that it might seem as if he were frustrated being merely their photographer and wished to be their maker as well. Peter Schjeldahl, in a review reprinted in his book *7 Days Columns, 1988–1990*, locates the exact center of Mapplethorpe's aesthetic: "Hunger craves union; taste demands distance. Mapplethorpe pushes these opposed terms to excruciating extremes, creating a magnetic field. His work is not about gratification, either sexual or aesthetic. Elegance spoils it as pornography, and avidity wrecks it as fashion. It is about a strenuously maintained state of *wanting*."

There is no denying that this tension between hunger and taste in Mapplethorpe engendered beautiful objects. The skin tones are lush, deep, rich, almost surreally tangible, conveying the precise degree of density and resistance between skin and bone. He makes luxurious compositions of whole or segmented bodies set against teasingly contrasted backdrops. Even the dullest celebrities are rendered profound and mysterious by the unyielding blackness or tender dovegray in which he shrouded them. But all of this is craft, skill, artfulness rather than art. Too often Mapplethorpe's hunger chooses the subject (which in the case of celebrities is celebrity itself), and then his taste sanctifies it. Only when his desire outdistances or befuddles or subverts his taste is he able to make a picture that is more than a beautiful vessel.

His yearning to escape from his internal knots is most poignantly visible in his self-portraits. In his 1983 masquerade as a knife-wield-

ing street tough he looks so feeble as to elicit protective feelings in his viewers; he seems more fierce in his 1980 drag pictures. He is an elegant and faintly dangerous roué wearing dinner clothes in 1986, and a ridiculous fop in white tie holding a submachine gun and posed under a pentagram in 1983. It is as the devil, though, that he is most at ease with his shortcomings. "Satan" or "the devil" was for Mapplethorpe what it is for many ex-Catholics, a name and a rather dashing figure with which to clothe a principle, that of the inversion of one's moral indenture. He made a great deal of it, was reportedly given to uttering "Do it for Satan" as a kind of sexual toast, and fooled with satanic imagery from late adolescence onward. He makes an impetuous young sprite wearing horns as late as 1985, and a glowering, remote dweller of darkness clutching a skull-headed cane in his last self-portrait, from 1988, when he knew death was at hand. But it is in the 1978 picture of himself wearing leather chaps and vest, fingering a bullwhip protruding from his anus, that he came closest to manifesting his own ideal. The picture is gleeful; he has managed to embody menace and joke-menace in a single gesture, to shock the spectator and laugh at himself simultaneously.

Mapplethorpe's work rebuffs piety, disdains analysis, sneers at understanding, snarls at interpretation, demands silent esteem, which some of it deserves. The cloud of contention that currently hovers over his work obscures its weaknesses and its strengths alike. Eventually the front will pass, and in the clearing many of his photographs will probably appear most notable as artifacts of the complicated and fascinating time in which they were made—certainly a nobler fate than to wind up as mere décor, which is another possibility for them. Besides the portraits of Patti Smith, the pictures most

likely to remain standing are the very ones that set off the uproar, the darkest, most difficult of the sex pictures. It is no accident that those two areas of exception should have provided his strongest work. Right now the sex pictures appear to present mainstream culture with an unscalable wall. Some of them will not be assimilable for a long time, but probably fewer will resist assimilation than anyone thinks at the moment. As unlikely as it might seem, they are even now creating a climate for their eventual acceptance, or if not acceptance then at least a blasé unconcern. After all, cultural taboos have in the past century tended to collapse not long after a furious battle for their maintenance was apparently won, since the resulting exposure and publicity inoculated the population against any possible shock, and eventually eroded fear.

Soon "Joe, N.Y.C., 1978," a cartoon sea creature in his black rubber body suit, enema hose sticking out of the mask, will not look out of place in the boardroom that also displays a Hans Bellmer doll; the bullwhip self-portrait will fit nicely into the paneled library alongside etchings by Félicien Rops. There will always be people who claim that morals are somehow at stake, as well as advocates of bland tolerance and solemn universality, all of them in their diverse ways trying to hose down art, but they will inevitably be bested in this task by the culture's boundless capacity for indifferent absorption. What is left over after the shock factor of Mapplethorpe's darkest pictures has been deflated is what actually constitutes his art.

1995

V

THE TOTAL ANIMAL SOUP
OF TIME

Was "Howl" the last poem to hit the world with the impact of news
and grip it with the tenacity of a pop song? I can't think of another
in the decades since. When I first read it I was thirteen or four-
teen and the poem was more than a decade old, although as far as I
knew it might have been published that morning. I had no idea what
most of it meant, but that didn't stop me from entering its rhythm.
I recognized that rhythm, or I thought I did. Its long breath and
hypnotic iterations were eerily evocative of the litanies in the Latin
ritual of the Catholic church, which were probably the first music I
ever heard. "Howl" immediately took me over, and stayed in my ear
like a Top Ten hit. I undertook to memorize it, or at least its first
part, which was the highest tribute I could pay, as well as a way of
owning it. I learned it well enough that I declaimed it whenever I
felt myself sufficiently alone, in my room or in the woods. Later in
adolescence, when I worked after school in a factory, I could bellow
it at the top of my lungs, unheard over the din of the injection-mold-

ing machines.

What was the poem about? For me, then, the title accounted for most of it. It stood for I Want to Be Free and We Are Multitudes and The Stars My Destination and incidentally Get Your Hands Off Me. The elegiac aspects I could understand in a general way—teenagers love to gaze back ruefully at the ashes of a ruined past—but the specifics were beyond my comprehension. What could I know about extremes of desire and exhaustion and need and rage and love and revolt? I pretended I knew, of course. The rage to live I had in spades. I thought I already contained every possible emotion, needing only the particular settings in which to apply them. Poetic madness was something I thought I could feel in my body. The scenes of the poem were only just out of reach. They all sounded good, indiscriminately: poverty and tatters and hollow-eyed and high all equally alluring. The poem was a travel brochure for the colorful world I would settle in as soon as I could get away from my parents, a world in which everything was large-scaled, dazzling, dramatic, dangerous, played for keeps. Its possible harshness sounded many times better than any happiness I knew.

Allen himself was an icon whose image was everywhere. There was the poster of him wearing the sandwich board reading "Pot Is Fun," and the other one of him in his Uncle Sam hat, and the picture of him chanting in a park surrounded by hippies in beads and feathers. He was as modern as any figure of the 1960s and at the same time he was mythic, biblical, a sage from the ancient world—you could imagine him parading along the time line of history, through Alexandria and Damascus and Jerusalem in his beard and robe, and even his eyeglasses, which were simply a part of his face. He was an

ideal father figure, comforting and reliable and permissive and inspi-
rational. He was maternal, too, in the same sense as William Carlos
Williams's image of Abraham Lincoln as the mother of the nation
("The least private would find a woman to caress him, a woman in
an old shawl—with a great bearded face and a towering black hat
above it, to give unearthly reality"). He was in the news regularly
then, and every appearance confirmed his standing as the President
of Youth. Being crowned King of May in Prague before being ejected
by the authorities, pacifying the Hell's Angels by chanting to them
and persuading them to join in, talking countless saps like you or
me down from bad acid trips—he was literally Christlike: wander-
ing the world healing the lame and the halt, distributing loaves and
fishes, being alternately hailed and jeered.

It was thrilling to read him taking on the police, the government,
the war in his later poems, which were prophetic and bristling with
hard facts. "Howl" was of another order, though. As great as some-
thing like "Wichita Vortex Sutra" might be, it didn't rock the way
"Howl" did. "Howl" was a transfusion of energy, a hurricane signed
up for the cause. It wasn't mere ammunition, but the force itself.
Reading "Howl" aloud or reciting it, you could feel the poem giving
you supernatural powers, the ability to punch through brick walls
and walk across cities from rooftop to rooftop. It had those long,
unflagging lines, which emptied and then refilled your lungs, and to
a teenager it contained every single one of the most powerful words
in the language: "madness," "dynamo," "supernatural," "illuminated,"
"radiant," "hallucinating," "obscene," "terror"—and that's just a sam-
pling from the first eight lines. At some point in high school a class-
mate played me a record that belonged to his parents, a recording

made in San Francisco soon after the famous Six Gallery reading of 1956. The blue laws of the era required Allen to cut out the bad words, and he complied by substituting "censored" for them, as in "who let themselves be censored in the censored by saintly motorcyclists, and screamed with joy." The effect was hilarious and somehow subversive, as if the word "censored" contained more variegated shades of sin than all of the original words put together.

It was the first time I ever heard Allen's voice, that very particular combination: the postwar street-hustler, bop-prosody cadences you can hear in recordings of Kerouac and in those tapes of nearly indecipherable monologic yammer by Neal Cassady in his last days, filtered through the accent—produced in large part by a vibrating larynx—that to me still sounds exotic coming from Allen, although I've since heard it issuing from other throats and can identify it as one strain of metropolitan-area middle-class Jewish. When I went off to college in New York City I began attending frequent readings by Allen, reveling in that voice, although I never heard him read "Howl." He read new poems; he chanted, accompanying himself on harmonium; eventually he sang, sometimes backed by a full band, but I remained frustrated in my wish to hear "Howl." The only time I ever heard it live was during a collective reading at St. Mark's Church on a New Year's Day in the 1970s, when some guy, either a postmodernist engaging in iconoclastic appropriation or just a fan doing a tribute on the order of a Led Zeppelin copy band, marched to the podium and began calling it out, weakly. He made it through maybe three lines before Allen himself appeared and told him to shut up. (All the while, up in the gallery, another fan reaching for an Allen-like mantra kept intoning "Remember your brothers and

sisters in prison," which only managed to produce mosquito-buzz irritation.) I didn't realize at that time how when you get to a certain point with your greatest hits you may never want to see or hear them again.

While still in high school I read Jane Kramer's *Allen Ginsberg in America*, and was greatly moved by her accounts of his openness, his benevolence, his mission as shepherd of my generation. Teenagers could just show up at his apartment and he would talk to them! I resolved to go there myself one day, although my arrogance and shyness prevented me from ever doing so. Then, a decade later, when I was badly in need of a new apartment, my Strand Bookstore colleague Will Bennett (may he rest in peace) told me about four rooms soon to be vacated in his building on Twelfth Street. I visited, and Will served me drugs and put on some music, his turntable connected to a Marshall amp jacked up to the proverbial eleven. Whatever the record was, it sounded like a Boeing 747 giving birth. I marveled at this tolerant building, where such extremes could be absorbed without complaint. Then there was a knock on the door, and there stood Allen, who had come down two flights to request, gently but firmly, that the volume be lowered. I marveled further. Imagine getting a noise complaint from Allen Ginsberg!

I wound up living in the building for eleven years. When Allen was in town, I saw him nearly every day: on the stairs, in the street, eating breakfast at the Ukrainian coffee shop on First Avenue. A large percentage of the tenants were poets who had been drawn there by him, and a large percentage of the hallway traffic was Allen-related as well: the people who worked in his office or played in his band, and Gregory Corso, Herbert Huncke, Harry Smith, various pass-

ing celebrities. I had a considerable chip on my shoulder by then, as an unpublished writer who didn't particularly cotton to any of the prevailing schools and whose putative talents went unnoticed by all. My exchanges with Allen tended to be brief. I was in awe and also guarded and maybe a little resentful. I did waste a considerable amount of his time at the wedding of some mutual friends, bending his ear about how I thought Lautréamont was the greatest poet of all time. He suffered me, if not especially gladly. By that time I thought I had his number, maybe that of all the Beats, because I had read the Situationists, who in the first issue of their journal, in 1958, had written: "The rotten egg smell exuded by the idea of God envelops the mystical cretins of the American 'Beat Generation.'" Like the Sits I had been raised in a Catholic culture, so I was not about to fall for any incense or chanting or beads, which I knew full well to be lollipops handed out by the police in order to mask the sight of their truncheons.

Despite this I remained in awe of Allen. However I might feel about the mystical claptrap I could not deny "Howl" (or, for that matter, "Kaddish"). "Howl" probably meant more to me then than ever before, because finally I could reconcile it to my own experience. "Poverty" and "tatters" and "hollow-eyed" and "high" were more than poetic figures by then. I could compile my own list of the best minds of my generation destroyed by madness.[1] The decade during which

[1]And I had acquired my own context in which to view the smug disdain of the Columbia English Department—which in my time still contained faculty relics left over from Allen's day, with attitudes intact—whose view was that the best minds of his generation, far from being destroyed, were leading Chaucer seminars all across the country.

I lived two flights down from Allen was particularly notable for its body count in suicides and overdoses, and those cadavers really had contained some of the best minds I knew. As in the poem, not all of those destroyed met their deaths, of course. Some did indeed vanish into nowhere Zen New Jersey, and some fizzled or suffered malignant hangnails or converted to money. But I also realized that if "Howl" is a catalog of flame-outs and collapses, it is ecstatic in its lamentation. And that is the basic measure of its strength: it is a list of fuck-ups and leprous epiphanies as redoubtable as Homer's catalog of ships, but rather than stopping at that, it seizes the opportunity to realize all the botched dreams it enumerates. It envisions every broken vision, supplies the skeleton key that reveals the genius of every torrent of babble, reconstitutes every page of scribble that looks like gibberish the next morning. It takes up the ragged flag of an entire generation of confused questers groping for something they can't begin to name, and in the process of recounting the story manages to incarnate the nameless thing sought. It is an illumination. It blows *the suffering of America's naked mind for love into an eli eli lamma lamma sabacthani saxophone cry that shivers the cities down to the last radio.*

And now Allen is dead, for me like a parent whose presence you take for granted while they are alive and ache for after they've gone. Right now we need him more than we ever did.

2005

A COMPANION OF THE PROPHET

On New Year's Eve, 1973, I sat on my bed in my room in my parents' house in New Jersey, bawling like an infant. I hadn't cried so hard in years, probably not since turning twelve, when I had made a pact with myself never to cry again. Now I was nineteen and halfway through sophomore year of college. I was sad because I didn't have a girlfriend and hadn't been invited to a party, and because I imagined I was nothing. None of these feelings was new or unexpected, of course. I carried them around routinely; misery and isolation were crucial parts of my self-definition. What drew all the hurt to the surface that night and caused me to dissolve into hot tears was a book I'd read before: Enid Starkie's biography of Arthur Rimbaud. I must have known what I was doing when I pulled it off the shelf, must have deliberately intended to use it as an instrument of mortification. I had to check a date: 1873. By the end of 1873 Rimbaud had finished *A Season in Hell*, which meant he had written all his major works, or very nearly. He would polish off the partly completed *Illuminations* the following year, but by 1875 he had ceased to make or care about literature. The

year mattered to me because Rimbaud was born in 1854, at one end of the Ardennes mountains, and I was born in 1954 at the other.

At some point before adolescence I had decided to become a child prodigy, an ambition probably inspired by garbled reports of the sorts of things that well-meaning teachers tell anxious parents of frustratingly underachieving pupils. I surely possessed gifts, but I daydreamed, wasted time, failed to work. Still, by nine or ten I possessed a vast fund of the kind of knowledge that impresses the pikers—catalogs of trivia. I wasn't one of those scary kids who know everything on earth about snakes or ancient Egypt or the F-111 jet fighter. I was a generalist, with interests in art and history and an age-appropriate obsession with all manifestations of the uncanny; I thought I might someday be a cartoonist or a historian or a researcher of the paranormal. Then, not long before my tenth birthday, a teacher told me I had talent as a writer, and for some reason that changed everything. I suddenly knew what I would be, and even though visual art continued to tug at me, I really never deviated from my course. I knew that I would soon be an impossibly young writer of astounding gifts and wisdom far beyond his years.

I promptly acquired some secondhand books, all of them entitled something like *How to Write for Publication*, and had my parents get me a subscription to *Writers' Digest*. These sources gave counsel on how to compose a cover letter, how to begin a factual account with a dramatic anecdote, how to prepare a special calendar to assist in writing seasonally themed sketches six months in advance. I followed their suggestions, submitting light verse to *Gourmet* and historical filler items to *Boating*, and happily collected rejection slips as if they were stamps. Imagining my work being read by busy people in skyscraper

offices was a thought imbued with the kind of magic that attended the sending away of box-tops in exchange for plastic figurines. I read indiscriminately, Sherlock Holmes and hot-rod novels, UFO exposés and accounts of the Civil War, Dickens and Bob Hope, *Horatio Hornblower* and *Worlds in Collision.* All of it was literature, and all of it was good. I imagined a worldwide communion of writers past and present seated at their desks, assembling words at the gratifying potential rate of ten cents per, C. S. Forester and Immanuel Velikovsky and Arthur Conan Doyle and Franklin W. Dixon all stamping self-addressed envelopes, filing away carbon copies, letting the steel jaw of the mailbox slap shut while murmuring a little prayer.

Then, at age thirteen, in Montreal with my family for Expo 67, I found myself in a French-language bookstore. For some reason I picked up a fat anthology called *Le livre d'or de la poésie française,* probably because it had been published in my native town in Belgium. I hadn't previously been much interested in poetry, but I was immediately drawn by the fact that the book's latter half was a regular riot of jagged lines, very long lines, very short lines, even entire blocks of prose. Poetry in regular stanzas, appropriately rhymed and metered, had always appeared obedient, pious, well-groomed, but this stuff clearly refused to be shepherded into church in ordered rows. Leafing through the book in search of more I found an odd chain of prose passages interspersed with thin columns of verse. It was headed: "DÉLIRES / ii / Alchimie du verbe."

My turn. The story of one of my infatuations.
For a long time I considered myself master of every possible landscape, and looked down on famous painters

|and modern poets.

I liked idiotic paintings, doorway moldings, decorative backdrops, carnival banners, signs, cheap prints; outmoded literature, church Latin, illiterate pornography, mildewed novels, fairy tales, children's books, old operas, silly ditties, naïve rhythms.

I dreamed up crusades, unrecorded voyages of exploration, republics with no histories, aborted wars of religion, revolutions in behavior, migrations of races and shifts of continents: I believed in every kind of magic.

I invented the colors of vowels!—A black, E white, I red, O blue, U green—I set the form and motion of each consonant, and using intuitive rhythms I decided I had invented a poetic language that would someday apply to all the senses. I reserved the translation rights.

At first it was an experiment. I wrote silences; I wrote nights; I jotted down the inexpressible. I froze the dizzying whirl.

[. . .]

Poetic cast-offs played a major part in my alchemy of the word.

I practiced elementary hallucinations: I clearly saw a mosque in place of a factory, a school of drummers made up of angels, coaches on the roads in the sky, a parlor at the bottom of a lake, monsters, mysteries. A title on a marquee would set phantasms before my eyes.

And then I explained my magical sophistries with
hallucinated words!
I ended up thinking my spiritual disorder was sacred.
I was idle, prey to fevers. I envied the bliss of animals:
caterpillars, who stood for the innocence of limbo; moles,
for the sleep of virginity!

I understood willed hallucination; I intuited synesthesia without
knowing the word; I knew all about imaginary history and every
kind of junk literature. The paragraphs were unlike anything I had
ever read, and they were intended for me specifically. I leafed back a
few pages and found the information: "1854–1891 — Poète, né à
Charleville." Charleville is in the French Ardennes, on the Meuse, a
river I knew well, and near the Belgian border, in fact quite close to
Bouillon, where I had cousins. The rest of the biography was mostly
lost on me, aside from a few key words: "Charleroi," "Bruxelles,"
"enfant prodige." There were many points of contact between this
Arthur Rimbaud and me. Maybe there was something more to the
pattern; maybe I was his echo, his reincarnation! I bought the book.
 That bookstore—all I have now is a vague impression of a large,
fluorescent-lit, faintly antiseptic room, like the library of a technical
institute—looms in retrospect like Ali Baba's cave. I left with two
books (the other was André Breton's *Anthologie de l'humour noir*,
bought under a fortuitous misimpression), and together they fur-
nished me with my permanent literary foundation; Rimbaud was
not the only figure I encountered as a result. And I was thirteen, and
it was the Summer of Love, and the world and I were changing in
synchrony. Girls and music and cigarettes and discontent were all

happening to me; just out of my reach were sex and drugs and poli-
tics, and glamour and fame and the wide world. A year later I won
a scholarship to a Jesuit high school in New York City, and the wide
world let me in. Every morning I would take a seven o'clock train
from the little clapboard suburban station where I was the anomaly
in a crowd of suits, and an hour and a half later I stood in the middle
of everything. The school quickly came to seem rather beside the
point.

I don't know whether it sounds more like a boast or an admission
to say that I have always been a good student as long as I was setting
the lessons myself. In school I slept or doodled or looked out the win-
dow or fine-tooled my fantasy life. Such activities could not sustain
Greek or trigonometry, however, and after a while I was expelled. But
outside school I was an eager pupil. I learned from walking around
the city, from sitting in cafeterias, from going to the movies, from
reading anything that landed under my nose. I learned in bookstores,
especially in Wilentz's Eighth Street Bookshop, the beacon of liter-
ary hipness in the Manhattan of the 1960s. I had little money to buy
books, so I read snatches of them on the spot, and books led me to
other books, sometimes just through physical proximity.

I was armed with a nice chunk of Christmas money, at least five
and perhaps as much as ten dollars, one day in late 1968 or early
1969 when I walked into the bookstore big-eyed with expectation.
Finally I was in a position to buy something, and at first I was dazzled,
wanting to take home everything from *Narcissus and Goldmund* to *A
Child's Garden of Verses for the Revolution*, the euphoria giving way
to calculation and then to disappointment. What, finally, was good
enough for me to spend actual money on? And then I saw a thick

New Directions paperback—those deadpan black-and-white covers still call to me from across a room—with a picture of a big-haired, pensive, beautiful adolescent: *Arthur Rimbaud* by Enid Starkie. I grandly forked over $3.25 for it. I still didn't know much about Rimbaud. I had read the four works in the anthology I possessed— "Ma bohème," "Le bateau ivre," and "Voyelles" in addition to the excerpt from *A Season in Hell*—again and again with emotions ranging from puzzlement to the sort of excitement that made me actually get up and do an awkward little dance, but their author was represented neither in my town's library nor my school's. It was overwhelming to have nearly five hundred pages about him, complete with pictures.

I read the book slowly, in part because it was dense and in part because I wanted to be seen reading it. I wore the book as much as I read it, "absent-mindedly" holding it in one hand on the street even when I was carrying a satchel of books in the other, "casually" parking it atop my notebook next to my coffee cup wherever I sat. I proudly displayed it on the subway, at Nedick's and Chock full o'Nuts and the Automat, in garment-district cafeterias, at the juice stand in the passage from the IRT to the shuttle at Grand Central Station, in the bar car of the 5:30 express home (drinkless but trying to outsmoke everybody), maybe once or twice at some dump on St. Mark's Place that advertised Acapulco Gold ice cream. There was no T-shirt available then, but I was identifying my brand in comparable fashion. Rimbaud, dead for eighty years, was enjoying one of his many rebirths. The Starkie biography, first published in 1938, had only just come out in paperback (along with its bookstore companion, the Louise Varèse translation of his works). His name was being thrown around in all sorts of places, such as interviews with pop stars—I

felt a little proprietary, as if I owned him and they were encroaching. And there was that face, of course, the detail of Fantin-Latour's *Coin de Table* on the cover and the (second) Carjat photograph within, which matched the work and the life and seemed utterly contemporary. He may be a bit of a conventional cherub in the former, but in the latter he is electric, with flames in those pale eyes. He was hipper than anyone alive.

But if in the fullness of my teenage fantasy I felt I must have been appointed a successor to Rimbaud—on the basis of a few biographical details merely shared by several thousand people—at most times Rimbaud came to stand as a reproach to my cowardice and mediocrity. Yes, I recognized myself in various aspects of his life. Part of this was the result of a childhood immersion in Catholicism, immediately flung down at puberty and followed by a pursuit of what I imagined was its inverse. I liked to think I was dangerous and terrible, even though the shoplifting, pot-smoking, truancy, and masturbation which were all I could muster in this regard would have so impressed no one but my poor unsteady mother. I liked to think I was illuminated, but while I could generate great clouds of smoke, imagining what my works would look like on the page and how they would be received, I couldn't actually write what I imagined. I liked to think that I, too, could manifest genius in a quick series of slaps and then suddenly leave the room never to return, stranding traduced friends and weeping sycophants out on the ice, flicking aside poetry and culture and civilization like a long ash on a cigarette, but I couldn't very well leave without having first entered.

My writing was pathetic and Rimbaud was unanswerable. He was a changeling, an alien. The deeper I burrowed into Rimbaud the less

I could see him or put flesh on him. I fancied I detected corresponding aspects in myself to some parts of him I thought I understood, but they were surface elements. He was not like a conventional idol, who will reliably turn out to be contemptible in private, and even though he was my age I couldn't make him into a schoolyard rival whom I could find some way of reducing to tears. I had made a grave error in choosing Rimbaud as my model—he wasn't even divisible into parts; you couldn't be half a Rimbaud. The alternative to being Rimbaud was to be nothing. If I had chosen somebody like Jack Kerouac instead I wouldn't have had a problem—him I could see all too readily, laugh at his neuroses, nail all his stupidities with no effort—but that was exactly why I hadn't chosen Jack Kerouac. I read and admired many other writers, but none was Rimbaud, who remained a perpetual admonition, a painful constant reminder of my failure, his nineteenth-century calendar mocking the years of my life. I quit writing poetry when he did, at twenty-one—although I only just now realized the coincidence—but there the chronological parallels end. He left France, I stayed in New York; he went to Aden, I moved downtown; he went to Harar, I began to write for magazines; he came home to die, I published my first book.

Rimbaud has been dead for thirteen years now, or one hundred and thirteen by everyone else's reckoning. I've read everything he ever wrote several times over, some of it many times, and I still feel as though I'm far from getting to the bottom of much of it, *Illuminations* in particular. I've been to his house in Charleville-Mézières and the museum across the street, and thought that maybe I should have done so as a teenager, since while the artifacts are terribly moving, the way the French have of institutionalizing their dead artists is a

wonderful homeopathic antidote to hero worship. Charleville is filled with Rimbaud junk merchandise, and in the suburbs you find here and there a sterile landscape traversed by a Rue Arthur-Rimbaud or a housing project with an immense blowup of the Carjat photograph on the wall of its inner court, and politicians quote him in their speeches, and television presenters cite him as if he had been some stuffed owl in the Academy rather than someone who would have caused them to call the police. Had I been a child in France I would have been made to memorize "Le dormeur du val" and that would have been the end of it. I wouldn't have paid any attention to the poem and wouldn't have wanted to hear any more about Rimbaud.

I can reread the Starkie biography today, with him doubly interred, and no longer feel as though I will have to put the book down at some point and go put on music and think hard about something else, because the race is over now. Our parallel has been shattered by time and circumstance. I can contemplate in tranquility just how wildly outmatched I was. Rimbaud, I see now, was never a kid, or at least never a kid poet. At fourteen he wrote a Latin verse in which Phoebus descends from the heavens to write "TU VATES ERIS" (you shall be a poet) on his brow, but that was merely in the service of rhetorical convention. Kid poets are composed of either wet flopping emotion or hollow technical showing-off, and if they are ever to amount to anything, they will as they mature slowly lean out and grab hold of the other branch. Rimbaud arrived fully equipped. And Rimbaud never had a Rimbaud. He killed his idols. He swallowed his influences whole, imitated them while improving upon their work, and if they were still alive made a point of flinging in their faces the fact that he was better at being them than they were.

I've known a couple of people who have reminded me in some way or other of what Rimbaud must have been like, one of them the painter Jean-Michel Basquiat, who well before he became famous seemed to live on a parallel plane, so absorbed in his art and its demands that like a heat-seeking missile he would blithely and apparently unconsciously vaporize anything that stood between him and his target. Rimbaud in the flesh, I can see now, was a snot-nosed pest who talked fast with a grating whine, who made fun of everybody in the room and knew that nobody could successfully answer back or hit him without losing face, who came to your house and ate everything in the fridge before disappearing abruptly and would come around again only when you had something he wanted. You would probably have to have been in love with him to tolerate him for long. Quite beyond lacking his genius, I could never have been anything like him. As a teenager I was constructed entirely of doubt, most of it self-doubt, and I am not much different today. I am larger and slower and older than Rimbaud, even though I am technically a century younger. Having outlived him I feel like one of those companions of the prophet, those friends of the brilliant young dead who go on to spend the rest of their lives reselling their anecdotes and testifying in documentaries. I remember Rimbaud, all those drunken nights, I will say, gazing wistfully off-camera. And I will silently realize, not without rancor, that now, finally, I can tame him.

2004

Lucy Sante was born in Verviers, Belgium. Her other books, heretofore published under the byline Luc Sante, include *Low Life*, *The Other Paris*, *Evidence*, *The Factory of Facts*, *Folk Photography*, and *Maybe the People Would Be the Times*. She has also translated and edited Félix Fénéon's *Novels in Three Lines*. Sante has received a Whiting Writer's Award, a Guggenheim Fellowship, an Award in Literature from the American Academy of Arts and Letters, an Infinity Award for Writing from the International Center for Photography, and a Grammy (for album notes). She has contributed to the *New York Review of Books* since 1981 and has written for many other publications. She is a visiting professor of writing and the history of photography at Bard College.

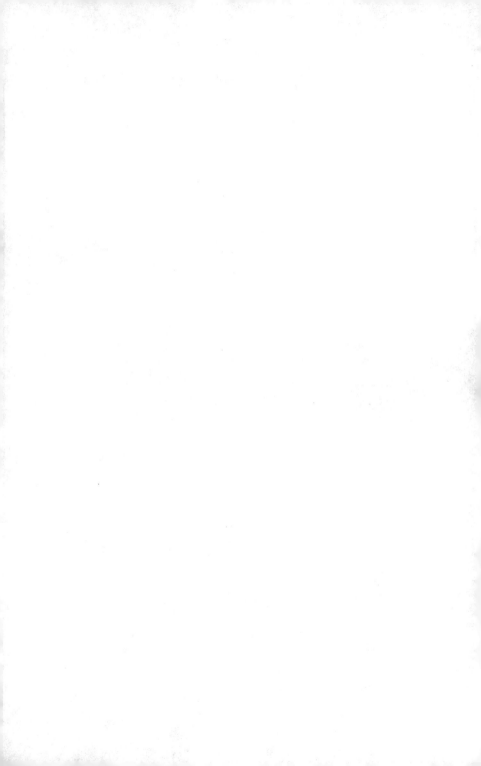